Master Drawings
of the *Italian Renaissance*

THE
**PAUL HAMLYN
LIBRARY**

———◆———

DONATED BY

THE PAUL HAMLYN

FOUNDATION

TO THE

BRITISH MUSEUM

———◆———

opened December 2000

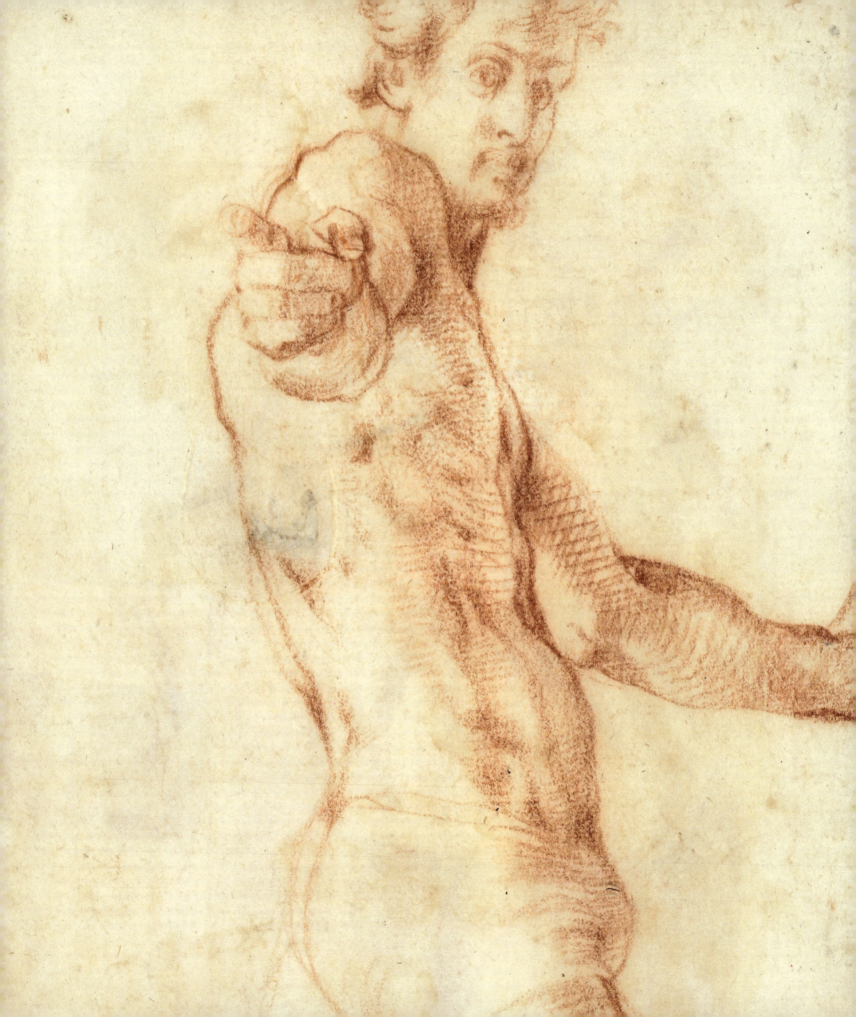

Master Drawings
of the *Italian Renaissance*

Claire Van Cleave

THE BRITISH MUSEUM PRESS

Published in 2007 by The British Museum Press
A division of The British Museum Company Ltd
38 Russell Square, London WC1B 3QQ

www.britishmuseum.co.uk

Claire Van Cleave has asserted the right to be identified as the author of this work

A catalogue record for this book is available from the British Library

ISBN 978-0-7141-2654-8

Designed and typeset in Adobe Garamond by Tim Harvey

Printed in Spain by Grafos SA, Barcelona

Illustration acknowledgements

British Museum images © Trustees of the British Museum.
Photography by Ivor Kerslake.
Images from French collections © Réunion des Musées Nationaux, Paris

Fig. 2: Map by David Hoxley, Technical Art Services.
Fig. 3: © The Royal Collection © Her Majesty Queen Elizabeth II.
Fig. 8: © The J. Paul Getty Museum. Fig. 19: © Ashmolean Museum, Oxford. Fig. 22: © Ursula Edelmann / Städel Museum, Frankfurt. Fig. 27: © Photo SCALA, Florence / Gabinetto dei Disegni e delle Stampe degli Uffizi, 1990.

frontispiece
Jacopo Carrucci, il Pontormo, *Self-portrait* (detail). See page 171.

Contents

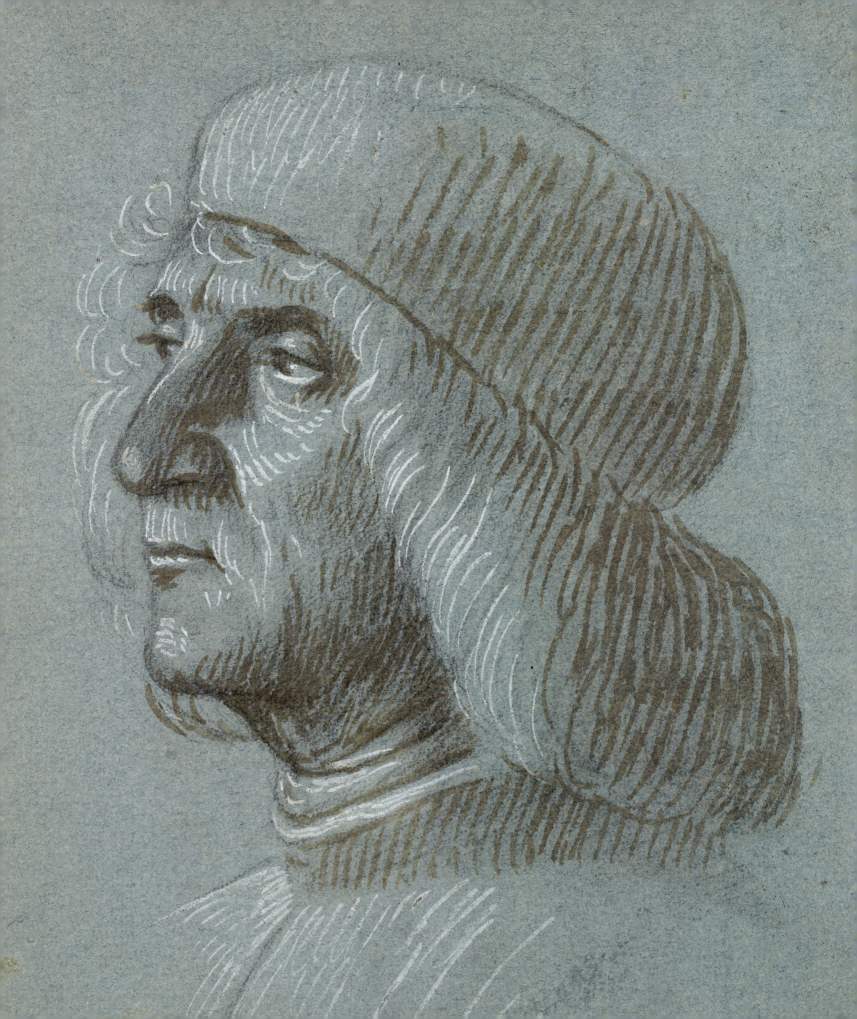

Drawing in Renaissance Italy

'… *il disegno, padre delle tre arte nostre, Architettura, Scultura e Pittura.*' Giorgio Vasari, *Lives of the Artists*, 1

FROM THE LATE FIFTEENTH to the mid-sixteenth century there was vigorous intellectual debate in Florence on whether painting or sculpture was the nobler art. Sculptors argued that their art was superior, citing the ability of sculpture to show three dimensions and therefore represent nature more accurately. Painters countered that they could give the illusion of three-dimensionality while also setting the figure into space and imbuing it with colour, light and atmosphere. This *paragone*, or comparison, was resolved by the argument that drawing was the foundation of both their disciplines. Giorgio Vasari (1511–74), the Florentine painter and art historian, called drawing the father of the arts.

The works illustrated in this book are therefore key to understanding Renaissance art as a whole. Drawings were used as learning tools and as the means by which artists designed their works. The Italian word *disegno* translates as both design and drawing, thereby encompassing the formulation of the idea in the artist's head as well as its expression on paper. The finished masterpieces of the period, whether architecture, sculpture or painting, generally give little insight into the process required for their creation. The preparatory drawings, on the other hand, reveal the thoughts of the artists as they worked.

It was uncommon for a Renaissance artist to sign

his drawings because they were preparatory studies intended for his own use. There are some exceptions, notably finished drawings such as Pisanello's *Three courtiers* (p. 37), which is signed 'PISANUS' on the bottom of the sheet. In order for scholars to recognize the author of an unsigned drawing, a clear idea of an artist's style must be developed. This process is initiated by identifying preparatory drawings related to recognized paintings. The composition drawing of *The Triumph of St Thomas Aquinas* (p. 101), for example, is a preparatory work for Filippino Lippi's fresco of the same subject in Santa Maria sopra Minerva, Rome, and so it is logical that the preliminary drawing is by his hand. Once a number of secure connections such as this are in place, they can be used as a framework upon which other drawings of a similar style, and therefore probably by the same hand, may be hung. This process, known as connoisseurship, is akin to recognizing the personal style of someone's handwriting.

It is extraordinary that these fragile sheets have survived for 500 years, given that Renaissance drawings were seen as working tools and not as independent artworks with any commercial value, and that most were discarded or destroyed after use. As an extreme example, Michelangelo is said to have burned large numbers of his drawings because he did not want them to be seen by others. When drawings were saved it was because they were regarded as records of completed projects or models to use for future works. They were often passed on as valued inheritances to future generations of artists. For example, when Francesco Squarcione (*c.* 1395–1468) adopted his apprentice Marco Zoppo he promised to leave him his estate, including 'reliefs, drawings and other things'. Such a collection would have been an important resource for

Figure 1. Vittore Carpaccio, *Head of a middle-aged man, c.* 1507 (detail). Ink and white highlighting drawn with the point of the brush on blue paper, 267 × 187 mm. London, British Museum, 1892-4-11-1.

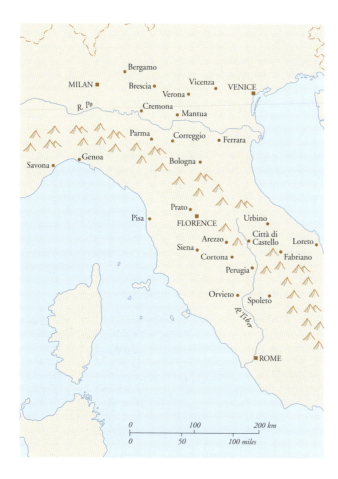

Figure 2. Map of northern Italy.

Zoppo. Certainly, the Dominican painter Fra Paolino (*c.* 1490–1547) made diligent use of the 830 loose drawings and 12 sketchbooks he inherited from his master Fra Bartolommeo. Gradually, drawings began to be more highly prized as examples of an artist's style and were collected by artists outside the original workshop. The Umbrian artist Timoteo Viti (1469–1525), for instance, possessed drawings by Signorelli, Raphael and others, and used them as models when designing his own paintings.

By the sixteenth century the perception of drawings solely as functional objects had started to change. This was partly due to artists such as Michelangelo, who made drawings like the *Fall of Phaeton* (Fig. 3) as a present for his friend Tommaso de' Cavalieri. The general fame of Leonardo, Michelangelo and Raphael also led to increased interest outside the artistic community in their drawings. Drawings began to be

collected by enthusiasts. Baccio Bandinelli boasted that his drawings were in demand by collectors who were willing to pay the enormous sum of at least 200 *scudi* for each drawing. Even if this is pure exaggeration, it shows that drawings had become more widely valued by the middle of the sixteenth century. The most important early collector was Giorgio Vasari, who amassed in an album, the *Libro de' Disegni*, specimen drawings by many of the artists represented in his book *The Lives of the Artists.* In this album Vasari drew elaborate frames around single or multiple examples of an artist's work. One of these can be seen in Raffaellino del Garbo's *Standing figure of Christ* (p. 115). Other drawings have been taken off Vasari's mounts, but are recognizable by fragments of their frames or attributions, for example the *Studies of a hand and feet* (p. 155), which is inscribed 'Andrea del Sarto Fior'. Vasari also mentioned having drawings of heads of women by Verrocchio in his *Libro*. These were probably similar to the two sheets illustrated in this book (pp. 66–7).

MATERIALS AND TECHNIQUES

Much of our knowledge about the materials and techniques used by Renaissance draughtsmen comes from written sources. The *Libro dell' Arte* by Cennino Cennini (*c.* 1370–*c.* 1440), written at the end of the fourteenth century, is one of the first books of practical advice for the aspiring artist. Later in the century *Della Pittura* by Leon Battista Alberti (1404–72) and the *Commentarii* of Lorenzo Ghiberti (1378–1455), both written in the 1430s, are less practical, more theoretical treatises on how to create paintings.

Leonardo da Vinci made copious notes throughout his life about paintings and drawings. After his death,

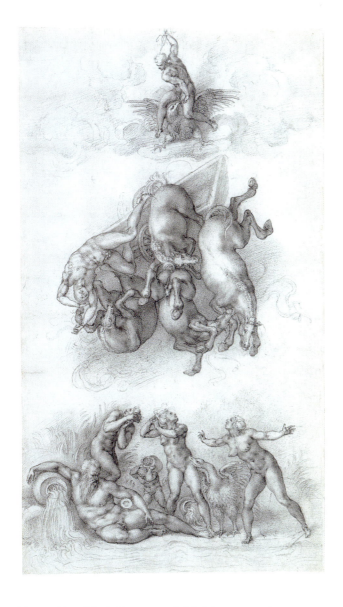

Cimabue in qua, as well as writing the first dictionary of artistic terms, the *Vocabolario toscano dell' arte del disegno*. All these sources, combined with visual and scientific examination of the drawings, are the basis for understanding how Renaissance artists drew.

Supports

For obvious reasons a class of drawings not represented in this book is preparatory drawings made on erasable tablets. We know that Renaissance apprentices learned to draw on wooden tablets that could be erased and used again and again. Cennini described how to prepare the surface of a boxwood tablet with a layer of ground bone mixed with saliva to make it suitable for practising drawing. Once his skills had been perfected on these tablets, an artist would move on to drawing on paper.

Italian paper traditionally came from the town of Fabriano in the Marches, where papermaking had been an important industry since the thirteenth century. The process began with cloth rags or ropes of hemp or linen that were sorted according to texture and colour. The rags or ropes were then pounded in water in a mill until they were reduced to fibres. A deckle, a rigid wooden frame holding a metal screen made to the measurements of a sheet of paper, was immersed in the vat of fibrous liquid. When the papermaker removed the deckle from the vat, a thin, evenly distributed paste of fibres collected on the screen. The fibres did not adhere to the screen, so the damp paper could be removed from the frame with ease. The screen's grid of wires left transparent lines in the paper. This pattern, called 'chain' for the vertical lines and 'laid' for the horizontal ones, is often visible when a sheet of paper is held to the light. Additional wires were often added in the shape of a symbol or letter that formed a transparent

his pupil and heir Francesco Melzi (1493–1570) compiled these notes into a treatise on painting. Vasari's *Lives*, first published in 1550 and expanded in 1568, begins with practical advice on the art of painting. At a similar date Giovanni Battista Armenino (*c.* 1533–1609) published his *De' veri precetti della pittura* which, like Cennini's book, included technical information on creating drawings and paintings. Finally, Filippo Baldinucci (1625–97), an amateur draughtsman, writer and collector of drawings, expanded Vasari's biographies and included technical information on drawings in his *Notizie de' professori del disegno da*

watermark to identify the manufacturer (Fig. 4). The damp paper was pressed between layers of felt, hung up to dry, and then treated with a glue-like size to make it suitable for drawing or writing.

The quality and colour of paper were dependent on several factors in its production. The best linen rags produced fine paper, while rougher hemp produced coarser paper. During production the cleanliness of the water determined its tone. Clean water produced the best, creamy white tones, while dirtier water produced poorer tones that fluctuated from brown to grey. Blue paper was also popular in the Renaissance, particularly in Venice where indigo cloth was a mainstay of the local fabric dyeing industry. Venetian artists soon appreciated it for its potential to create atmospheric effects. However, blue paper is prone to fading and many sheets that were once vibrant are now pale. This may be seen by comparing the remarkably fresh blue of the paper in the *Head of a middle-aged man* by Carpaccio (Fig. 1) with the faded *Standing female nude with her arms behind her back* by Sebastiano del Piombo (p. 151).

Parchment, also called vellum, was made from sheep-, pig-, goat- or calf-skins soaked in lime, burnished to diminish irregularities in the surface and then dried on a wooden stretcher. The surface of parchment is smooth, somewhat translucent and more durable than paper. The use of parchment for manuscripts and drawings predates the introduction of paper in Italy, but in the second half of the fifteenth century, as paper became cheaper and more widely available, the use of parchment declined. In this book the *Prophet David* by Fra Angelico (p. 35), the *Three courtiers* and the *Medals of Alfonso V of Aragon* by Pisanello (pp. 37 and 41), and the *Dead Christ supported by angels* by Marco Zoppo (p. 69) are drawn on parchment. Of these, only the Fra Angelico was intended for a manuscript. The others may have been drawn on parchment because they were made as gifts to be preserved.

Tools and drawing media

When *garzoni*, or boys in the workshop, learned to draw, they started with the most basic drawing tool, a stylus. This is a slender point of metal held like a pen that leaves only a scored line on a prepared writing tablet or paper. The image of a *garzone* sketching on a tablet (Fig. 5) demonstrates this most basic drawing method as practised in the workshop of the Florentine goldsmith and engraver Maso Finiguerra (1426–64). The youth in the drawing is sitting on a bench with a tablet on his raised knee and a stylus in his hand.

The stylus was a practical training tool because it did not leave a coloured mark, merely an indentation that was easily wiped off the surface of the tablet. When used on paper, the incised lines helped to guide the artist when he went over them with a permanent medium. Artists often used a stylus as the first step to block in a basic drawing. Understandably, incisions left by a stylus are difficult to see, but a careful look at drawings such as Raphael's *Sibyl* (p. 149) or Perugino's *Head of a man* (detail, Fig. 6) show the indented lines of the stylus, especially in the areas where the chalk has skipped over the furrow of paper that the stylus throws up on either side of the indentation.

Figure 5. Workshop of Maso Finiguerra, *Seated youth sketching on a tablet, c.* 1450. Pen and ink with brown wash, 192 × 114 mm. London, British Museum, 1895-9-15-440.

Figure 6. Detail from Perugino's *Head of a beardless man,* (p. 81), showing indented lines made by a stylus.

Metalpoint is closely related to stylus. It was held and used in the same way, but the slender point was made of a softer metal that left a visible mark on a prepared page. Silver, lead, copper and even gold could be used, but silver was the most popular choice. The preparation of the paper was key to the visibility of the line. The blank page was brushed with layers of a liquid mixture of finely ground chalk, bone gesso or lead white tinted with pigment and bound with gelatine and hide glue. Cennini recommended the use of poultry bones found under the dining table, burned until they were white and ground to a powder. In his time the pigment added to the preparation was generally green *terra verde.* Later, a variety of pigments became popular, including indigo, sinopia, yellow ochre and cinnabar. The grounds for metalpoint drawings in this book range from vivid salmon pink, blue, red-orange and purple-grey to more subtle pink and white (Fig. 7). Deposits from the soft metal point adhered to the slightly rough surface of the preparation and left a thin line that immediately oxidized and darkened. To replicate this process, a mark can be made with a modern coin on a wall painted with matt emulsion.

Metalpoint was a rigid medium. Variation of pressure on the stylus did not increase or decrease the intensity or breadth of the line. The resulting fine line was inappropriate for loose sketches. Like tempera paint, an equally inflexible medium, metalpoint must be applied in thin strokes that cannot be blended. Close examination of the darkest tones on the face in Benozzo's *Head of a monk* (p. 49) shows meticulous hatching made up of fine strokes. Metalpoint cannot be erased from the page, so the artist's first marks as he set down his drawing are often still visible. The tiny, indecisive lines around the fingers, feet and back of the gown in Filippo Lippi's *Female saint* (p. 45) show the

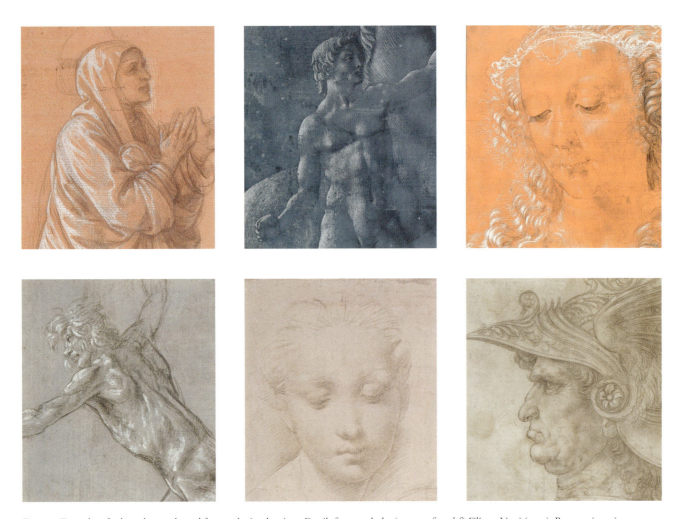

Figure 7. Examples of coloured grounds used for metalpoint drawings. Details from works by (*top row, from left*) Filippo Lippi (p. 45), Benozzo (p. 47) and Verrocchio (p. 67); (*bottom row*) Filippino Lippi (p. 99), Raphael (p. 144) and Leonardo (p. 95).

artist's corrections to the drawing. Because of metalpoint's limitations it was more popular with artists who painted in fresco and tempera than those who worked in oil paint. By the sixteenth century it was almost obsolete, and Raphael appears to be one of the few artists who continued to use it, notably in his *St Paul rending his garments* of *c.* 1514–15, made in preparation for the Sistine tapestries (Fig. 8). The figure in this drawing has a sweeping, vibrant pose, but the technique of the metalpoint is still tight and painstaking.

Leadpoint was softer than metalpoint and it had its own distinct characteristics. Cennini suggested beating two parts lead with one part tin to increase the strength

of the lead so that the tip would not become blunt too quickly. The advantages of leadpoint were that it did not require any preparation of the paper and that it could be erased with a lump of stale bread. In these respects, it resembles modern graphite. The lead is not indelible on the page and wears off in time. The fugitive nature of this medium has undoubtedly contributed to the scarcity of surviving leadpoint sheets. A notable exception is Jacopo Bellini's extraordinary sketchbooks, where many of the drawings have become so faint that, especially in the Louvre sketchbook, the lines have been strengthened in other media.

According to Cennini, the aspiring artist could

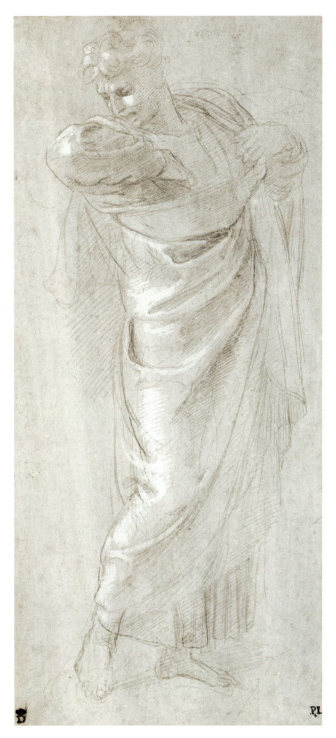

Figure 8. Raphael, *St Paul rending his garments*, 1514–15. Metalpoint heightened with white gouache on lilac-grey prepared paper, 230 × 103 mm. Los Angeles, J. Paul Getty Museum, 84.GG.919.

progress to drawing with pen and ink on paper after a year of practising on tablets with stylus, leadpoint or metalpoint. Ink was permanent once applied to paper, so mistakes could not be erased or obliterated except by carefully scraping out the line. Diligent training was therefore required to become proficient.

The most common ink in Renaissance Italy was made from iron gall. Its principal components, gall nuts, are growths on oak trees that can become as big as 5 centimetres in diameter. The nuts are rich in resin and tannic acid which, when infused in water or wine, strained, and then mixed with iron sulphates and gum arabic and exposed to the air, created a liquid black ink ideal for drawing. Over time, the colour of iron gall ink fades, so that although the ink in most Renaissance drawings is described as brown, it would originally have been much blacker.

During the Renaissance ink was generally applied to paper with a quill pen. Cennini explained how to cut a goose feather quill to make it broad or fine according to the intended use. Quills were by nature flexible and sensitive to increased or decreased pressure by the hand as the quill was drawn across the paper. The resulting line could be thin and meticulous or broad and sweeping (Fig. 9). This variation may also be illustrated by comparing works by the brothers Gentile and Giovanni Bellini. Gentile's *Turkish man* and *Turkish woman* (pp. 52–3) were drawn with incredibly fine strokes of a thin pen that convey fastidious detail. By contrast, Giovanni's *Pietà* (p. 54) was drawn with broader, bolder strokes of a thicker pen with a line that is far more sketchy and spontaneous. Giovanni's handling is somewhat hesitant, but pen can also be used for accurate strokes. The confidence of Ghirlandaio's hand in the *Standing figure of a lady* (p. 73)

Figure 9. Variations in ink colour and density. (*From left*) Details from drawings by Mantegna (p. 57), Giulio Romano (p. 167) and Peruzzi (p. 135).

shows how pen can make both swift and precise strokes within the same drawing. Leonardo's *Virgin and Child with a cat* shows yet another aspect of the use of pen and ink (Fig. 10). The tannic acid in iron gall ink can be corrosive, especially when applied in heavy strokes to paper: the frenzy of lines below the Child and the cat shows how ink can bite into the page. The freedom of these strokes also points out the rapidity with which ink may be applied.

The adaptability of pen and ink is the opposite of the inflexibility of metalpoint. Ink remained popular throughout the Renaissance for a wide variety of drawings, from rapid sketches to detailed compositions. Its range of expression was even greater with the

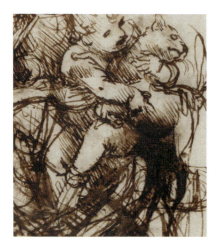

Figure 10. Detail from Leonardo's *Virgin and Child with a cat*, (p. 90), showing how the acid in iron-gall ink can burn into paper.

addition of wash and highlighting. In order to create areas of shadow, artists made repeated strokes of parallel or crossed lines to darken an area of a drawing. This hatching or cross-hatching was not unique to ink, but was a particularly effective way of producing shadow when using pen. Hatching on a drawing could be quite subtle and used only in specific areas, or very comprehensive, as in Parmigianino's *Man holding up a pregnant bitch* (p. 186), where the cross-hatching is used in a very precise manner to create tonal differences and contour. Despite the fluid nature of ink, the need to dip the quill repeatedly into it to continue a line made it unsuitable for large-scale drawings such as cartoons. These were normally drawn in chalk or charcoal, not ink.

A brush loaded with diluted ink could be used to shade an ink drawing. The shading was often done with the same iron gall ink that was used with the pen, but it could also be done with bistre, which was made from wood soot scraped from the inside of a chimney and infused in water. The result was a brown wash that was not viscous enough for use with a pen, but ideal for use with a brush. The application of wash to a pen drawing enhanced the three-dimensionality of the image.

Like the pen, a brush loaded with ink could create a great diversity of strokes suited to a variety of purposes. In works such Benozzo Gozzoli's *Studies of a*

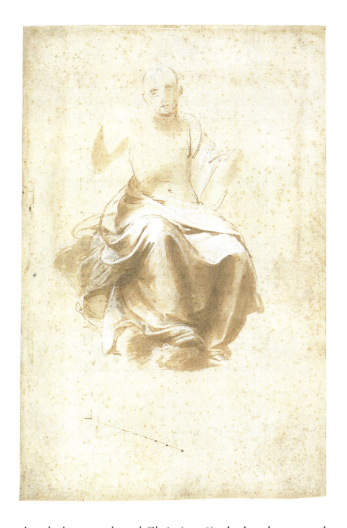

Figure 11. Raphael, *Drapery study for Christ in the Disputà*, 1508. Brush and wash heightened with white, 408 × 269 mm. Lille, Musée des Beaux-Arts, PL 471.

man (Fig. 1) was created with strokes of a brush loaded with ink or white highlighting. The combination of blue paper with the brushstrokes is typical of a Venetian artist's interest in colour and atmosphere. Raphael's *Drapery study for Christ in the Disputà* was created solely with the brush, used in a combination of broad strokes to block in areas of shade, and fine strokes, where the tip barely touched the page, to create partial outlines of the figure (Fig. 11). Similarly, the contours of figures in Correggio's *Sts Mark and Gregory* (p. 162) were created by strokes of the brush that were later strengthened with a pen, but the face of the figure on the right was drawn with the brush alone. Even Zoppo's complex *Dead Christ* (p. 69) was created more with the brush than with the pen.

Stylus, metalpoint and pen with ink are defined as fine line media as opposed to the broad line of charcoal and chalks. Renaissance artists initially employed broad line media for very specific purposes, but as the use of oil paint increased, chalk in particular became more popular for a range of drawings. This was primarily because chalk, like oil paint, may be blended and smudged to create a range of tones.

The degree to which charcoal was used during the Renaissance is difficult to assess because it is such a fugitive medium. Charcoal is made of carbonized wood. Cennini described how to take sticks of willow as long as the palm of a hand and the thickness of a match, sharpen the ends, and then seal them in an airtight container before cooking them in hot coals. He recommended taking the sealed container to a baker at the end of his working day to carbonize the willow overnight in the residual heat of his oven. The resulting medium drew a broad, loose line that could be easily erased with a feather. It was particularly useful for

hand, three angels and Christ (p. 48), the brush was used sparingly to create a cast shadow or deepen the shadows on a figure. In other drawings, such as Filippino Lippi's *St Thomas Aquinas* (p. 101), wash was used throughout the sheet to block in the architecture and to help build up the figures. Wash could be applied with subtlety to create the illusion of rounded shapes, as in Giulio Romano's *Shallow vessel* (p. 167 and detail Fig. 9), or dramatically to enhance the emotion of a drawing, as in Polidoro da Caravaggio's *Entombment* (p. 179). The possibilities were endless. Moreover, wash was not restricted to ink drawings. Filippo Lippi's metalpoint study of a *Standing female figure* (p. 45) includes shadows made with wash.

Artists occasionally made brush drawings in ink or bistre without a pen. Carpaccio's *Head of a middle-aged*

Figure 12. Detail from Botticelli's *Abundance or Autumn*, (p. 71), showing underdrawing in black chalk.

underdrawing on paper or the painted surface because it could be modified before fixing the line in a more permanent medium. Once the design had been drawn in metalpoint or ink, the charcoal could be erased.

Unfortunately, the same characteristics that made charcoal easy to erase have also resulted in poor preservation of charcoal drawings. The very slight lines of a black, broad line medium in Pisanello's *Harnessed horse* (p. 39) appear to be faint traces of a charcoal underdrawing. Because of its powdery nature, charcoal would only adhere to paper if it was treated with a fixative. Throughout most of the Renaissance, fixatives were uncommon and few charcoal drawings from the period survive.

The most versatile broad line media in the Renaissance was chalk (Fig. 13). Although chalk was not as ephemeral as charcoal, it was to some degree erasable and therefore useful for tasks unsuited to indelible media such as metalpoint or ink. In addition, chalk could draw both a thick and a thin line that could swiftly cover large expanses of paper. Natural chalk came in red, black or white, and although all the colours share these basic characteristics, the specific uses for each type were dependent on its particular qualities.

During the Renaissance the black chalk used by artists was a form of natural shale composed of carbon and clay. Natural black chalk is now nearly impossible to find. It has been replaced by man-made compressed chalk that is cheaper and more consistent in its line. In the Renaissance, however, chalk seems to have been available throughout Europe. Cennini and Vasari stated that black chalk came from Germany or France, while Baldinucci said that the best chalk came from Spain. Artists would probably have bought it in bulk and then cut it down to a convenient size to fit into a holder the

size of a pen. Because black chalk was a natural substance in which the proportion of carbon and clay could vary, the density of the line that it drew on paper was not uniform. Its stroke could be thick and waxy like a crayon's, broad and powdery like that of charcoal or thin and dense like that of modern graphite. Black chalk could therefore be used for both large-scale drawings and, when sharpened to a fine point, for small-scale drawings. Most importantly, black chalk could be smudged to produce uniform darkness. Smudging was achieved by stumping (rubbing the line of chalk with the tip of a roll of leather or paper known as a stump) or by smearing the line with a cloth or a finger. The resulting subtle shifts of tone between light and dark are unique to chalk: neither ink nor metalpoint could match this delicacy of shading.

The emergence of black chalk as an independent drawing tool is difficult to pinpoint. Cennini explained that black chalk was similar to charcoal and could be sharpened with a knife, but he did not go into detail about its use. This implies that chalk was not common during his lifetime. Over a hundred years later Vasari defined black chalk in terms of red chalk, a medium that had become more popular in his time. Fifteenth-century drawings show that black chalk was traditionally used for the underdrawing of composition or figure studies and for cartoons. Botticelli's *Abundance or Autumn* is a good illustration of how black chalk was employed in underdrawing because the

Figure 13. Examples of black chalk and red chalk, showing variations in thickness of line and pressure. (*From left*) Details from drawings by Perugino (p. 81), Verrocchio (p. 66) and Andrea del Sarto (p. 156).

cornucopia and putto on the left of the sheet were not drawn over in ink (Fig. 12). Botticelli laid down the figures in chalk in a precise yet sketchy manner before developing the drawing with pen and ink, wash and highlighting that obscured the black chalk underneath.

Black chalk was also the ideal medium for creating cartoons because its broad line could swiftly cover a large expanse of paper. Raphael's *St Catherine* (p. 147) and his *Cartoon for the Mackintosh Madonna* (Fig. 24) are typical examples of this. Chalk could even be sharpened to render fine detail if necessary. As a consequence of its use for cartoons, black chalk also became popular for detailed studies of heads, such as

Figure 14. Verrocchio, *Head of a woman, c.* 1475. Black chalk, 325 × 273 mm. London, British Museum, 1895-9-15-785 (verso).

Pisanello's *Filippo Maria Visconti* (p. 40) and Boltraffio's *Portrait of a young man* (p. 113). Verrocchio's manipulation of black chalk in the *Head of a woman* (p. 66) demonstrates his particular skill in the medium. He began by drawing an outline of the head on one side of the sheet (Fig. 14). To this he added simple areas of hatching and smudging without fully working up the drawing. Then he turned the sheet over to elaborate upon the design. On this side, dark strokes of chalk in the hair show how the line of black chalk can sometimes appear waxy and intensely dark (Fig. 13), while the extremely delicate areas of smudged shading on the skin of the face demonstrate the range of tonal values that may be achieved with repeated applications.

Gradually, black chalk began to be used for more than just underdrawing, cartoons and head studies. Luca Signorelli was one of the first artists to perfect its use for drawings of the human figure. The bold qualities of black chalk were perfectly suited to his assured studies of muscular nudes (pp. 78–9). In this respect he was the precursor to Michelangelo who, in the last thirty years of his career, preferred black chalk to all other media. Similarly, Leonardo showed a preference for black chalk at the end of his life, perhaps because of its ability to render atmospheric effects.

Increased interest in broad line drawing prompted

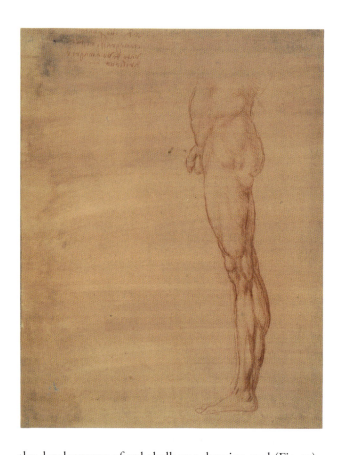

the development of red chalk as a drawing tool (Fig. 13). Natural red chalk was composed of clay with iron oxide and haematite. The intensity of colour was dependent on the percentage of haematite. Like black chalk, red chalk came from various European sources and was supplied in large pieces that were cut down for use in a holder. Armenino recommended that the best chalk for drawing should be neither too hard nor too soft and certainly not sponge-like: in the latter case it would quickly splinter when used as a drawing tool. Red chalk was a harder medium than black chalk and therefore more indelible on paper. However, its range of tone was limited and it could not be used to achieve the deep hues attainable with black. This, and its hardness, made it unsuitable for large-scale drawings. Despite these detractions, red chalk had a warmth and subtlety of tone that were in many ways superior to black chalk. Because its colour was closer to that of flesh, it was often used for nudes. Signorelli used it to great effect in combination with black and white chalks to create the

flesh tones in his *Moneylender* (Fig. 16). The line of red chalk could also be smudged to achieve lighter, softer hues or moistened to draw a denser line. Most importantly, because red chalk was harder than black chalk, it could retain a sharpened point and therefore produce a fine line. This could be employed for underdrawing, as in Gentile Bellini's *Procession in the Piazza di San Marco* (p. 51) and Raphael's pen and ink *Virgin and Child* (p. 144), but the indelible nature of the chalk made it less useful than black chalk for this task.

Leonardo was the first draughtsman to pioneer red chalk as an independent medium. He used it for many kinds of drawings, from studies of the human figure to studies of nature. In the *Abdomen and legs of a man* (Fig. 15) the range of red chalk can be seen in the contrast of the fine, dark outline of the leg with the subtle flush of shading on the musculature. Leonardo also used red chalk in numerous studies of grotesque heads, a tradition continued by his follower Giovanni Agostino da Lodi (Fig. 17). Red chalk caught on quickly and was soon used by artists for figure studies

Figure 16. Detail from Signorelli's *Study for the moneylender in the Orvieto Antichrist*, (p. 77), showing red chalk used in combination with black and white chalks.

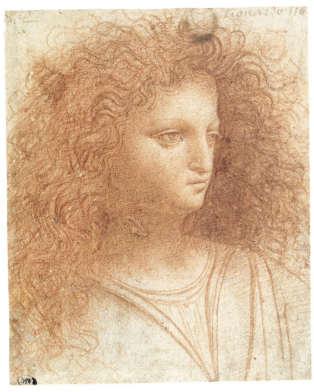

Figure 17. Giovanni Agostino da Lodi (*c.* 1467–1524/5), *Bust of a young man, c.* 1513. Red chalk, 100 × 83 mm. Paris, Louvre, inv. 2252.

such as Raphael's *Alba Madonna* (pp. 140–1) or *Sybil* (p. 149), and composition studies such as Pordenone's *Lamentation* (p. 139). Michelangelo's red chalk figure studies were some of the most admired and imitated of his drawings. His use of red chalk may have inspired Andrea del Sarto to take it up: Andrea's virtuoso handling of the medium in drawings such as the *Birth of John the Baptist* (p. 157) and the remarkable *Four studies of a child* (p. 156 and detail Fig. 13) show his deep understanding of its varied qualities of line and shade.

Drawings in all media were often heightened with white to pick out the areas of brightest light and to enhance the plastic effect of the modelling. There were three ways of heightening a drawing: with white chalk directly on the paper, with wet pigment applied with a brush, or simply by leaving the paper blank. The latter was not as easy as it might appear. Close inspection of Vittore Carpaccio's *Vision of St Augustine* (p. 107), where the highlights are crucial to both the modelling and the narrative, confirms Vasari's comment that 'Many others make highlights with the pen alone by

leaving the luminosity of the paper which is difficult but very masterful.' The areas of paper that Carpaccio left blank are often very subtle. Note for example how the thinnest slivers of white paper enhance the modelling of the chair to the left of the sheet.

Like all chalks, white chalk could be smudged to soften its line. It was generally applied to drawings made in red or black chalks as its broad line suited these. As already noted, it was used to particularly striking effect in combination with both black and red chalks in Signorelli's *Moneylender* (Fig. 16). White chalk, a very fugitive medium, is easily rubbed off the page, and it is possible that many drawings made with it no longer show traces of its use.

The application of white highlighting with a brush was the most common method of heightening a drawing. This liquid highlighting, a gouache sometimes called lead white, or *biacca*, was made by mixing opaque pigments with zinc or lead white and gum arabic. It could be either diluted or concentrated, and was applied to the page with a thin or thick brush. The highlighting in Raffaellino del Garbo's *Standing figure of Christ* (p. 115) was delicately applied with a tiny brush in a manner appropriate to the fine strokes of a metalpoint drawing. By contrast, the sweeping highlights of Parmigianino's *Martyrdom of Sts Peter and Paul* (p. 184) were far better suited to the sketchy pen and broad wash on that sheet.

The addition of highlighting could make a significant difference to a drawing without highlights. In Raphael's study for the *Disputà* (p. 148), for example, the single figure on the left that is treated with white highlighting leaps off the page when compared with its surrounding figures.

As Renaissance artists became more adept at

manipulating light to intensify dramatic effects, white heightening became more prevalent. In drawings from early in the fifteenth century, white heightening on a dark background was occasionally used to create drama through the contrast of light and shadow. Benozzo's *Dioscuro* (p. 47), for example, is essentially a drawing in white on a dark blue ground. Similarly, the white curls of hair in Verrocchio's *Head of a woman* (p. 67) give the illusion of light hair in contrast to the orange background. By the sixteenth century the dramatic impact of a white drawing on a dark background was better understood, making Rosso Fiorentino's *Mars and Venus* (p. 175) and Polidoro's *Entombment* (p. 179) powerful images.

In considering all the media available to the Renaissance draughtsman, it becomes apparent that an artist's choice of drawing tool often depended on his own style. An artist who worked in tempera and was used to building up layers of colours in tiny brushstrokes was likely to create drawings that were equally layered and finely executed. This is one of the reasons why Botticelli's *Abundance or Autumn* (p. 71) looks so different from Peruzzi's *Woman and the head and shoulders of two men* (p. 135). The increasing use of oil paint that could be applied in longer, thicker strokes inspired the use of the bolder broad line media. Therefore Mantegna's *Man lying on a stone slab* (p. 57) has different tactile qualities from Correggio's sensuous *Eve* (p. 161). Equally important to the choice of medium was the manner in which the artist executed a drawing. This is especially visible in pen drawings, where pressure on the quill or speed of execution could produce quite different results. These variations are clues to the personal style of each artist. The rigid, harsh handling of the pen in drawings by Baccio

Bandinelli (p. 169) could not be more different from the equally precise, yet much more free-flowing pen of Michelangelo (p. 121). Similarly, Ghirlandaio's sketchy yet careful penwork (p. 73) is completely different from Leonardo's flowing strokes, which feel as if they have rushed directly from his brain onto the page (p. 93).

DRAWINGS AS LEARNING EXERCISES
Drawing was at the core of any artist's education, the means by which goldsmiths, sculptors and painters learned to train their eyes and transcribe what they saw into works of art. Cennini's description of making a wooden tablet and practising on it for an entire year before picking up a pen is evocative of workshop training, but this may not have been the only method of learning to draw. Alberti discounted the usefulness of these tablets, stressing the importance of large-scale drawings because in small ones weaknesses might be hidden, but in big drawings they must be addressed. Whatever the method, young artists were trained in making drawings after nature and copies after works by other artists. The Renaissance *bottega* was filled with aspiring artists making drawings, just like the boy in the study from the Finiguerra workshop (Fig. 5).

Learning from the direct study of nature represented a crucial part of an education in drawing. Leonardo recommended that an artist learn perspective, dimension and proportions from looking at the world around him. He himself was an unrelenting student of nature who sketched everything he observed, from swirling rills of water in a stream to wizened faces of old men and women, but of course he was the exception to every rule. For ordinary artists, drawing was mostly confined to the workshop, where *garzoni* often used each other as models. These drawings were

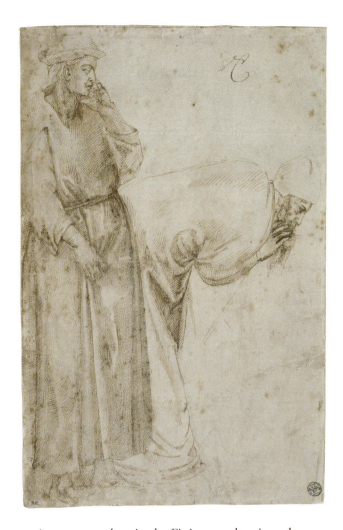

Figure 18. Michelangelo, *Study after Giotto's Ascension of St John the Evangelist*, c. 1495–1500. Pen and ink over stylus, 315 × 230 mm. Paris, Louvre, inv. 706r.

features. The sketch of a hand on Benozzo's *Studies of a hand, three angels and Christ as Salvator Mundi* (p. 48) appears to be a drawing of the artist's own left hand, proving that an artist could often be his own best model.

Copying examples by accomplished artists represented another phase of learning to draw. Leonardo recommended that copying *exempla* enabled the young artist to confirm the rules that he learned while studying nature. Early in the century young artists made copies after model-books, compilations of accomplished drawings that were used as patterns for drawings and paintings. By the mid-fifteenth century Francesco Squarcione, the Paduan master of Mantegna and Zoppo, was actively promoting his large collection of drawings and sculptures to entice apprentices to join his workshop. In Florence the frescoes of Giotto (1267/75–1337) and Masaccio (1401–28) were revered as *exempla*. Vasari explained that when Filippo Lippi joined the Carmelites he had direct access to Masaccio's renowned frescoes in the Brancacci Chapel within the order's church and would go there every day to sketch and learn. Even Michelangelo's early drawings reflect study of Giotto's weighty figures (Fig. 18). Students would of course copy the examples made by their own master. On a wonderful sheet of eyes and locks of hair (Fig. 19), Michelangelo's students vied to match the examples supplied by their master. At the bottom of the sheet Michelangelo wrote sage words to a pupil: 'Andrea, have patience'.

Alberti urged the young artist to copy sculptures as well as paintings because whereas the former merely enabled an artist to acquire another's style, the latter encouraged more naturalistic imitation of three-dimensional forms and the fall of light upon them. He wrote: 'He who does not understand the relief of the

at times unposed, as in the Finiguerra drawing where the artist is obviously sketching one of his fellow workers. More often, the boys in a workshop sketched posed male models in order to learn about the proportions of the body and how it appeared when static or in motion. Examples of figure drawings made solely as learning tools and not as models for paintings are often difficult to separate from figure studies in general, but one can imagine that the drawings by Filippino Lippi of pairs of men (p. 100) were made as exercises to explore the interaction of the two protagonists. Likewise, his study of a nude man lunging forward (p. 99) must represent the kind of drawing after a posed model made by countless artists in their search to give a figure a sense of motion. In the absence of a model an artist could always observe his own

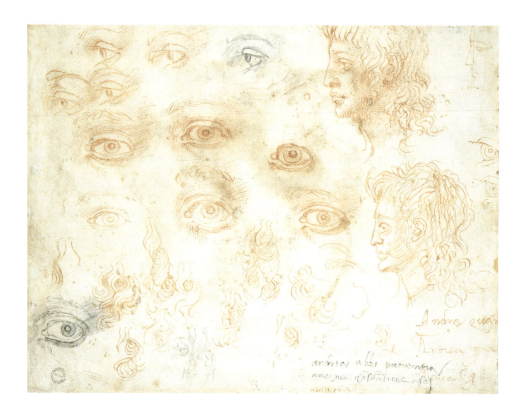

Figure 19. Michelangelo and pupils, *Studies of profiles, eyes and locks of hair*, c. 1525. Red and black chalks, 254 × 338 mm. The Ashmolean Museum, Oxford, Parker 323.

thing he paints will rarely paint it well' (*On Painting*, book 3). Benozzo's *Dioscuro* (p. 47) is an early example of the inspiration of ancient sculpture. Artists also copied contemporary works, including sculptures made expressly as models for drawings and paintings. This latter practice was particularly popular in the workshop of the sculptor/painter Verrocchio, where purpose-made terracotta statuettes served as models for the Christ Child. Francesco di Simone Ferrucci's *Studies of the Christ Child* (Fig. 20) reproduces a very similar model to the standing child in Verrocchio's *Five studies of infants* (p. 65) and may have been drawn after such a statuette. Sculptors also often made drawings of their own works. Antonio del Pollaiuolo's *Study of a male nude seen from the front, back and in profile* (p. 63) was probably drawn from a small bronze made in his workshop. This drawing, like Baccio Bandinelli's *Two standing nudes* (p. 169), demonstrates how an artist could rotate a sculptural model to observe the position and light from a variety of angles. The process of learning to draw never ceased: even an accomplished

artist would have continued to hone his skills through drawing for the duration of his career, much as a talented pianist continues to practise his scales.

DRAWINGS FOR DESIGNING PAINTINGS

The majority of drawings featured in this book were functional, created to design paintings. Designs on paper for sculpture are extremely rare, perhaps because sculptors often made small-scale, three-dimensional models to develop their works. Preliminary drawings were especially important to Florentine painters, who so highly prized *disegno*. It is possible to recreate the basic practice of designing a Renaissance painting by examining the wide variety of drawings. Naturally these methods varied somewhat from artist to artist, but the basic procedure remained the same. First the artist would make rapid sketches to put down his early ideas for the overall composition. These ideas were then explored through studies of the figures, either alone or in groups. The figures could be refined with detailed studies of parts of the body or examinations of clothing.

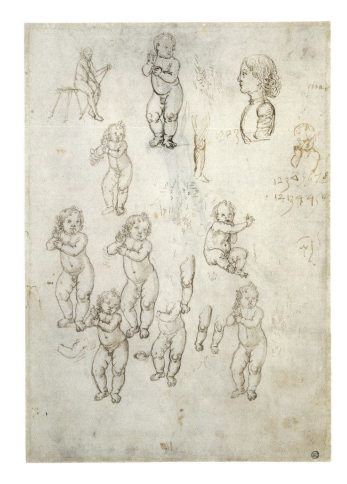

Figure 20. Francesco di Simone Ferrucci (1437–93), *Sheet of studies of an infant Christ*, 1470s. Pen and ink over black chalk, 255 × 185 mm. London, British Museum 1875-6-12-15.

Then the artist could explore the setting, perhaps while making a more defined composition study that incorporated the finished state of the figures. These later composition studies were often squared for transfer to a larger surface, either directly to the canvas or panel or to a full-size cartoon to be used for direct transfer.

The phrase *primo pensiero*, literally meaning 'first thought', is used to describe a sheet with on which an artist put down his initial ideas for a composition – a rough sketch where details were noted but not explored in depth. Examples include Gentile Bellini's *Procession in the Piazza di San Marco* (p. 51), where the entire composition is blocked out and the figures are reduced to simple strokes to indicate their shapes. Bellini's sketch is fairly assured, if brief in its notations. Ghirlandaio's study for the *Birth of the Virgin* (p. 74) is another typical example of a *primo pensiero* in which the artist explored the basic architectural setting and characters of the story, but reduced the figures to simple outlines of their shapes. Both of these drawings were made with pen and ink without any wash or highlighting to develop the image. Although such drawings were usually quick notations, they could also be complex. Perugino's *Adoration of the Magi* (p. 82) is an example of a work that was swiftly drawn, yet includes many details of the entire composition. Numerous changes might also be made between these first ideas and the completed work of art. For example, a comparison of Mantegna's *St James on his way to execution* (p. 58) and the completed fresco reveals that although he retained the basic figure groups, the artist refined the figures around the kneeling man, moving the central figure to the far left, and adjusted the head of St James. More importantly, he substituted a monumental arch for the architecture in the drawing

and altered the perspective from the head-on view of the drawing to a steep *di sotto in sù*, or worm's-eye perspective. Pen was useful for swift sketches, but artists often chose the medium with which they were most comfortable. Andrea del Sarto chose red chalk for his study of the *Birth of John the Baptist* (p. 157). In this sheet he blocked out the basic composition as well as studying the fall of light on the figures and setting.

Each of these three drawings gives the impression that the artist had a fairly clear idea of the composition before he began to draw. Other artists preferred to evolve ideas directly on the paper. This often resulted in drawings with many changes on the sheet. Close examination of Leonardo's pen and ink *Adoration of the Magi* (p. 89) reveals that before he committed the figures of the Virgin and Child to ink, he explored various possibilities for their position in both stylus and leadpoint. Inspired by Leonardo, Raphael's multiple

Figure 21. Detail from Raphael's *Study for the altarpiece of St Nicholas of Tolentino* (p. 143), showing figures of God and a saint in contemporary dress.

pen and ink studies on a single sheet for the Virgin and Child (p. 145) spill onto the page in a flurry of ideas.

Once an artist had set the basic plan for the structure of a work, he moved on to drawing individual figures within the composition. As the fifteenth century went on, artists became increasingly interested in naturalistic depiction of the human form, and studies from life became more common. Workshop assistants or apprentices could pose as models, but it is also likely that some artists brought in models from outside. Models were drawn either clothed or in the nude. Occasionally a preparatory drawing shows evidence of the use of a studio model. The figures of God and the saint on His left in Raphael's *Study for the altarpiece of St Nicholas of Tolentino*, for example, were drawn in contemporary dress (Fig. 21). Raphael evidently sketched the posed models just as he saw them in the studio, with the intention that the figures would appear in suitable costume in the painting.

Alberti encouraged study of the nude in order to understand how a body should look when clothed. Leonardo, the great observer of nature, made intricate drawings from live models (Fig. 15) as well as dissected corpses. He felt that such in-depth scrutiny was vital: 'The painter who knows the sinews, muscles, and tendons, will know very well, when a limb moves, how many and in which sinews are the reason for it, and which muscle, by swelling, is the reason for the contraction of the sinew…' (*Notebooks*, vol. I). Luca

Signorelli was a virtuoso of studies of the male body. The *Nude man seen from the back* (p. 79) is a typical example of his robust black chalk studies of muscular nudes. On the upper right corner of this sheet he drew a quick sketch of the position. It is easy to imagine that he made this rapid notation of the pose in the short moment while the model was on tiptoe from the force of the upswing of his arms. In the large drawing the model appears to be better grounded, suggesting that he adopted a more comfortable position that could be held for long enough to make a detailed study.

Close study of live models and the inspiration of antique art led to an increased interest in depicting the body in motion. This change began around the time of Pollaiuolo's *Hercules and the Hydra* (p. 61), a drawing that turns away from the static figures of the past and thrusts itself into a new dimension of movement. Similarly, Filippino Lippi's lunging *Nude man* (p. 99) is a type of drawing that was unknown earlier in the century. Michelangelo's drawings are filled with figures in motion. The pose of his *Youth beckoning* (p. 121) is loosely based on the Apollo Belvedere, and yet the way that he positioned the upraised arm and leg and elaborated the musculature transformed the static antique sculpture into a figure that appears to be moving across the page.

The use of female models was uncommon throughout most of the fifteenth century. Men were generally used as models for either sex. Raphael's two-sided sheet of *Studies for the Alba Madonna* (pp. 140–1) shows this very literally in the fine red chalk study of a male model posed as the Virgin. On the other side of the drawing Raphael transformed this figure into a woman. During the sixteenth century the use of female models became more common despite the fact that it

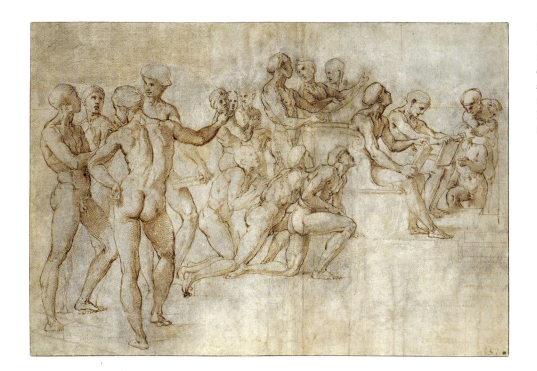

Figure 22. Raphael, *Study of nudes for the lower left section of the Disputà*, 1508. Pen and ink over traces of black chalk and stylus, pricked for transfer, 280 × 416 mm. Städelsches Kunstinstitut, Frankfurt, inv. 379.

was officially outlawed. Sebastiano del Piombo's *Standing female nude* (p. 151) or Rosso Fiorentino's *Recumbent nude female figure asleep* (p. 174) are sensuous drawings, probably because they were studied from female models.

In addition to studies of individual figures, studies of groups of figures were important to developing a composition. These were not always drawn from life, but from an accumulation of the studies to date. Ghirlandaio's *Naming of St John the Baptist* (p. 75), for example, reflects a further stage of design than the *primo pensiero* of his *Birth of the Virgin* (p. 74). The poses, expressions and clothing of the figures are more highly defined than in a rapid sketch of the composition, but no attention has been paid to the setting. Other studies, such as Mantegna's *Virgin and Child* (p. 59) or Fra Bartolommeo's *Annunciation* (p. 119), explore the relationship between figures. Raphael often developed many figures of a composition at once. His numerous drawings of the *Entombment* (p. 146) demonstrate that it took a series of multiple figure studies to arrive at the final composition. Similarly, the drawing for the figures on the left of the *Disputà* (p. 148) has progressed from

his initial idea, but was to be even further developed in studies of nudes in similar positions (Fig. 22).

To elaborate upon figure studies, artists made drawings of particular details. Raffaellino del Garbo's metalpoint drawing of the Risen Christ includes two equally detailed drawings of hands on the same sheet (p. 115). Interestingly, these hands do not belong to this Christ, but were studies for another painting and show how artists routinely worked on more than one commission at a time. Andrea del Sarto's *Hand and feet* (p. 155) are intricate studies for the figure of St Francis in his *Virgin of the Harpies*. Close examination of these details allowed him to get the lighting, musculature and bone structure just right. Michelangelo often singled out parts of the body for further study. His red chalk studies for *Adam* (p. 123) and *Haman* (p. 122) from the Sistine Chapel show how alongside the main study he would focus on specific parts of the body to refine their positions and the fall of light.

Fifteenth-century artists increasingly tried to make their figures stand out as individuals by infusing their faces with expression and character. As a consequence, separate drawings of heads became the most common

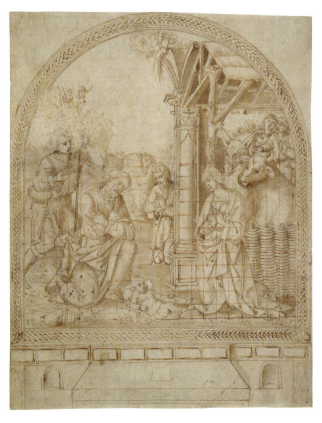

Figure 23. Bernardino Fungai (*c.* 1460–1576), *Nativity, c.* 1512. Pen and brown ink, partially squared in red chalk, 330 × 261 mm. London, British Museum, 1860-6-16-79.

highly polished studies were sometimes finished artworks in their own right, an issue that will be discussed below, but it is worth examining them in the context of designs for paintings. Preliminary drawings for portraits are so detailed because they were drawn from life. Pisanello's *Profile of Filippo Maria Visconti* (p. 40) and Boltraffio's *Portrait bust of a young man* (p. 113) show the great care that often went into them. Although a true likeness should precisely reproduce a face, a portrait was often made to flatter the sitter and therefore idealized some features.

Drapery studies are another type of drawing that focuses on a particular detail of a composition. The fall of light and shadow across the drapery is in many ways the subject of Fra Filippo Lippi's *Female saint* (p. 45). The artist heightened the effect of relief on the folds of fabric by making the most of the contrast of the white highlighting against the saturated colour of the paper. In a similar study (p. 105) the Venetian Giovanni Battista Cima utilized the blue of the paper combined with brown wash and white highlights to create fine, sculptural folds of drapery reminiscent of the work of Andrea Mantegna (p. 59). Both Cima's and Lippi's drapery studies focus on the entire figure, leaving no part of the body unfinished. In Florence in the late fifteenth century Verrocchio seems to have pioneered the practice of making detailed studies of drapery alone. His disciple Leonardo made extensive notes on how to portray folds in garments. He also described how to dip fabric in diluted plaster before arranging it on a wooden mannequin to dry. Once stiff and solid, the drapery could be studied at length from a variety of positions. In Leonardo's extraordinary drapery studies on linen (p. 87), his command of light gives the folds a palpable sense of volume.

type of detailed study. Artists often anticipated a head study by rendering heads in figure studies with simplified features or, as in the example of Ghirlandaio's drapery study (p. 73), even omitting the head completely. Head studies are often very beautifully and carefully drawn. Perugino's *Head of a beardless man* (p. 81), Lorenzo di Credi's *Bust of an old man wearing a hat* (p. 103) and Andrea del Sarto's *Four studies of a child* (p. 156) are fine examples of drawings devoted to the details of character and lighting. The verso of Raphael's *Study for the altarpiece of St Nicholas of Tolentino* (p. 142) has a separate study of a head. The artist probably flipped over the paper to clarify his earlier figure study. Michelangelo made a similar recto–verso study in the *Ignudo* (pp. 126–7), where he drew the body of the nude in greater detail with only simple notations for the head, and then turned the page over to make a detailed study of the face on the other side.

The mainly Florentine practice of making detailed studies of heads is closely linked to portraiture. These

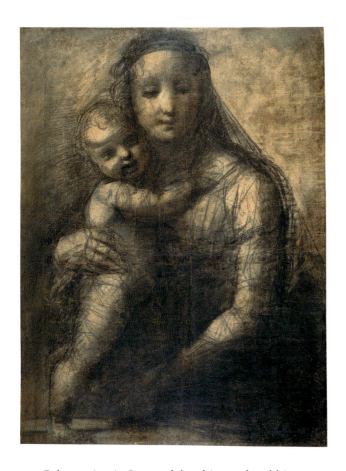

Figure 24. Raphael, *Cartoon for the Mackintosh Madonna, c.* 1512. Black chalk with touches of white chalk, 707 × 533 mm. London, British Museum, 1894-7-21-1.

Other artists in Leonardo's orbit emulated his drapery studies. The nearly featureless torso in the *Drapery study for a figure of Christ* by his fellow Florentine Fra Bartolommeo (p. 118), or the barely outlined figure in the *Drapery study for a resurrected Christ* by his Milanese follower Marco d'Oggiono (p. 111), show that these artists also studied draperies from mannequins. In each of the drawings the drapery is the focus, as it was key to augmenting the sculptural sense of the painted figure.

After details of the figures had been refined, an artist might return to a compositional study, pulling together the disparate elements of the previous studies. Even though drawings made at this stage were normally the culmination of many other studies, they rarely match the finished work. Typical of this late tinkering is Solario's *Lamentation* (p. 109). It is a fully developed, highly pictorial drawing and very close to the related painting in the Louvre. Comparison with the painting

shows, however, that Solario swapped the position of John and one of the Maries and omitted the crosses in the background. Similarly, Parmigianino's *Martyrdom of Sts Peter and Paul* (p. 184) is a fully worked-up drawing, but still there are changes between it and the print for which it was drawn. Such polished composition studies must have been made to allow the artist to consider the overall design, highlighting flaws that could be corrected before beginning work on the painting itself.

Other composition drawings at this stage required no further design. The *Vision of St Augustine* by Carpaccio (p. 107) is so close to the painting that additional studies are unlikely to have been needed. Some finished drawings probably record paintings that have either not survived or were never executed. Within this group fall the Lotto *Ecclesiastic in his study* (p. 133), the Sebastiano *Clement VII and Charles V in Bologna* (p. 152) and the Peruzzi *Adoration* (p. 136), in which the figures are fully fleshed out and the surrounding architecture or landscape has been included, as have indications of the lighting for the whole composition. These highly finished drawings bring up the problem of studies of architecture or landscapes. Although a few drawings of landscapes do survive, there are almost no surviving landscapes or architectural studies that study the setting of a composition without its figures. Drawings like Peruzzi's *Last Supper* (p. 137) or Parmigianino's *Study for the Steccata vault* (p. 185) pay equal attention to the figures and their settings, but it is very uncommon to find a drawing of the setting alone.

Once an artist settled on his final design, he needed to transfer the drawing to the painted surface. This led to the use of squared drawings and cartoons to transfer

Figure 25. Detail showing the tiny pricking dots on Leonardo's *Portrait of Isabella d'Este* (p. 94).

a small-scale design to a full-scale image. A close look at Pordenone's *Lamentation* (p. 139) shows a regular grid of squared lines superimposed over the figures. The purpose of squaring was to break down the image into regular, smaller sections. A similar grid with larger squares was drawn on the painted surface, and then the artist would copy the image in the smaller square into the larger space, thereby enlarging the entire image. The *Nativity* by Bernardino Fungai (Fig. 23) is an interesting example of a finished drawing squared for transfer. Fungai's drawing includes the surrounding frame and even the altar below. Only the lower, detailed part of the drawing is squared up to aid him in the transfer of the most complicated part of the composition to the painted surface.

An artist could also use a cartoon to transfer the finished design to the surface to be painted. A cartoon was normally made up of many sheets of paper glued together to make a page large enough to be of equal size to the painting. Seams of the glued sheets are visible in Raphael's *St Catherine* (p. 147). Although cartoons were often loosely drawn, they were of critical importance in determining the appearance of the painting as they established the design and often the lighting. Both aspects are evident in Raphael's much-battered *Cartoon for the Mackintosh Madonna* (Fig. 24). This drawing is a good example of how the broad tonal qualities of black chalk were well suited to drawing the

large expanse of a cartoon. Cartoons were also useful to a busy artist who delegated work to assistants because they were a form of quality control, ensuring that the painting followed his original designs. This was particularly true in the case of Raphael, who at the height of his work in Rome often left the execution of paintings to his workshop.

Once the artist had drawn the cartoon, he had two options for transferring the design to the painted support. The first involved pricking tiny holes into the drawing with a pin or stylus, along the outlines and contours. The cartoon was then held up to the painted surface and the holes were tapped with a muslin bag filled with charcoal dust. This is called pouncing. When the cartoon was removed, tiny dots of black charcoal replicating the design were left on the painted surface to serve as guidelines for painting. The second method of transfer was by incision. This technique was most useful for frescoes. The cartoon was held up to the moist plaster wall and its outlines were traced with a stylus, leaving an imprint of the design on the wall.

Pouncing was a laborious process, while incision was much faster. The only problem with incision was that it cut the cartoon to shreds. Pouncing did not destroy the cartoon, although the charcoal dust blackened it. Cartoons were also destroyed when they were cut up into sections that could be painted in a day's work. The best way of preserving a cartoon was to put an identical, blank sheet below the drawing during the pricking. This produced a substitute cartoon that had no drawing on it but that could be used for pouncing. This is undoubtedly what happened to Leonardo's *Portrait of Isabella d'Este*, which was copied on more than one occasion in Isabella's lifetime (Fig. 25).

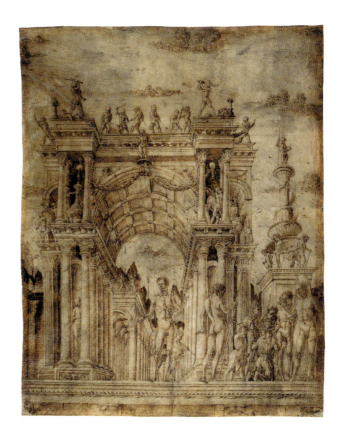

Figure 26. Marco Zoppo, *St James on his way to execution*, 1455–60. Pen and ink with wash on parchment, 350 × 280 mm. London, British Museum, 1995-5-6-7 (verso).

Renaissance cartoons are now very rare. Even if they survived the transfer process, their very scale made them difficult to preserve.

DRAWINGS AS COMPLETED WORKS OF ART

All the sheets discussed up to this point – and indeed the majority of sheets made in the Renaissance – were working drawings, but a small number of works on paper were produced as finished works of art. These were made as examples for a patron, gifts to a friend or very personal drawings to be kept by the artist. Drawings in this category were never hurried, undeveloped ideas and were generally preceded by preparatory studies. A highly finished drawing might be a proposal for a work of art submitted to the patron for approval. This was undoubtedly the case with Pisanello's *Medals of Alfonso V of Aragon* (p. 41), which was drawn on parchment, a sturdy and elegant support worthy of presentation to Alfonso for his comments. Likewise, Rosso's *Design for an altar* (p. 173) is a detailed drawing in which, as in the Fungai *Nativity* (Fig. 23), all aspects of the altarpiece including the frame, surrounding pictures and central panel have been established. Its exact purpose is not known, but the high degree of polish suggests that it was made for a patron as a finished proposal for a commission. These kinds of drawings were sometimes kept with a legal contract as a record of the promised work of art.

Drawings were occasionally given as gifts to friends or patrons. Pisanello's *Three courtiers* (p. 37), drawn on parchment and signed by the artist, has the hallmarks of a polished drawing made as a gift. Pollaiuolo's *Prisoner led before a judge* (p. 62) and Zoppo's *Dead Christ supported by angels* (p. 69), which has an equally elaborate composition of *St James on his way to*

execution on the verso of its parchment sheet (Fig. 26), may also have been made as finished drawings, intended either as presents or as representations of the artists' abilities. Rosso drew the highly worked-up *Mars and Venus* (p. 175) as a purpose-made gift to the French king, serving as a calling card to advertise his skills. Leonardo's now lost drawing of Neptune, a present to to his dear friend Antonio Segni, was said by Vasari to have been made with such diligence that it appeared to be alive. Michelangelo also made highly finished drawings as gifts to people close to his heart. Although these were very personal expressions of his friendship, they were soon admired by a wider audience as examples of his genius. The *Fall of Phaeton* (Fig. 3), for example, is a highly polished invention created for Tommaso de' Cavalieri, the young Roman nobleman with whom Michelangelo had fallen in love in the early 1530s. The drawing quickly became known and was held in high regard among Michelangelo's many admirers in Rome.

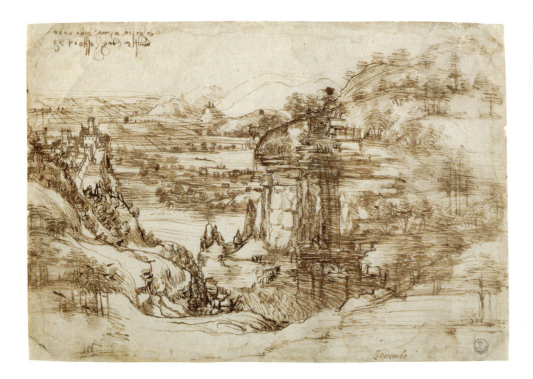

Figure 27. Leonardo da Vinci, *View of the Arno valley*, 1473. Pen and ink, 196 × 287 mm. Florence, Gabinetto dei Disegni e Stampe degli Uffizi, inv. 8p.

Portraits or idealized heads might also be drawn as gifts or demonstrations of the artist's talent. Vasari prized the sophisticated and exquisitely drawn idealized heads of women by Verrocchio in his *Libro de' Disegni*, and Leonardo's *Bust of a warrior in profile* (p. 95) comes from Verrocchio's tradition. Idealized heads could be both beautiful and ugly, as the grotesque red chalk heads by Leonardo (p. 88) and Giovanni Agostino da Lodi (Fig. 17) demonstrate. They often had elaborate hair or headgear, as in Verrocchio's heads of women, Leonardo's *Warrior* and Michelangelo's *Ideal head of a woman* (p. 131).

It is difficult to know how to categorize Renaissance drawings of landscapes because, as already mentioned, so few of them survive and even fewer can be connected to completed paintings. This genre of drawing was practically unheard of in the fifteenth century and was not popularized until sixteenth-century Venice in works by Titian and his followers. The airy atmosphere of Titian's *St Eustace* (p. 159) is typical of the Venetian landscape tradition, although the inclusion of the saint makes this drawing more of a narrative than pure landscape. Even in Venice very few

artists appear to have drawn landscapes in the open air. Unsurprisingly, Leonardo is an exception. His magnificent *View of the Arno valley* is annotated with the date, 5 August 1473 (Fig. 27). Fra Bartolommeo also studied Tuscan landscapes. An album of his landscape drawings made in Pian di Mugnone survives from the last part of his career (p. 117). Although he incorporated elements of these drawings into his paintings, they were made while he was on a retreat, perhaps with no other purpose than to admire the surrounding scenery.

Finally, a few very personal drawings survive that appear to have been made purely for the love of drawing. Amusing drawings such as Pontormo's *Self-portrait* (p. 171), where he is clad only in his underpants, and Parmigianino's *Man holding up a pregnant bitch* (p. 186) may be rare survivals of drawings made for fun. Michelangelo's series of Crucifixion drawings seems to have been done for its own sake too, although in his case the drawings appear to have been personal devotional aids as the octogenarian sculptor meditated on his imminent death. These deeply spiritual drawings, worked and reworked by Michelangelo's tremulous hand, are intensely private

images that allow us to experience a sense of the emotional torment of their creator.

The selection of drawings in this book was made from the best Renaissance drawings in the British Museum in London and in French public collections. The British Museum and the Louvre possess two of the three greatest assemblages of Renaissance drawings in the world; the third is of course in the Uffizi in Florence. The foundation of the Louvre's outstanding collection dates to 1671, when Louis XIV purchased the collection of Everhard Jabach. By Jabach's own account he possessed 2,258 Renaissance drawings, including sheets from Vasari's *Libro de' Disegni* and Raphael's *St Catherine* (p. 147). In the eighteenth century the royal collection was augmented by the purchase of the collection of Pierre-Jean Mariette, a print dealer and connoisseur of drawings who created an extraordinary collection for himself and his client Pierre Crozat, including over 1,000 Renaissance sheets. After the French Revolution the treasures of the Cabinet du Roi along with other drawings confiscated for the nation passed into the public collection at the Louvre. By contrast, the collection of the British Museum was formed much later, mostly in the second half of the nineteenth century. In 1895 the Museum purchased the collection of John Malcolm, a Scottish collector who had amassed extraordinary early Italian drawings by Botticelli, Michelangelo, Raphael and many others from the collections of Sir J.C. Robinson, his adviser, and the portrait painter Sir Thomas Lawrence. The acquisition of Malcolm's drawings catapulted the British Museum's collection into the same league as the earlier collections of the Louvre and the Uffizi.

The principal criterion for including drawings in this book was that they should be the highest quality sheets from artists born roughly between 1400 and 1500. Every attempt has been made to be comprehensive, but the selection is swayed towards quality rather than inclusivity. The artists represented are intended to demonstrate the geographical range of art in Italy during the Renaissance, but because the Florentines stressed *disegno* so assiduously and collected drawings from a much earlier date, the numbers of their outstanding drawings seem to be greater. The drawings were all made on paper unless otherwise noted. They are intended to display all the media and types of drawing made by Renaissance artists. The illustrations are organized by artist and arranged chronologically by the artists' dates of birth.

Leafing through these pages reveals trends in the history of Renaissance art, from meticulous metalpoint drawings made for tempera paintings to sweeping chalk studies designed for oils. The range of drawings follows the stylized representation of the human form seen in early works by Fra Angelico or Pisanello to more naturalistic renderings of the nude by artists such as Leonardo and Signorelli and back again to the more stylized, emotive expression of Pontormo or Parmigianino. Most of all, it is hoped that the reader will appreciate the beauty of these extraordinary works of art.

Master Drawings
of the Italian Renaissance

Fra Angelico
Vicchio di Mugello *c.* 1395–1455 Rome

FRA GIOVANNI DA FIESOLE was given the nickname 'il Beato Angelico' shortly after his death in recognition of his angelic creations and saintly character. He was born Guido di Pietro and trained in Florence under the Gothic painter and monk Lorenzo Monaco (*c.* 1370–*c.* 1425/30). In 1418, some years into his independent career, Guido joined the Dominican convent in Fiesole near Florence and became Fra Giovanni. His ascetic life introduced him to a new set of patrons. As chief painter of the order, he was given commissions to paint altarpieces for Dominican churches throughout central Italy and also worked as an illuminator of sacred texts.

In 1437 the Dominicans began an ambitious building programme at San Marco in Florence. This was possible due to the extraordinary generosity of Cosimo de' Medici, *Pater Patriae* of the Medici family, who funded all aspects of the project from the building of a church and convent to new habits for the friars. Fra Angelico was in charge of decorations, responsible for managing a team of artists that included Benozzo Gozzoli to help complete the vast array of works. The high altarpiece of the *Virgin and Child with Sts Cosimo and Damian*, the patron saints of the Medici, was one of the first projects to be completed, but Fra Angelico is best remembered for the contemplative serenity of the simple frescoes on the walls of the friars' cells.

An early visitor to these cells was Pope Eugenius IV, who subsequently commissioned Fra Angelico to paint a chapel in the Vatican Palace. Completed in early 1447, the frescoes were later destroyed by Pope Paul III to make an antechamber for the Sistine Chapel. Michelangelo is said to have treasured one of the fragments. After the death of Eugenius, Fra Angelico moved to Orvieto, where he agreed to paint the vault of

the Cappella Nova in the cathedral. The contract of 14 June 1447 states that while scaffolding was being erected in the chapel, Fra Angelico was making drawings of the '*picturarum et figurarum*', the pictures and the figures, that he intended to paint. This is interesting proof of his working practice, especially since none of the drawings survives. A call from the new pope, Nicholas V, to paint his private chapel and a studio in the Vatican interrupted the Orvieto work. The Cappella Niccolina survives as one of Fra Angelico's late masterpieces.

The *Prophet David* is a rare example of Fra Angelico's drawings. As in his paintings, the line of the pen is elegant, the purple shading is delicately applied and overall the sheet is meticulously executed. It was drawn on parchment in around 1430 for a psalter, or Book of Psalms. On the reverse of the sheet is an index which shows that the figure would have faced the Psalm of David.

There is no indication that Fra Angelico's production slowed as he aged. In 1450 he was elected prior of San Domenico in Fiesole, but this did not stop him from returning to Rome to paint. He died in Rome in 1455 and was buried in Santa Maria sopra Minerva.

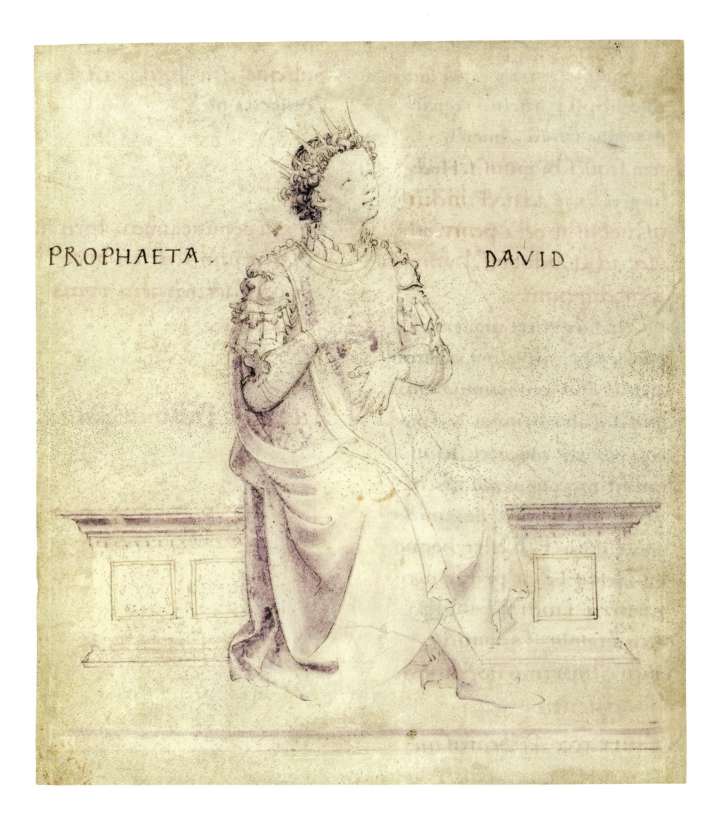

PROPHAETA . DAVID

The Prophet David playing a psaltery, c. 1430.
Pen and ink with purple wash on parchment, 197 × 179 mm.
London, British Museum, 1895-9-15-437.

Antonio Pisanello
Pisa before 1394–1455 Rome

ANTONIO PISANO was brought up in Verona. Facts about his early training and career are few, but he was probably taught in the workshop of Gentile da Fabriano (*c.* 1385–1427), with whom he later collaborated. His interest in nature, which was particularly evident in keenly observed depictions of animals and landscapes, was a legacy of this training and one of the areas where he may be compared with his contemporary Jacopo Bellini. Pisanello became a painter and medallist to the most influential courts of Italy. Only a small number of his panel paintings and frescoes survive, but his distinctive medals and elegant drawings, which exist in greater numbers, attest to his brilliance as a designer.

The three men stylishly dressed in fur-trimmed capes and seen from three distinct angles are typical of Pisanello's courtly style. This drawing is extraordinary because it is signed *PISANVS.F* below the left and central figures: it is extremely rare to have a signed sheet of this date because drawings were not normally seen as finished works of art. It is perhaps a reflection of Pisanello's remarkable fame that even his drawings were highly valued.

Numerous studies of animals by Pisanello survive, many of them in the Louvre. They reflect a northern European tradition of model-books – books of example drawings used by artists as stock patterns to learn to draw or to depict motifs, especially animals. Pisanello lifted the model-book to a higher level. Rather than copying the designs of other artists, his drawings of animals were observed from life. The two sheets illustrated here (pp. 38–9) are typical. Details such as the intricacy of the individual hairs on the female boar and the veins on the horse's nose were obviously created from close examination of the animals themselves.

Pisanello was celebrated for his portraits both in paint and on medals. Filippo Maria, the last of the Visconti dukes of Milan, was one of his influential patrons. The duke's imposing profile (p. 40), drawn in black chalk with the background shaded to enhance the modelling and light, is a study for his medal. Filippo is said to have been an ugly man who was reticent about having his portrait done. Pisanello may have idealized his features, but the steely gaze tells much of his ferocious personality.

Portrait medals made to commemorate an event or person were pioneered in the Renaissance by Pisanello. They were directly inspired by classical medals of Roman emperors and reflect an increasing intellectual interest in the ancient world. Alfonso V of Aragon was a collector of ancient texts and coins and a cultivated patron of the arts. The eight studies for obverses and reverses of medals of Alfonso (p. 41) date from the last part of Pisanello's career, when he worked for the king in Naples. The drawing depicts four possible projects and may have been a sheet shown by Pisanello to his patron as his ideas developed. The resulting three medals differ from the drawings, but clearly derive from these earlier studies. Pisanello's contract with Alfonso praises his genius, a quality that can still be seen in his art today.

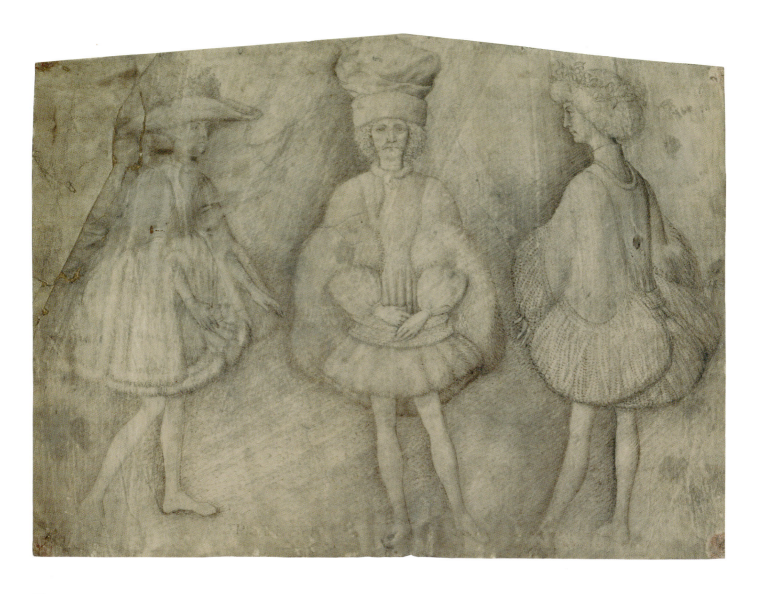

Three courtiers, c. 1433.
Pen and ink and grey wash over black chalk on parchment, 233 × 338 mm.
London, British Museum, 1846-5-9-143.

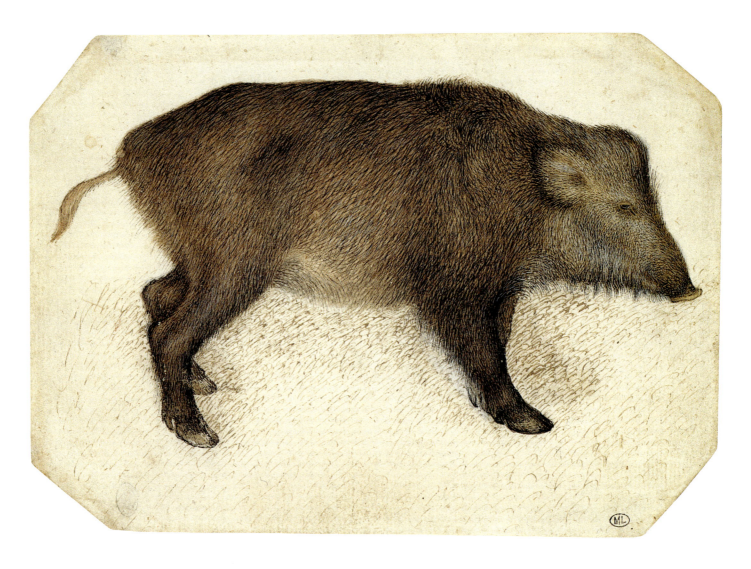

Wild boar, c. 1434–45.

Pen and ink, watercolour, white gouache, traces of black chalk or metalpoint and stylus, 140 × 200 mm.

Paris, Louvre, inv. 2417.

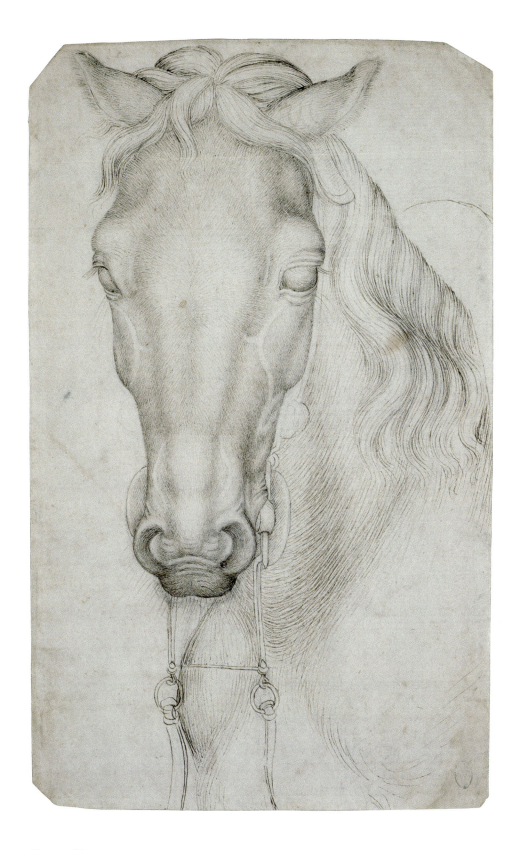

Harnessed horse, c. 1434–42.
Pen and ink, traces of black chalk (or charcoal?), 265 × 165 mm.
Paris, Louvre, inv. 2360.

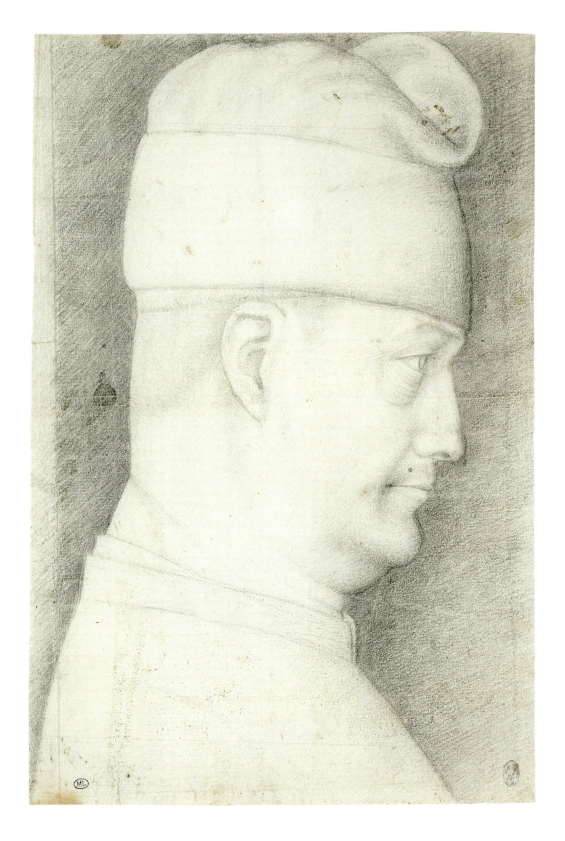

Profile of Filippo Maria Visconti, c. 1430–2.
Black chalk with traces of red chalk, 290 × 201 mm.
Paris, Louvre, inv. 2483.

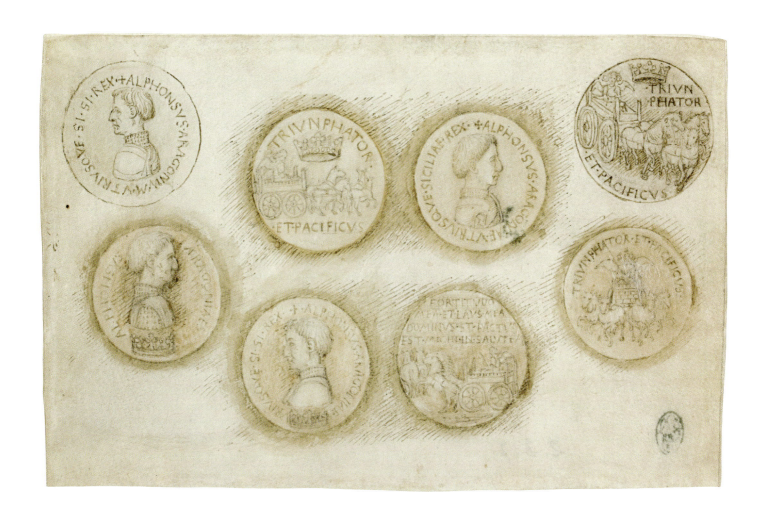

Obverse and reverse of four medals of Alfonso V of Aragon, 1449.
Ink with pen and brush on parchment, ochre wash, traces of metalpoint preparation, 100 × 152 mm.
Paris, Louvre, inv. 2317.

Jacopo Bellini
Venice *c.* 1400–1470/1 Venice

Jacopo was the patriarch of the Bellini family and of Venetian painting. Before him, Venetian painting had little of its own style and was dominated by the International Gothic, a style popular in Italy and northern Europe that emphasized pattern, gold backgrounds and two-dimensional compositions. Jacopo developed a purely Venetian style in which there was greater emphasis on atmospheric light and colour, perspective and narration. It is paradoxical that this artist, who was so important to the history of Venetian painting, is now better known through his drawings. Only about a dozen of his paintings survive, but two extraordinary books of drawings, one in the British Museum and the other in the Louvre, preserve Jacopo's legacy as an exceptional draughtsman.

Each of the albums originally contained 102 pages of drawings of elaborate compositions, often spread over two pages, depicting architecture, nature subjects and groups of figures. They depart from the medieval tradition of model-books collated by artists to provide patterns for animals, costumes or poses in that the drawings do not focus on individual elements of a composition, but are instead complete narrations. Nor should they really be labelled 'sketchbooks': the word 'sketch' implies a drawing that is quick or undefined, while these drawings are quite the opposite. The purpose of the albums is unclear. The drawings do not appear to be studies for paintings, but finished works of art in their own right.

The British Museum drawings were made in leadpoint on paper, while those in the Louvre were drawn in leadpoint and pen and ink on parchment. Leadpoint is a fugitive medium that is easily rubbed from the page. Scholars disagree about whether the ink in the Paris album is original or was added at a later date to reinforce faint images. The albums appear to have been bound together from the time that the pages were first drawn, and were highly prized by the Bellini family. Both books were inherited by Jacopo's elder son, Gentile Bellini. The album now in London later passed to Gentile's brother, Giovanni, while the album now in Paris was presented by Gentile to the Sultan in Istanbul during his trip in 1479.

Each page of the albums presents an extraordinary insight into Jacopo's imagination. He explored a variety of subjects ranging from landscapes and nature to biblical stories and even antiquity. The *Vision of St Eustace* is reminiscent of Jacopo's early training under Gentile da Fabriano in its close attention to naturalistic depictions of animals. The drawing depicts the moment of Eustace's conversion to Christianity, when he had a vision of a crucifix in the antlers of a stag. The subject is also known through a contemporary painting by Jacopo's rival Pisanello (now in the National Gallery, London): whereas Pisanello's work is more two-dimensional, Jacopo's craggy mountains receding into the distance give a greater feeling of space.

The vision of St Eustace, 1445–60.
Leadpoint, 415 × 336 mm.
London, British Museum, 1855-8-11-71.

Fra Filippo Lippi
Florence *c.* 1406–1469 Spoleto

THE 1420S WERE AN INNOVATIVE PERIOD in Florentine arts, when intellectual and practical explorations into depicting three-dimensionality led to a greater naturalism in painting, sculpture and architecture. In this decade Filippo Brunelleschi (1377–1446) was building the Old Sacristy at San Lorenzo, the loggia for the Ospedale degli Innocenti and the dome of Florence Cathedral. Lorenzo Ghiberti was casting his bronze doors for the Baptistery, Donatello (1386/7–1466) was working on his three niche sculptures for Or San Michele and Masaccio was painting his seminal *Trinity* and collaborating with Masolino (1383–1435) in the Brancacci Chapel. It was also during this decade that Filippo Lippi matured as an artist.

Vasari's *Life* of Filippo is remarkably anecdotal. He noted that Filippo was not a studious Carmelite novice: 'Rather than studying, all he did was cover his books and those of others with doodles. Eventually the prior resolved that he should be given every opportunity to learn to paint.' This opportunity allowed him countless hours to draw in the Brancacci Chapel. Filippo's own early works in the Carmine (destroyed in 1771) were influenced by Masaccio's solid figures. From 1428 Filippo travelled outside Florence, acting as a sub-prior in Siena and in 1434 working in Padua on paintings in the Podestà and the Santo (both destroyed). Vasari tells the tale of how he was abducted by Moorish pirates, held captive in Barbary and only released when he amazed his captors with his skills as a draughtsman. This story may be apocryphal, but no works by Filippo can be securely dated to the mid-1430s. By 1437 he was back in Florence, where he painted the Barbadori altarpiece for Santo Spirito (now in the Louvre).

In the 1440s Filippo achieved fame as one of the foremost painters of panels and frescoes in Florence during the height of Cosimo de' Medici's influence over Florentine politics and culture. Filippo executed various paintings for the Medici, including pictures for the palace and family chapels. From 1452 to 1466 he was engaged on frescoes in the choir of Prato Cathedral. Stories of Filippo's lapsed morals persisted throughout his life, as attested in both Vasari and contemporary sources, and in the midst of the project he fathered a son with a young nun called Lucrezia Buti. Remarkably, Filippo never left the Carmelites and the boy, Filippino, remained with him. Filippo's last project was in Spoleto, where he was commissioned to produce frescoes for the apse of the cathedral. He died there in 1469 and is buried in the cathedral.

Few of Filippo's drawings survive, but those that do mirror the beauty of his paintings. The sheet opposite appears to be a study for a Virgin mourning at the foot of the Crucifix, but it does not relate to any extant painting. Filippo built up the drawing in layers by making a light sketch in black chalk and then emphasizing the chalk with metalpoint and a grey-brown wash. On top of this, and with a delicate touch, he painted white highlights to depict the light as it caught the folds of the robe. 'Paint the soul, never mind the legs and arms', says the artist in Robert Browning's poem *Fra Filippo Lippi*. The emotional power of Lippi's representation of this grieving woman gives an inkling of why the Moorish pirates released Filippo.

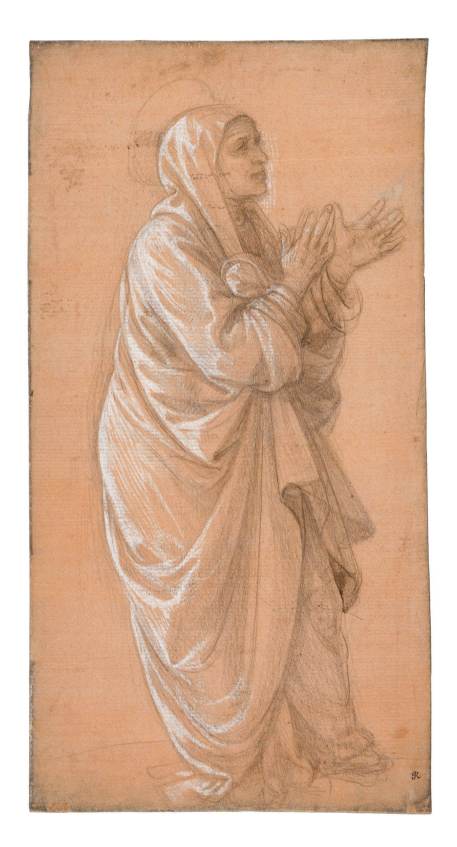

Female saint, standing, c. 1440.
Metalpoint and brown wash over black chalk, heightened with white on salmon-pink prepared paper, 308 × 166 mm. London, British Museum, 1895-9-15-442.

Benozzo Gozzoli

Florence *c.* 1420–1497 Pistoia

IN ORDER TO COMPLETE the vast works at San Marco, Fra Angelico hired assistants. Foremost among them was Benozzo di Lese, later identified by Vasari as Benozzo Gozzoli, who joined the busy workshop in around 1438. By that time he was about eighteen years old and would have already completed most, if not all, of his apprenticeship elsewhere. At San Marco Benozzo assisted on the many altarpieces and murals in the chapter-house and the monks' individual cells.

In 1444, when the bulk of the work at San Marco was finished, Benozzo left Fra Angelico and signed a three-year contract with Lorenzo Ghiberti to assist on the second set of bronze reliefs for the doors of the Florentine Baptistery. Benozzo's contribution to Ghiberti's *bottega* is unclear, although it seems likely that his painter's eye would have helped in the design of the perspective and narration of the reliefs. In 1447 Benozzo again joined Fra Angelico, this time to assist on frescoes in Pope Eugenius IV's chapel. He continued to work with Angelico in Orvieto and returned with him to Rome to paint the private chapel and study of Nicholas V. By 1449 Benozzo had set out on his own. He made a failed bid to finish the frescoes left incomplete when Fra Angelico left Orvieto, and afterwards worked in Umbria and Lazio on a variety of frescoes and altarpieces.

Eventually Benozzo made his way back to Tuscany, where he painted some of his most memorable works. His frescoes of the *Adoration of the Magi* in Cosimo de' Medici's palace remain one of the jewels of Renaissance art. Commissioned in 1459, the frescoes on the palace chapel walls depict a spectacular parade of the Magi through an idyllic Tuscan landscape rendered in brilliant colours.

Benozzo's final project, which started in 1468 and lasted for sixteen years, was the murals of the Old and New Testaments in the Camposanto in Pisa. These frescoes were Benozzo's crowning glory, but the building was bombed in the Second World War and only fragments survive.

The stunning drawing on blue prepared paper of one of the *Dioscuri* shows Benozzo's interest in antique sculpture. The colossal *Dioscuri*, or horse tamers, was one of the few antique sculptures visible in Rome throughout the Middle Ages. Benozzo's study of the left figure and horse, minutely rendered in tiny strokes of white highlighting applied with a brush, is not a literal copy of the sculpture, but rather an arrangement inspired by the original. His refinements to the model show that he was not merely mimicking, but digesting and assimilating the lessons of movement and three-dimensionality offered by the antique.

The sheet of *Studies of a hand, three angels and Christ as Salvator Mundi* (p. 48) dates from the time of the Orvieto project. The hand is undoubtedly the artist's own, held up as a model while he sketched. The Christ and the three angels relate to the Salvator Mundi and surrounding angels in the vault of the cathedral. It appears that Benozzo was copying Fra Angelico's preparatory drawings, perhaps as a learning exercise to better emulate his style. On the verso of this sheet is the sensitively rendered *Head of a monk* (p. 49). This drawing is perhaps a thoughtful portrait of his long-time employer, Fra Angelico.

Study after one of the Dioscuri of Monte Cavallo, c. 1446–9.
Metalpoint with white highlighting on blue prepared paper, 360 × 247 mm.
London, British Museum, Pp. 1–18.

Studies of a hand, three angels and Christ as Salvator Mundi, 1447.
Pen and brown ink with brown wash, 247 × 149 mm.
Chantilly, Musée Condé, DE 7 (recto).

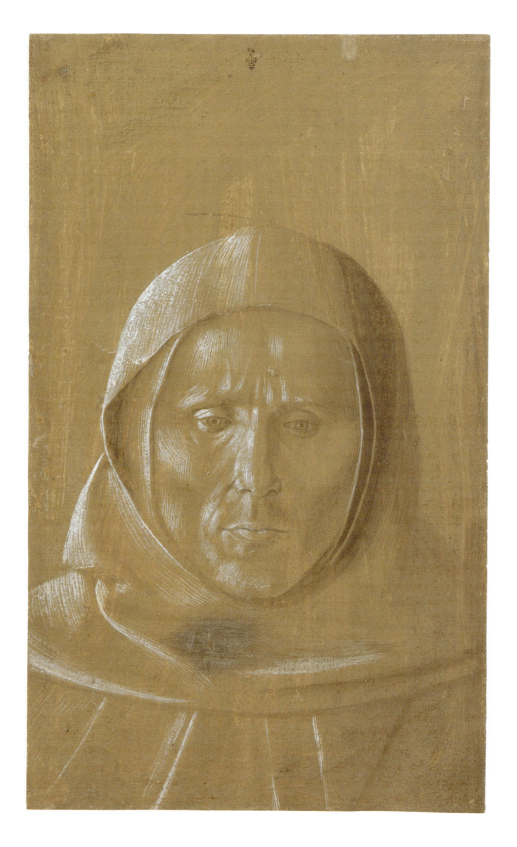

Head of a monk, 1447.
White highlighting and brown gouache over metalpoint on ochre prepared paper,
247 × 149 mm. Chantilly, Musée Condé, DE 7 (verso).

Gentile Bellini
Venice *c.* 1429–1507 Venice

Giovanni Bellini
Venice *c.* 1430–1516 Venice

GENTILE AND GIOVANNI BELLINI followed their father Jacopo into the family business: as boys they trained under him in his Venetian workshop. When they were teenagers they met Andrea Mantegna, who had become friendly with Jacopo, and his art helped to develop their formative styles. Mantegna later married their sister Nicolosia and became part of the extended Bellini family. By the 1460s the brothers were receiving independent commissions, but may have shared a workshop. They certainly collaborated with Jacopo in 1460 on the Gattamelata altarpiece in Padua and in 1465 on the Scuola di San Giovanni Evangelista (now lost). Alongside these collaborations, Gentile and Giovanni emerged as independent painters.

Gentile's early reputation was formed in his paintings of 1466 for the Scuola Grande di San Marco. This led to his most important assignment, repainting the Sala del Maggior Consiglio in the Doge's Palace, where the original frescoes by Gentile da Fabriano and Pisanello had deteriorated beyond repair. Gentile's pictures, painted in oil on canvas, comprised twenty-two narrative scenes and a portrait of each doge. Both painting cycles were destroyed by the mid-sixteenth century, eclipsing further analysis of Gentile's early maturity.

In 1479 Gentile travelled to Istanbul to work for Sultan Mehmed II as part of the peace negotiated between the Venetians and the Byzantine empire. He took one of Jacopo's sketchbooks (now in the Louvre) to present to the Sultan, and the meticulous drawings of a Turkish man and woman (pp. 52–3) date from this journey. By 1481 Gentile had returned to Venice and continued to work in the Doge's Palace. In addition, he oversaw a team of artists painting the *Legend of the True Cross* in the Scuola di San Giovanni Evangelista. Of the eight paintings, three were by Gentile, including the *Procession of the True Cross in the Piazza San Marco.*

Giovanni's earliest independent work was the St Vincent Ferrer altarpiece painted in 1464–8. In this and numerous half-length pictures of the Virgin and Child, he established his reputation as a painter of altarpieces and devotional works. He developed the idea of the *sacra conversazione*, in which the older form of altarpiece made of many panels each with different saints was replaced with a single central panel where the Virgin and Child and surrounding saints were unified within the same space. His major altarpieces, the Pesaro of 1471–4, the Frari and the Barbarigo of 1488 and the Zaccaria of 1505, transformed church decoration in Venice. Although he contributed to narrative cycles in collaboration with his father and brother, and on his own in the Doge's Palace, devotional works were his forte. Characteristic of these are the two drawings of the *Pietà* (pp. 54–5), in which the figures are pushed to the foreground in front of a landscape. The style resembles Mantegna, but with a far more nervous line.

A comparison of the brothers' styles reveals that Gentile was an artist obsessed with meticulous detail, even in the large narrations. Giovanni's works were more intimate and infused with luminous light and gentle colours. Giovanni was also an influential and popular teacher: in the next century his students Giorgione and Titian built on his interest in colour and light to forge a new style of painting.

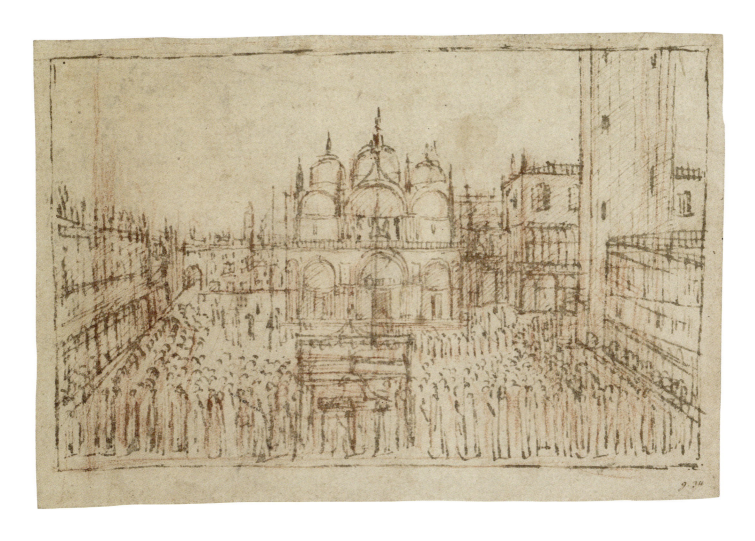

Gentile Bellini. *Sketch for a procession in the Piazza di San Marco, Venice, c.* 1481.
Pen and ink over red chalk, 130 × 196 mm.
London, British Museum, 1933-8-3-12.

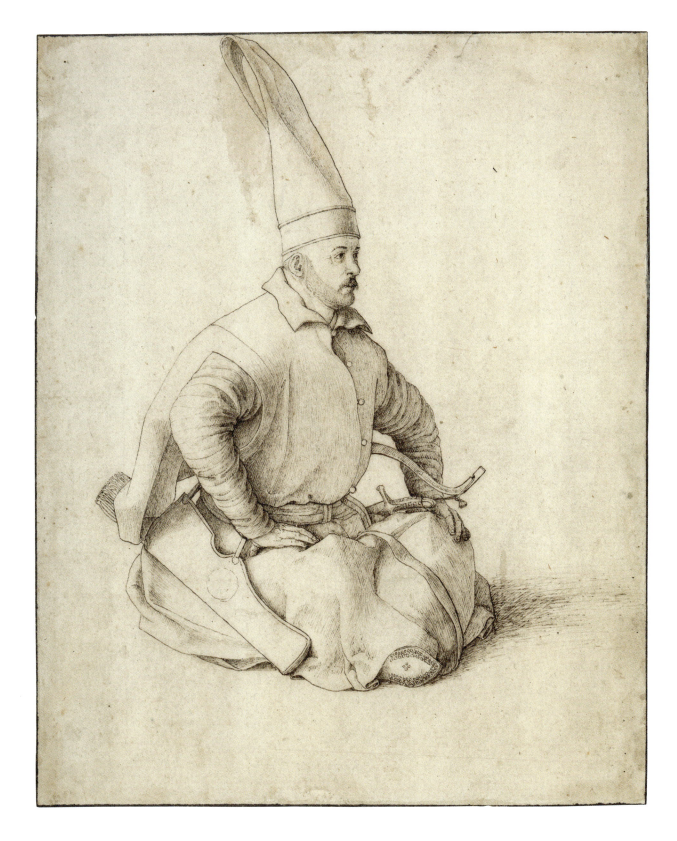

Gentile Bellini. *A Turkish man*, 1479–81.
Fine pen and Indian ink, 214 × 175 mm.
London, British Museum, Pp. 1–19.

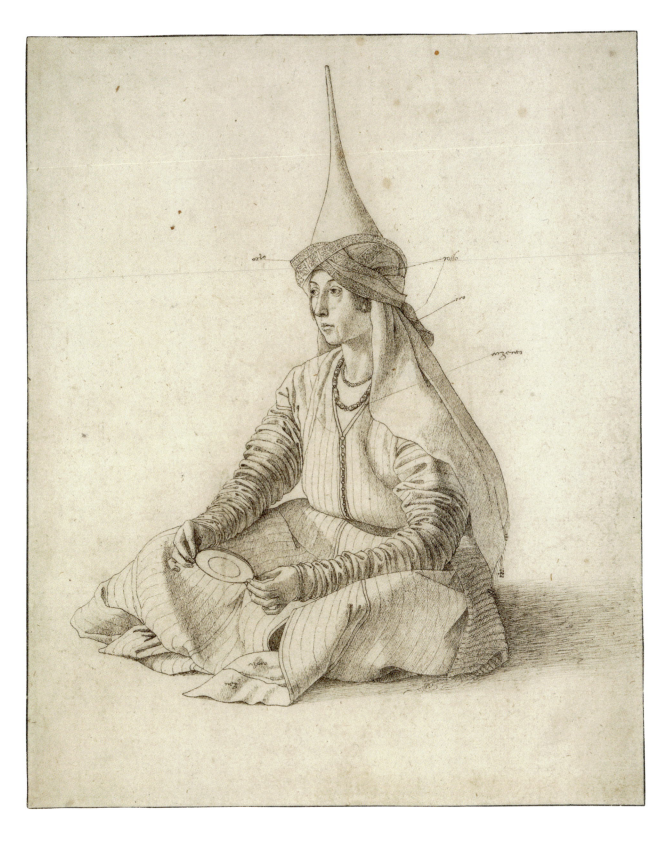

Gentile Bellini. *A Turkish woman*, 1479–81.
Fine pen and Indian ink, 215 × 177 mm.
London, British Museum, Pp. 1-20.

Giovanni Bellini. *Pietà, c.* 1480.
Pen and ink, 132 × 90 mm.
Rennes, Musée des Beaux-Arts, 794.1.2503.

Giovanni Bellini. *Pietà, c.* 1480.
Pen and ink and brown wash, 130 × 94 mm.
London, British Museum, 1895-9-15-791.

Andrea Mantegna
Isola di Carturo 1431–1506 Mantua

WHEN MANTEGNA WAS TEN YEARS OLD he was apprenticed to, and later adopted by, Francesco Squarcione in Padua. Squarcione was an undistinguished painter but evidently an inspiring teacher, and during the six years he was under his guidance Andrea learned to draw and paint. While in Padua, the young Mantegna acquired a lifelong passion for the ancient world. His near obsession manifested itself in his *all' antica* style, a conscious emulation of the antique within a modern idiom. Another early influence was the Florentine sculptor Donatello, who in 1443 began a decade of work in the city during which he produced the bronze equestrian sculpture of Gattamelata, a large crucifix and numerous bronze figures and stone reliefs for the high altar of the Santo, Padua's greatest church. The combination of Squarcione's teaching, a fascination with antiquity and the study of Donatello's sculptures moulded Mantegna into an unconventional artist.

As Mantegna matured the relationship with Squarcione soured, and in 1447–8 there was a formal separation between the master/father and pupil/son. Soon afterwards, Mantegna and three other artists were commissioned to decorate a chapel for Antonio degli Ovetari in the Church of the Eremitani, Padua. The church was bombed in the Second World War and the complete cycle is now known only through old photographs and Mantegna's early sketch for *St James on his way to execution* (p. 58). The rapid strokes of the pen describe James blessing a kneeling man surrounded by a crowd. Many of the figures were drawn nude, and the underlying outlines of bodies are visible even within the clothed figures. The dramatic viewpoint, angular style and attention to accurate detail in the Roman soldier's attire are characteristic of Mantegna.

Around the time of the break with Squarcione, Mantegna met Jacopo Bellini. Their friendship influenced Mantegna's use of light and colour and also led to his marriage to Jacopo's daughter in 1453. When one compares Giovanni Bellini's drawings of the *Pietà* (pp. 54–5) with Mantegna's *Man lying on a stone slab* (opposite) there can be no doubt of the effect that these brothers-in-law had upon each other. Mantegna's approach is, however, more hard-edged and dramatic than Giovanni's, with his softer strokes of the pen.

In 1460 Mantegna began his career as court artist to three generations of rulers of Mantua. Compared with cosmopolitan Padua, Mantua was a backwater. However, the enlightened patronage of Ludovico, Frederico and Francesco Gonzaga, as well as Francesco's wife Isabella d'Este, transformed Mantuan culture to a high level of sophistication with Mantegna as its leading light. Mantegna's numerous Mantuan works include everything from portraits to tapestries, but he is best known through his charming frescoes in the Camera degli Sposi in the Ducal Palace (1465–74).

Mantegna remained a passionate antiquarian, even designing his own house after a Roman villa. His involvement with printmaking transformed it from a craft to high art. His sharp, angular style was well suited to the burin of the engraver, yet tender depictions of the Virgin and Child seen in paintings such as the San Zeno altarpiece (Verona), the *Madonna della vittoria* (Louvre), the *Virgin of the stonecutters* (Uffizi) and the drawing of the *Virgin and Child enthroned* (p. 59) demonstrate that even this relentlessly intense artist had a soft, human side.

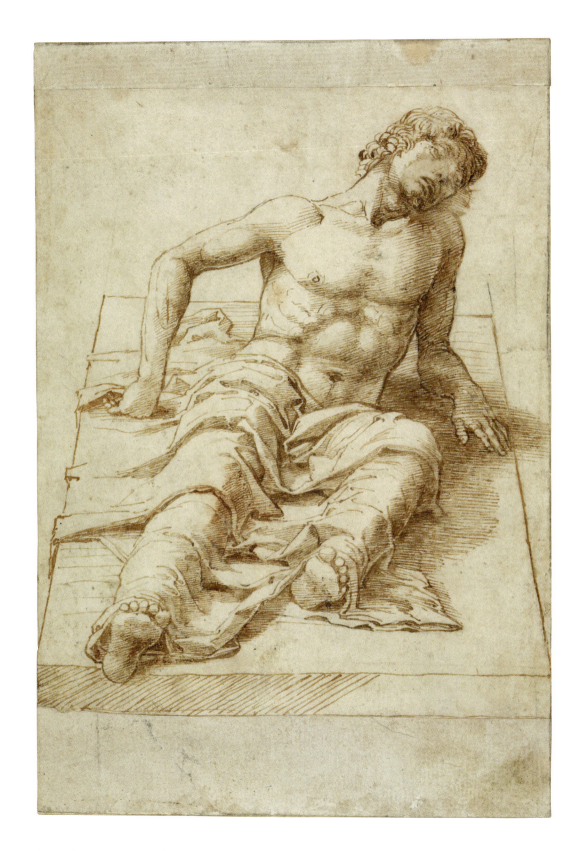

A man lying on a stone slab, 1470s.

Pen and ink over traces of black chalk, 204 × 140 mm.

London, British Museum, 1860-6-16-63.

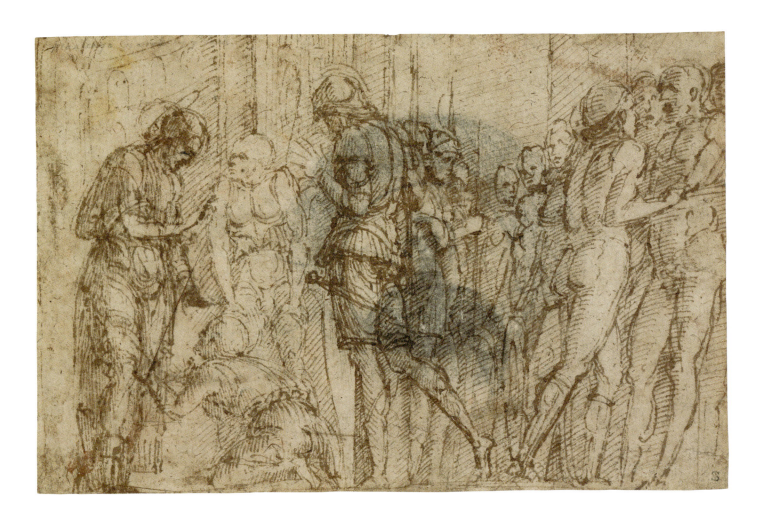

St James on his way to execution, c. 1453.
Pen and ink with traces of black chalk on pale pink prepared paper, 155 × 234 mm.
London, British Museum, 1976-6-16-1.

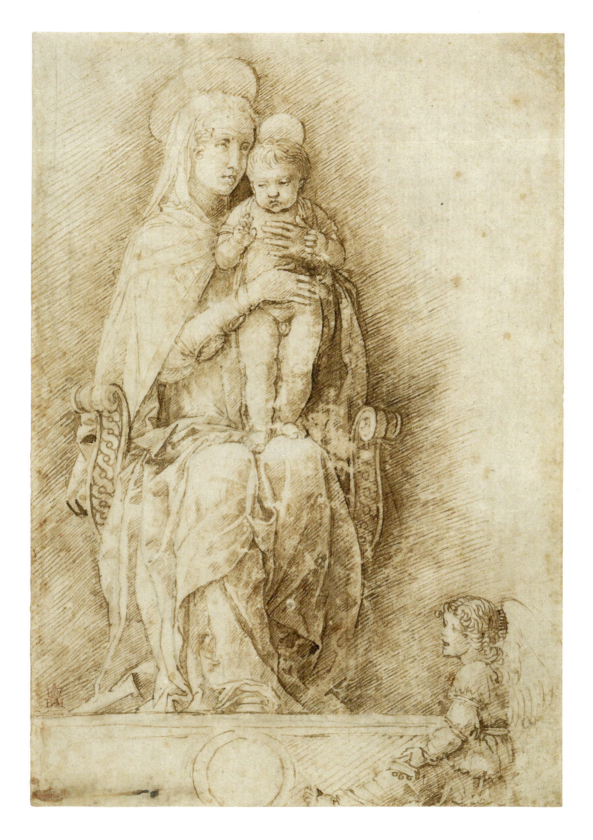

Virgin and Child enthroned with an angel, 1480s.
Pen and ink, 197 × 140 mm.
London, British Museum, 1858-7-24-3.

Antonio del Pollaiuolo

Florence 1431–1493 Rome

FLORENTINE ARTS IN THE 1460S AND 1470S were dominated by the rival workshops of the Pollaiuolo brothers and Andrea del Verrocchio. Remarkably, these artists specialized as goldsmiths, sculptors and painters. A generation earlier, Lorenzo Ghiberti's shop had included painters as well as sculptors, but his primary output was sculpture. The successful combination of all these arts within a single workshop was exceptional.

Antonio spent his early career designing objects in precious metals, notably a silver reliquary cross for the Florentine Baptistery. From 1464 he established a goldsmith's shop and continued to receive commissions for religious and domestic objects. His first paintings originate from a similar date. Vasari wrote that his younger brother Piero (c. 1441–96) taught him to paint, but this is implausible. It is, however, true that the brothers collaborated on many projects and that Piero was better known as a painter than as a goldsmith. Of Antonio's early paintings, the large canvases depicting the labours of Hercules for the Palazzo Medici were the most important. They are now lost, but his smaller panels of *Hercules and Antaeus* and *Hercules and the Hydra* (now in the Uffizi), along with the British Museum drawing of the same subject (opposite), reproduce the original composition. The rapid pen sketch emphasizes Antonio's attention to the musculature of a body in motion, a recurring theme of his work.

Like Mantegna, Antonio was fascinated by the antique. The *Prisoner led before a judge* (p. 62) is based on antique sculptural reliefs and may be an attempt to recreate a classical composition. Alberti advocated this practice when he praised Pliny's description of the *Calumny* by the Greek painter Apelles, and inspired artists like Botticelli to display their skill by reproducing this ancient composition in a modern manner. The exact subject of Antonio's drawing is not clear but, like the *Calumny*, it may represent a prisoner being unjustly accused.

Antonio was fond of experimentation, not just in rendering *all' antica* subjects, but also in exploring new means of artistic expression. Again like Mantegna, he experimented with printing, engraving his depictions of the nude in violent motion in the print of the *Battle of the nudes*. His drawing of a nude seen from three angles (p. 63) explores a similar theme. This sheet, revered even in his lifetime, is inscribed with a near-contemporary Latin inscription: 'This is the work of Antonio di Jacopo del Pollaiuolo, most excellent and famous Florentine painter and most outstanding sculptor. Whenever he depicted the image of man, see how marvellously he rendered the limbs.'

Antonio's artistic output was remarkably varied. As well as numerous sculptures and decorative objects in metal, he designed a tomb for the Cardinal of Portugal in San Miniato (1466), vestments for the Florentine Baptistery and a painting of the *Martyrdom of St Sebastian* for the Pucci Chapel in Santissima Annunziata (1475). Many of these projects were completed with the collaboration of his brother Piero. In 1484 the brothers moved to Rome, where the last decade of Antonio's career was devoted to the tombs of Popes Sixtus IV and Innocent III.

Hercules and the Hydra, c. 1460.
Pen and ink, 235 × 165 mm.
London, British Museum, 5210-8.

A prisoner led before a judge, 1470s.
Pen and ink over traces of black chalk, the background in dark brown wash, 369 × 693 mm.
London, British Museum, 1893-5-29-1.

Study of a male nude seen from the front, back and in profile; study of two arms, c. 1469–70.
Pen and ink with brown wash and stylus, 265 × 357 mm.
Paris, Louvre, inv. 1486.

Andrea del Verrocchio

Florence 1435–1488 Venice

ANDREA DEL VERROCCHIO was trained in three different art forms. As a boy he was apprenticed to a goldsmith to learn to work with metal. He then trained as a sculptor, learning to carve in stone and wood and, finally, after he had matured in these other crafts, he learned to paint. All these arts were practised together under the roof of his *bottega*, with the result that the young artists educated by him emerged with extraordinary skills.

After Donatello's death in 1466, Verrocchio became Florence's leading sculptor. His works for the Medici family show the range of his remarkable talents, from the imposing porphyry, marble and bronze family tombs in the Old Sacristy in San Lorenzo to the elegant, free-standing bronze *David with the head of Goliath*. He also secured important civic commissions such as the *Christ and St Thomas* for the Mercanzia niche on the church of Or San Michele, the ball for the top of Brunelleschi's dome on the cathedral and a large candlestick for the Signoria. His creations were not just beautiful, but also beautifully crafted. The *Christ and St Thomas*, for example, is a technical marvel, cast in a single piece. Verrocchio's fame spread to Venice where, late in his life, he was commissioned to make a monumental equestrian monument to Bartolomeo Colleoni.

After the 1460s Verrocchio became equally interested in painting. It was during this period that Perugino, Lorenzo di Credi and Leonardo joined the workshop, perhaps with the express intent of helping Verrocchio to paint. It was common practice for assistants to help their master make paintings, but in the unique environment of Verrocchio's shop the assistants appear to have completed most of the painting with very little intervention from the master.

Underlying Verrocchio's talents as a sculptor, painter and teacher was his exceptional skill as a draughtsman. The drawings in this selection demonstrate his facility with ink, chalk and metalpoint. Both sides of the *Studies of infants* (opposite) are crammed with sketches drawn with a confident, fluid line of the pen. Verrocchio turned the page around as he drew, so that the figures do not overlap excessively. The idea of working out many ideas on a single page anticipates Leonardo's invention sheets (p. 96). The purpose of this drawing is not straightforward. Verrocchio's solid, life-like children are convincingly naturalistic. The standing putto with an upraised arm appears to be a Christ Child blessing, the dancing putto to the right relates to Verrocchio's bronze *Putto with a dolphin* (Palazzo Vecchio, Florence), while the other three could be sketches for a Christ with the Virgin.

In his *Life* of Verrocchio, Vasari praised his drawings of female heads: 'There are some drawings by his hand in our *Libro de' Disegni*, made with much patience and sensitivity, amongst these are some female heads with beautiful appearance and elaborate hairstyles that, for their beauty, Leonardo always imitated.' Leonardo could have had in mind these very drawings (pp. 66–7) when he advised in his treatise on painting that women should be represented in modest poses with their heads looking down or leaning on one side.

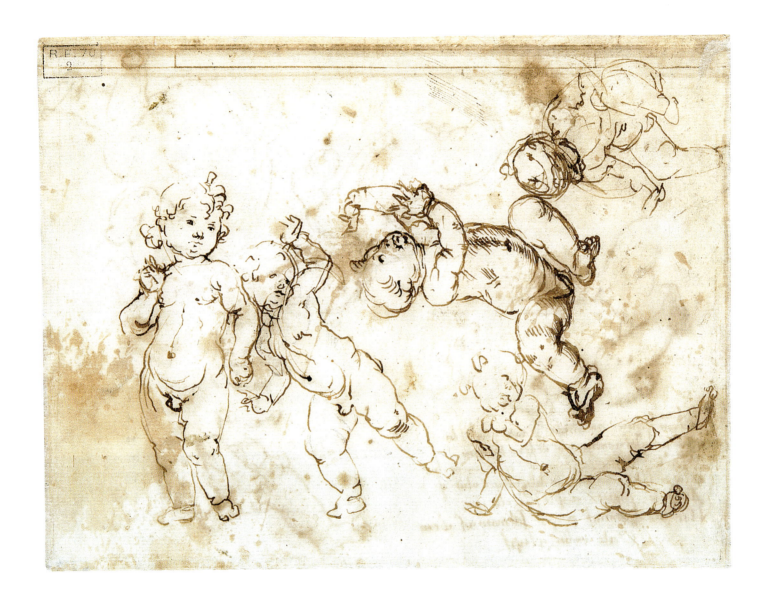

Five studies of infants, early 1470s.
Pen and ink, 158 × 210 mm.
Paris, Louvre, RF 2 (verso).

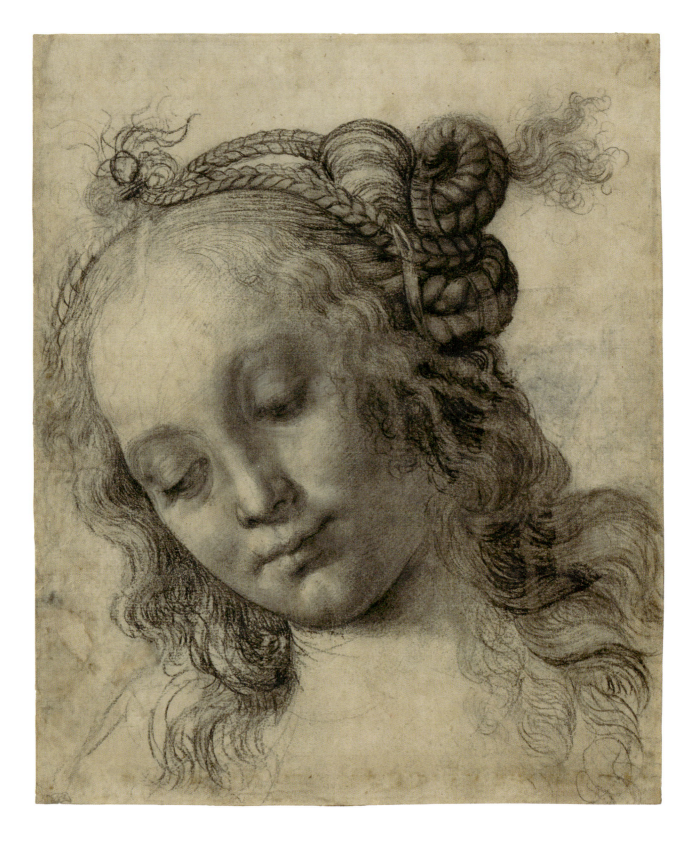

Head of a woman, c. 1475.
Black chalk with white heightening, 325 × 273 mm.
London, British Museum, 1895-9-15-785 (recto).

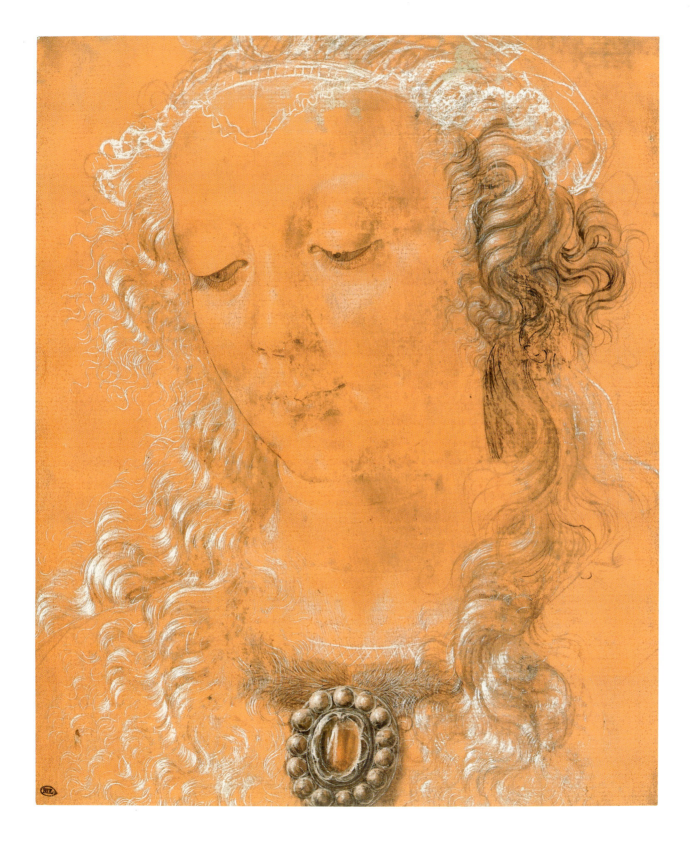

Head of a woman, 1470s.
Metalpoint, brush with black and grey inks, heightened with white on red-orange prepared paper, 267 × 224 mm.
Paris, Louvre, inv. 18965.

Marco Zoppo
Cento *c.* 1443–1478 Venice

PADUA IN THE FIFTEENTH CENTURY was a cultured city. It was the seat of a respected university specializing in classics and the law, and an important destination for pilgrims who came to worship St Anthony at his tomb in the Santo. Fine arts in the city were similarly sophisticated. Painting in Padua had strong Florentine influences from the early fourteenth century, when Giotto produced frescoes for the Arena Chapel. In the 1430s and 1440s Filippo Lippi and Paolo Uccello (1397–1475) worked on Paduan projects, and by the 1440s and 1450s the Florentine sculptor Donatello and the workshop of local artist Francesco Squarcione dominated Paduan arts.

Donatello came to Padua in 1443 and stayed for ten years. Squarcione ran a flourishing workshop in which artists were trained. By his own account he taught 137 pupils. He adopted the most promising students, but may have done this to secure his financial position rather than out of affection. Andrea Mantegna famously broke with Squarcione in 1447–8, not only severing a professional relationship, but also renouncing Squarcione as his adopted father.

In 1453–4, when Marco Zoppo arrived in Padua, Mantegna and his colleagues were producing frescoes for the Ovetari Chapel. Details of Zoppo's apprenticeship are unknown, but he was in his twenties and already referred to as *maestro*. In all probability he trained in the late Gothic style still popular in his native Bologna. Padua's urbane environment may have attracted Zoppo, who soon followed Mantegna's footsteps in joining Squarcione's workshop. By May 1455 Squarcione had adopted him with the promise that he would receive living expenses and instruction, and inherit the workshop on Squarcione's death.

The *Dead Christ supported by angels* reflects the influence of Donatello and Mantegna on Zoppo's newly developed Paduan style. The body of Christ draws upon Donatello's bronze relief of the *Dead Christ mourned by two angels* from the Santo altar. The monumental vaulted arch behind Christ is typical of compositions in works by Donatello and his Paduan followers. Donatello also inspired the charming angels – note the intense grief of the angel on the right who buries his head in his hands. Zoppo updated these motifs with elements of the antique such as the coffering of the arch and the sculptural frieze at the bottom. In this respect Mantegna's impact is evident. The verso of the drawing depicts *St James on his way to execution* (Fig. 26), the same subject that Mantegna tackled in the Ovetari Chapel. Zoppo was not as accurate as Mantegna in his *all' antica* quotations and the result is a more fanciful adaptation of classical motifs. Nevertheless, Mantegna's impression upon Zoppo is clear.

Zoppo's contract with Squarcione made him heir to the studio and he stood to inherit a thriving business plus the numerous sculptures and *exempla* used to teach students. Unexpectedly, the previously childless Squarcione married soon after the contract was signed and his new wife bore him an heir. Without the prospect of inheriting the estate, perhaps compounded by Squarcione's miserly personality, Zoppo again followed the path of Mantegna and left the workshop in 1455, settling eventually in Venice.

Dead Christ supported by angels, 1455–60.
Brush and brown wash with ink, traces of red wash, on parchment, 350 × 280 mm.
London, British Museum, 1995-5-6-7 (recto).

Sandro Botticelli

Florence *c.* 1445–1510 Florence

BOTTICELLI IS SYNONYMOUS with the golden age of Florence under Lorenzo de' Medici. His elegant style was honed in the workshop of Filippo Lippi during the 1450s and 1460s. After Lippi's departure to Spoleto, Botticelli remained in Florence, perhaps in Verrocchio's workshop. His first recorded work, in 1470, is a panel – *Fortitude* – made for the Palazzo della Signoria, a commission that came from the Pollaiuolo brothers. He thus had direct contact with all the major Florentine artists of the previous generation. In the 1472 register of the Compagnia di San Luca, Botticelli is named as a master, with Filippino Lippi, the illegitimate son of Filippo, as his assistant.

The mid-1470s saw the beginning of the relationship between Botticelli and the Medici. This was the period when the Medici nearly lost their power and then consolidated it. In April 1478 members of the rival Pazzi family attempted a coup and killed Giuliano, Lorenzo's brother. The conspirators were swiftly hung and Botticelli was commissioned to paint their portraits on the gallows as a reminder of their infamy. He went on to create numerous pictures for the Medici, including altarpieces, portraits, mythologies, allegories and even ephemeral works for tournaments and celebrations. Botticelli rarely strayed from Florence and commissions from the Medici and their supporters. The notable exceptions are his frescoes in the Sistine Chapel, painted alongside Perugino, Ghirlandaio and Cosimo Rosselli (1439–1507) in 1481–2.

Botticelli did not adapt to the times and his style became old-fashioned. He never made the transition to oil paint, steadfastly preferring egg-based tempera. His figures remained stylized in comparison with those of younger artists whose interest in anatomy led them to develop a greater naturalism in depicting the human form. Vasari says that Botticelli abandoned painting to follow the charismatic preacher Girolamo Savonarola, but in fact his workshop was active until 1504, long after Savonarola was burned at the stake. When Botticelli died, at the age of sixty-five, he had sunk into oblivion, something that is hard to imagine considering the current iconic status of the *Primavera* and *Birth of Venus*.

Botticelli's drawings are less familiar and do not survive in large numbers. *Abundance or Autumn* is just the kind of delicate drawing one expects of Botticelli at the height of his powers, when he painted the *Primavera* and *Birth of Venus*. It was probably drawn in the 1480s when the mythologies were created. Its purpose is not known. It has been identified by the cornucopia, an attribute of the personification of either autumn or abundance. The sinuous curve of the woman's body as she gracefully steps forward is similar to that of the naked Venus or the central figure in the *Primavera*. The complex technique is interesting. The unfinished cornucopia and putti show the first sketch in black chalk. The central figures were tinted with pink by rubbing the sheet with red chalk, a technique often used in Florentine drawings to give an indication of colour and volume. Botticelli improved his chalk sketch with pen and ink, and then ink wash applied with a brush. Finally, he picked out the areas of greatest light with white highlighting, again applied with a brush.

Abundance or Autumn, 1480s.

Pen and ink and faint brown wash over black chalk on pink-tinted paper, heightened with white, 317 × 253 mm.

London, British Museum, 1895-9-15-447.

Domenico Ghirlandaio

Florence 1448/49–1494 Florence

CONTEMPORARY ACCOUNTS PORTRAY Domenico Ghirlandaio as a diligent worker who ran a productive workshop. Vasari praises his accurate techniques and recounts that Ghirlandaio went to such lengths to please his clients that he and his *garzoni* would accept any job that came to the workshop, even down to painting a woman's shopping basket. Domenico's *bottega* was a family business: his partner was his brother Davide. Domenico's earliest training was as a goldsmith. As an apprentice he would certainly have learned to draw, because drawing was as important to the goldsmith as it was to the painter. Vasari states that Domenico was apprenticed to the painter Alesso Baldovinetti (1427–99), but similarities with works by Pollaiuolo and Verrocchio demonstrate that the young Ghirlandaio was receptive to all the dominant artistic forces in Florence at the time.

Ghirlandaio excelled at paintings of religious narratives set against a fifteenth-century backdrop populated with contemporary portraits. His skills are apparent from the earliest frescoes in San Gimignano, through his narratives in the Sistine Chapel and his two masterpieces in Florence, the Sassetti Chapel in Santa Trinità and the Tornabuoni Chapel in Santa Maria Novella. Ghirlandaio's panel paintings were equally important. He painted altarpieces in many churches in Florence and its provinces, as well as captivating portraits such as the touching *Old man and his grandson* (Louvre).

In 1485 Domenico and Davide accepted the commission from Giovanni Tornabuoni to decorate his chapel with scenes from the lives of the Virgin and John the Baptist. The sketch of the *Birth of the Virgin* (p. 74) is a *primo pensiero* for the fresco. It explores the rudimentary architecture and basic positions of the figures within the space, with the figures reduced to mere notations of their shapes. Domenico must have made further designs for the figure groupings because the attendants in the completed fresco are dispersed differently. The *Naming of the Baptist* (p. 75) demonstrates the next stage of design. Here the focus is on the poses, which in this case tell the story of the moment when Zachariah confirms in writing that his baby should be called John, is immediately cured of muteness and speaks words of praise to God. The penwork becomes more complicated as the figures are fleshed out, with greater areas of shadow created by hatching and cross-hatching. Following this, Ghirlandaio focused on separate figures, imbuing them with individual characteristics. The *Standing figure of a lady* (opposite) examines the dress of one of the attendants in another scene, the *Birth of the Baptist*. Whereas the previous two drawings were conceived in the artist's imagination, this one may have been drawn from life. The folds of the drapery, position of the hands and fall of light and shadow are more carefully studied than in the previous sheets. The head is left in outline to be drawn from a live model, in this case a member of the Tornabuoni family. Working in these separate stages meant that Ghirlandaio could delegate some of the painting to his assistants, who would use his drawings to guide them in their work.

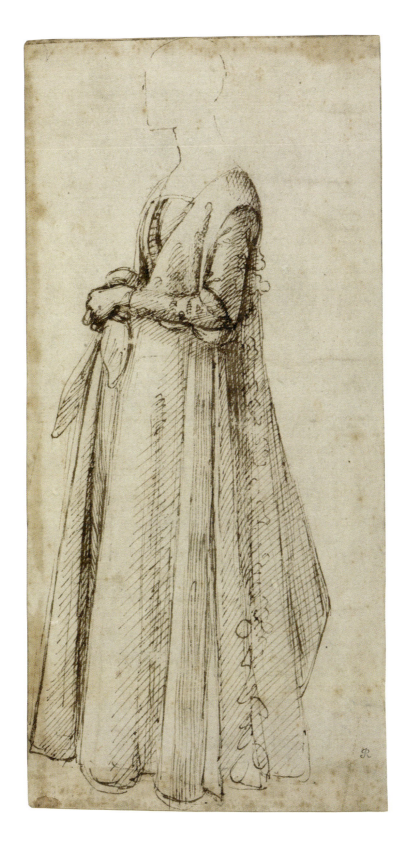

Standing figure of a lady, 1485–90.
Pen and ink, 241 × 117 mm.
London, British Museum, 1895-9-15-451.

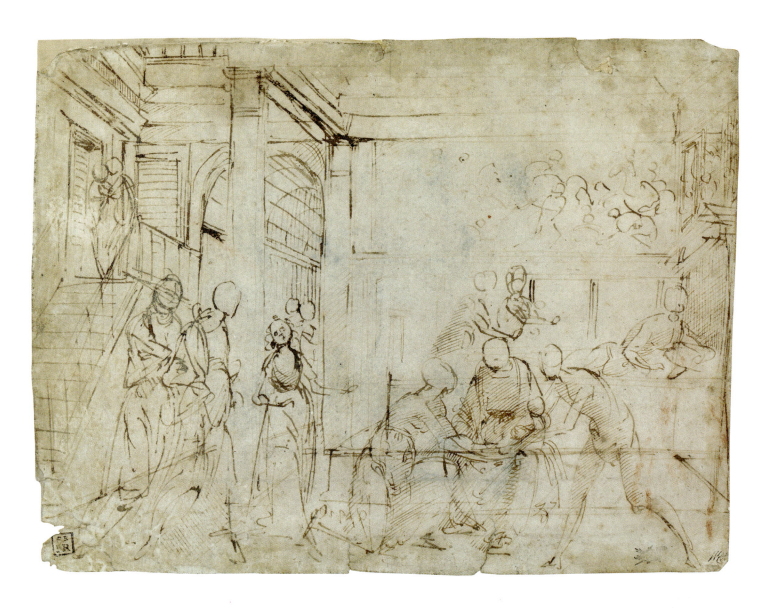

The Birth of the Virgin, 1485–90.
Pen and ink, 215 × 285 mm.
London, British Museum, 1866-7-14-9.

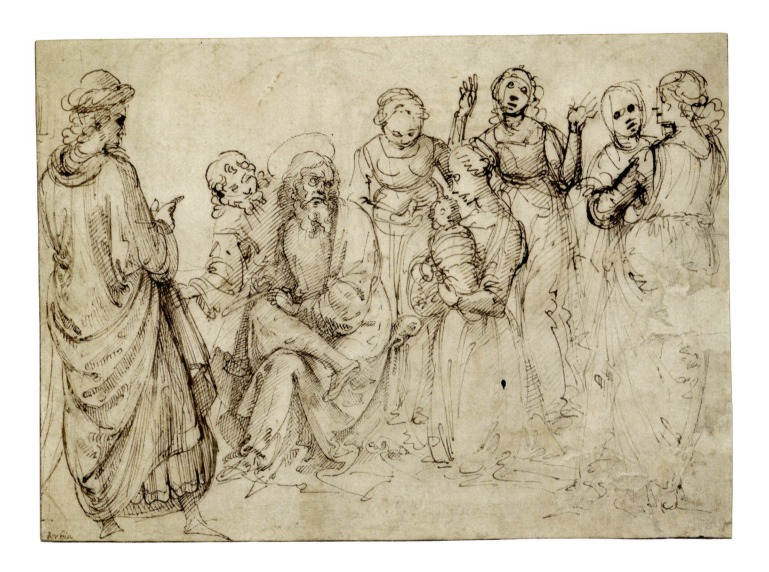

The Naming of St John the Baptist, 1485–90.
Pen and ink, 185 × 263 mm.
London, British Museum, 1895-9-15-452.

Luca Signorelli

Cortona *c.* 1445–1523 Cortona

SIGNORELLI'S SKILL AS A DRAUGHTSMAN was the reason why Vasari placed his biography in the *Lives* at the cusp of the new generation of artists heralded by Leonardo. Signorelli excelled in drawing with black chalk, imbuing his sketches of nudes with both power and finesse that anticipate Michelangelo.

It is difficult to classify Signorelli as either a Florentine or an Umbrian, even though he worked throughout both these regions. His first artistic instruction was under his father Egidio, a minor painter and decorator in Cortona, a city under the jurisdiction of Florence but geographically close to the Umbrian border. In the 1460s Signorelli worked with Piero della Francesca in Arezzo, and Piero's solid figures and interest in perspective set important examples for him. The closest precedent to Signorelli's mastery of black chalk is found in Verrocchio's drawings, perhaps suggesting that Signorelli passed through Verrocchio's workshop. Certainly, his inclusion as a late addition to the team of artists – including Botticelli, Ghirlandaio, Perugino and Rosselli – who produced frescoes for the Sistine Chapel indicates that he was connected with associates of Verrocchio.

Signorelli was well into his forties when he emerged as an independent artist, and into his fifties when in 1499 he received his most important commission, to complete the frescoes in Orvieto Cathedral left unfinished by Fra Angelico fifty years earlier. In the contract he is referred to as 'Master Luca da Cortona, famous painter in all of Italy'. This may be an exaggeration, but it is a telling reflection of a career that had already taken Signorelli from Volterra in the west to Loreto in the east, down the Tiber valley from Città di Castello to Rome and throughout the provinces of Florence and Siena.

Signorelli painted the Cappella Nova with scenes of good and evil populated with countless vigorous nudes. Even the clothed figures wear such tightly fitted garments that their naked forms underneath are visible. To create this vast array of poses, Signorelli must have drawn numerous studies, but relatively few of these survive. One of the most spectacular extant sheets is the study of a cloaked man for the moneylender at the centre of the *Antichrist* (opposite). Close examination of its black, red and white chalks shows Signorelli's manipulation of these to create both soft tones and bold strokes.

After Orvieto, Signorelli continued to receive commissions all over central Italy using his Cortona workshop as a base. His style remained remarkably consistent throughout his long career, often making it difficult to date undocumented works. The dynamic sketch of a nude man seen from the back (p. 79) is a study for one of the assailants beating Christ in a *Flagellation* painted shortly after the Orvieto frescoes. In it Signorelli cleverly captured the figure in motion in relatively few strokes of the chalk. The *Study for a Massacre of the Innocents* (p. 78) is more difficult to date because it cannot be connected with a known painting. It is characteristic of Signorelli's skill in rendering muscular bodies in movement.

Signorelli died as an old man in Cortona. By the 1520s his style was very old-fashioned, yet his successful workshop remained active until his death.

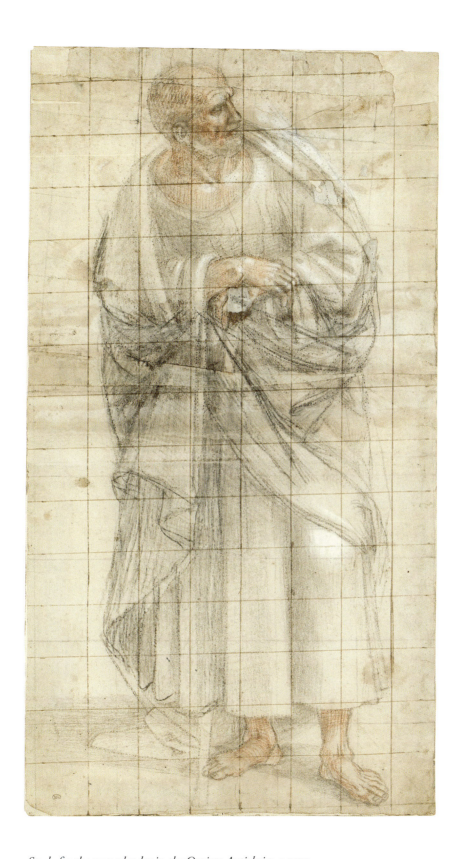

Study for the moneylender in the Orvieto Antichrist, c. 1500.
Black, red and white chalks, squared in black chalk and brown ink, 466 × 258 mm.
Paris, Louvre, inv. 1796.

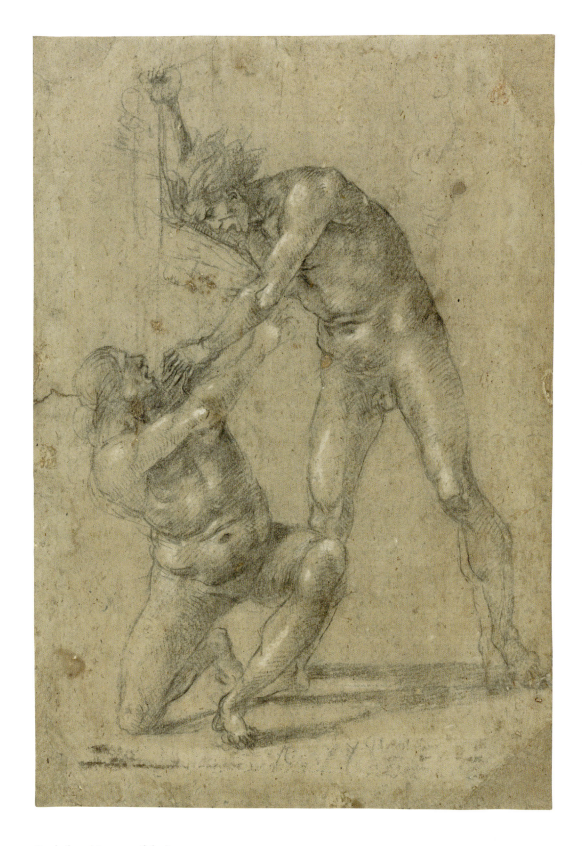

Study for a Massacre of the Innocents, 1490s.
Black chalk with white lead highlighting. 288 × 200mm.
London, British Museum, 1946-7-13-10.

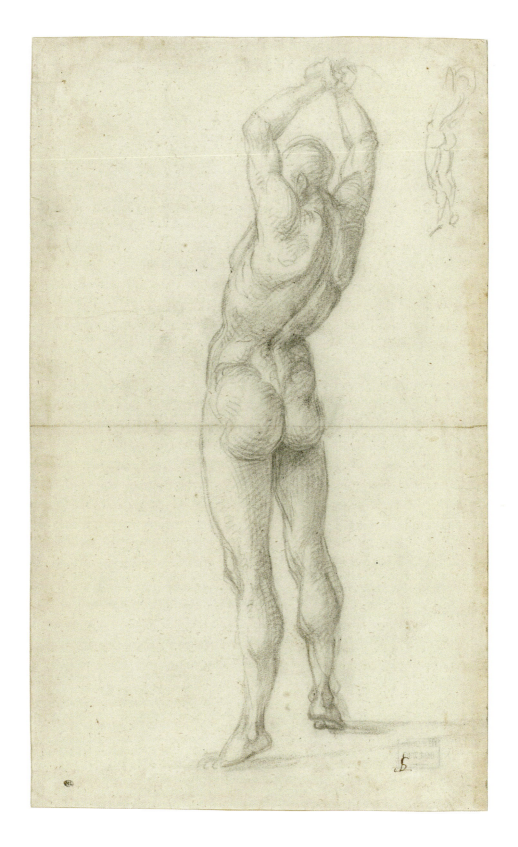

Nude man, seen from the back, 1504.
Black chalk, 412 × 253 mm.
Paris, Louvre, inv. 1797.

Pietro Perugino
Città della Pieve *c.* 1450–1523 Fontignano

PIETRO PERUGINO'S VERY FIRST TRAINING may have been in Umbria, but his formative years were spent in Verrocchio's Florentine workshop. Vasari wrote that Perugino, Lorenzo di Credi and Leonardo were 'companions and friends' under Verrocchio's roof. Although Verrocchio's workshop was often engaged in a number of projects in different media, the three companions were primarily involved with painting, and seem to have been trusted to execute many of their master's paintings after his designs.

Perugino's early *Adoration of the Magi* (p. 82) is thought to be a *primo pensiero* for a fresco in the Gesuati convent outside the Porta a Pinti, Florence. The destruction of the convent enraged Vasari, who wrote a long passage about the church, describing Perugino's *Adoration* thus: 'This he brought to perfect completion with great liveliness and a high finish, and it contained an infinite number of different heads, many of them portrayed from life, among which was the head of Andrea del Verrocchio, his master.' The preparatory drawing with Perugino's rapid notations of his first ideas for the fresco demonstrates that it was an ambitious composition.

In 1481–2 Perugino was included in the team of Florentine artists sent to paint Sixtus IV's new chapel in the Vatican. He was responsible for at least two narrative scenes as well as the frescoed altarpiece of the *Assumption of the Virgin*, destroyed in the 1530s to make way for Michelangelo's *Last Judgement*. In the narrative scenes the *Giving of the keys to St Peter*, set against a view of an idealized Renaissance cityscape, is indicative of Perugino's imaginative inventions of this period. In the late 1480s and 1490s Perugino became so successful that he was able to maintain workshops in Florence and

Perugia: his extensive civic works in Perugia included frescoes in the Collegio del Cambio. It is thought that the *Head of a beardless man* (opposite) may date from this period. It is close in features, although not in lighting, to the *King David* in the Cambio. The naturalism of Perugino's description of the sagging flesh of his model contrasts with the bland idealization of his painted figures.

Having perfected his style, Perugino did little to amend or develop it later in life. Thus, a drawing such as the *Baptism of Christ* (p. 83) is difficult to date because it resembles similar compositions from throughout Perugino's career. Eventually this obstinacy worked to his disadvantage. In 1505 Perugino completed an *Assumption of the Virgin* for Santissima Annunziata, Florence. In that same year, Leonardo, Michelangelo and Raphael were all in Florence. It was immediately apparent that Perugino's altarpiece was hopelessly outdated. He was derided for his formulaic approach, 'particularly because Pietro had availed himself of those figures that he had been wont to use in other pictures; with which his friends teased him, saying that he had taken no pains, and that he had abandoned the good method of working' (Vasari). He became an object of ridicule for the younger generation of Florentine artists, and yet in 1508 he was called by Julius II to work in the Vatican, demonstrating that his style continued to be in demand by the most exalted patrons.

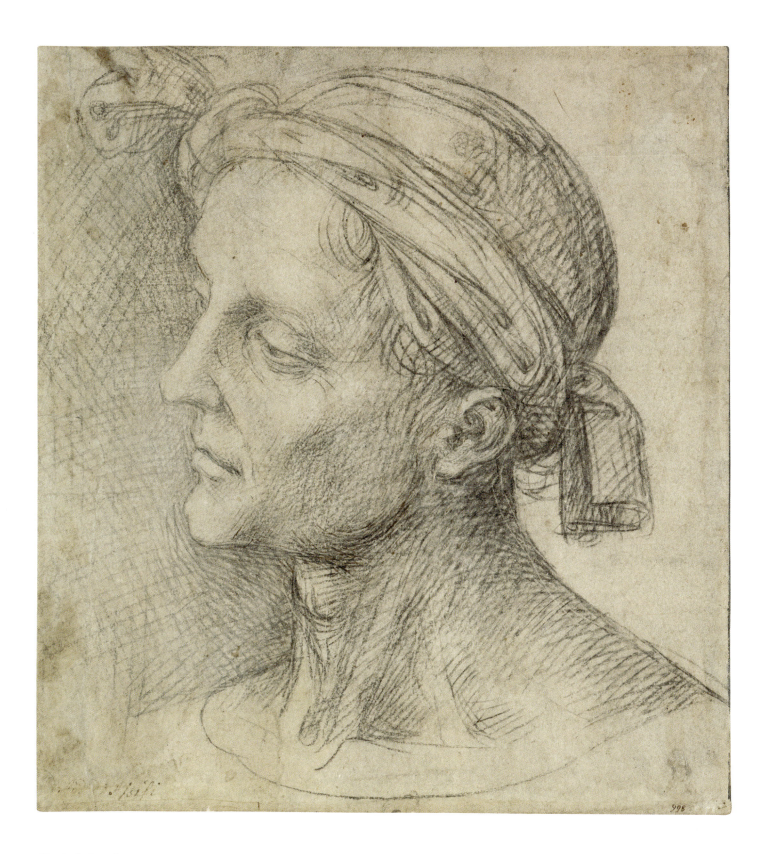

Head of a beardless man, 1490s.
Black chalk over stylus, 201 × 188 mm.
London, British Museum, 1895-9-15-600.

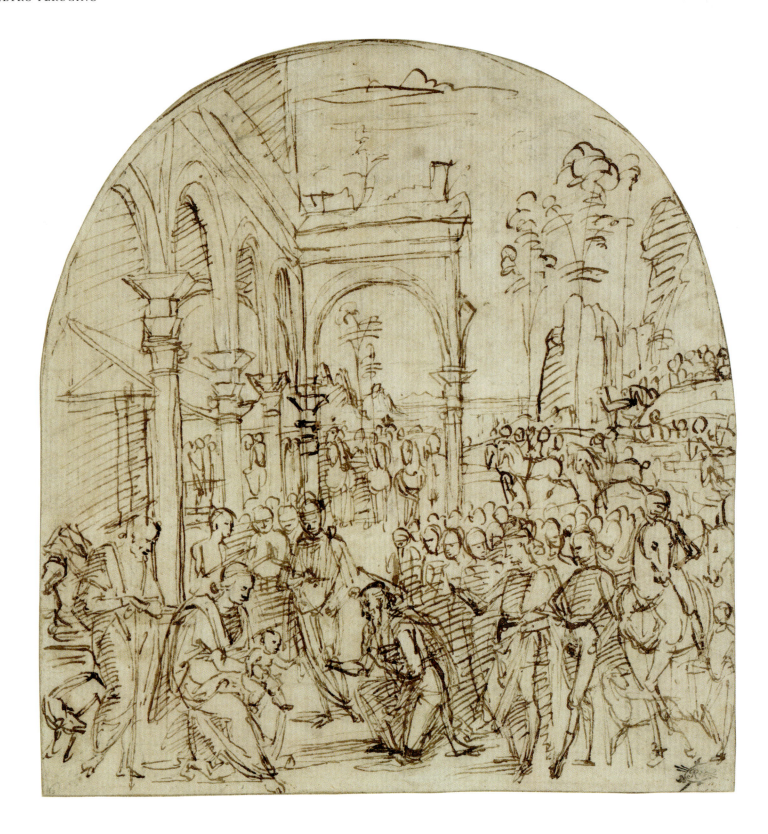

The Adoration of the Magi, 1470s.
Pen and ink, 191 × 182 mm (arched top).
London, British Museum, 1853-10-8-1.

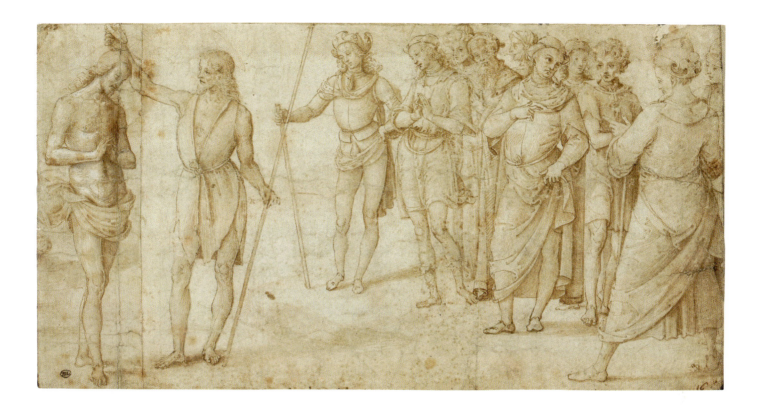

The Baptism of Christ, 1480s?
Pen and ink with brown wash and white highlighting, 170 × 333 mm.
Paris, Louvre, inv. 4367.

Bartolomeo Montagna

Brescia *c.* 1450–1523 Vicenza

MONTAGNA'S BIRTH DATE is calculated from family documents of 1467 and 1469 that refer to him as a minor, and another from 1474 that reveals he was an adult living in Vicenza. Little is known about his early training, but further family documents record him as resident in Venice from 1469 to 1474. This, coupled with visual clues in his early paintings, indicates that the artists Giovanni Bellini, Antonello da Messina (*c.* 1430–79) and Alvise Vivarini (1442/53–1503/05) had a strong influence on his development. Although some scholars think that he could have trained in Bellini's workshop, this assertion cannot be supported by documentary evidence.

After Montagna returned to Vicenza, he received various commissions to paint altarpieces for local churches in the late 1470s and 1480s, most notably the high altar for the church of San Bartolomeo (now Pinacoteca Civica, Vicenza). The altarpiece depicts a Virgin and Child enthroned between two saints and set in a rocky landscape. The monumentality of the figures, subtle colouring and atmospheric landscape behind the figures are characteristic of Montagna's style.

In 1482 Montagna briefly returned to Venice, where he painted large biblical canvases for the Scuola Grande di San Marco. The canvases were destroyed along with the Scuola in a devastating fire, but the commission is a testimony to the notable position that Montagna had achieved by this date. When he returned to Vicenza his style was at its peak. He was in demand throughout the Veneto, and had patrons in Vicenza, Padua and even distant Pavia.

Montagna's late career is marked by his increasingly provincial and old-fashioned style. He was unable to keep up with the psychological depth and narrative complexity introduced to Venetian art by Giorgione and Titian in the early years of the sixteenth century.

The *Virgin and Child* is particularly interesting because of its technique and its connection with an altarpiece by Montagna. Although the paper has now faded, it was originally the blue colour favoured by Venetian artists in the fifteenth and sixteenth centuries. The subtle blue helped to render the soft atmosphere that binds together figures and their surroundings in Venetian paintings. The majority of this drawing was executed in black chalk and is not a quick sketch, but a detailed study. Further detail was added through the application of blue wash and white highlights.

The drawing was made in preparation for the altarpiece depicting the *Virgin and Child with Sts Jerome and Sebastian* painted for the church of San Sebastiano in Verona. It is dated 1507 and comes from the late period in Montagna's career. The Virgin and Child are enthroned on an elaborate plinth with arches behind them. Unlike many of Montagna's pictures, this one has no landscape in the background. The drawing corresponds very closely with the figures in the painting, indicating that it represents the last stage of the design process.

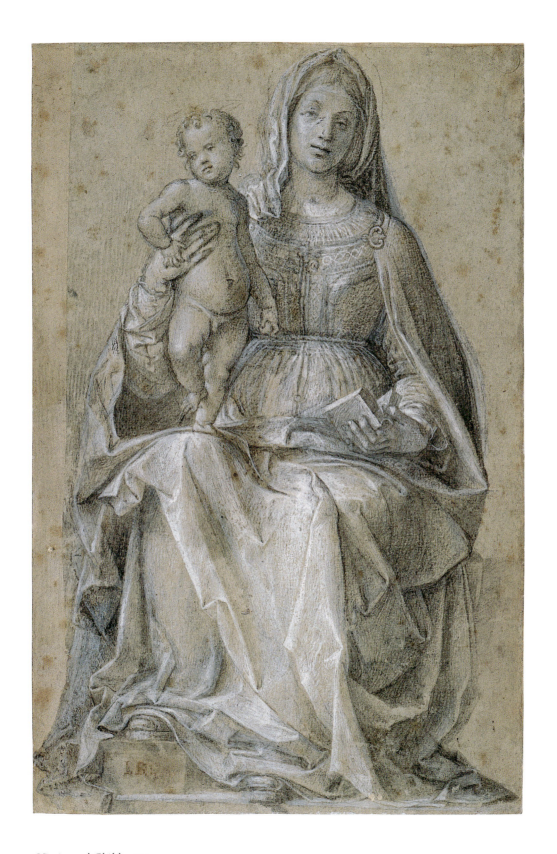

Virgin and Child, 1507.
Black chalk with blue wash heightened with white on blue paper, 332m × 203 mm.
Lille, Musée des Beaux-Arts, PL 58.

Leonardo da Vinci
Vinci 1452–1519 Amboise

I T IS DIFFICULT TO AVOID USING SUPERLATIVES when discussing Leonardo. His brilliance was unprecedented in his own lifetime and has never been exceeded. The universality of his genius is extraordinary: he was a painter, sculptor, musician, architect, engineer, inventor, scientist, anatomist and mathematician. In some respects, his all-encompassing curiosity may have held him back from bringing many of his projects to completion. It is clear from his drawings that he relished solving problems, but that he often got bored when he arrived at the solutions and abandoned the projects. His numerous surviving drawings show an unparalleled expertise in rendering nature, light and shade, and atmosphere on a two-dimensional surface.

Leonardo was fortunate to be an apprentice in Andrea del Verrocchio's workshop, where he could witness painting in tempera and fresco, carving in marble and wood, casting in bronze, modelling in clay and, of course, drawing. Verrocchio seems to have been an extraordinary teacher, encouraging his pupils to find their own styles. Vasari's comments on Verrocchio's curious mind, stating that he was 'a man who was not content with being excellent in one thing only' and that he often had many projects under way at the same time 'in order to avoid growing weary of working always at the same thing', prefigure Leonardo's own artistic temperament.

By 1472 Leonardo was an independent master of painting, and yet he remained in the *bottega* for another four years. Much of his graphic style is indebted to Verrocchio. The stream of variations in Leonardo's double-sided *Three studies of a child with a cat* (pp. 92–3) is reminiscent of his master's method in the *Five studies of infants* (p. 65). Leonardo's drawing shows his keen observation of life and talent for capturing movement and mass with just a few strokes of the pen. Similarly, the shadows and highlights of the *Virgin and Child with a cat* (pp. 90–1). especially on the recto in the contrast between the wash and the blank paper, demonstrate Leonardo's competence in evoking the bulk of the figures through light and shade. Repeated practice at studying the fall of light over sculptural models in Verrocchio's workshop must have helped him understand how to depict the mass of a figure. The numerous *pentimenti*, or corrections, often drawn one on top of the other, are characteristic of Leonardo's style. Reliefs by Verrocchio of Alexander the Great and Darius may have inspired another drawing from the 1470s, the metalpoint *Bust of a warrior in profile* (p. 95). The fanciful headdress is, however, a typical Leonardo invention, as is the witty use of the snarling lion's mask to underline the figure's martial valour.

The drapery study on linen was one of Leonardo's innovations. The tradition of making a separate study of drapery was well established and undoubtedly practised in Verrocchio's workshop, but Leonardo raised such works to a new level in a small number of drawings from the 1470s. His drapery drawings are remarkable for their three-dimensionality and luminosity. These qualities are best seen in the Louvre's breathtaking drapery study (opposite), possibly one of Leonardo's most outstanding drawings and without question the finest example of this genre by his hand.

In March 1481 Leonardo contracted to paint an *Adoration of the Magi* for the monastery of San Donato a Scopeto outside the walls of Florence. His numerous drawings for the commission, now widely scattered, demonstrate that he put significant thought into this design. The composition in the Louvre (p. 89) is the

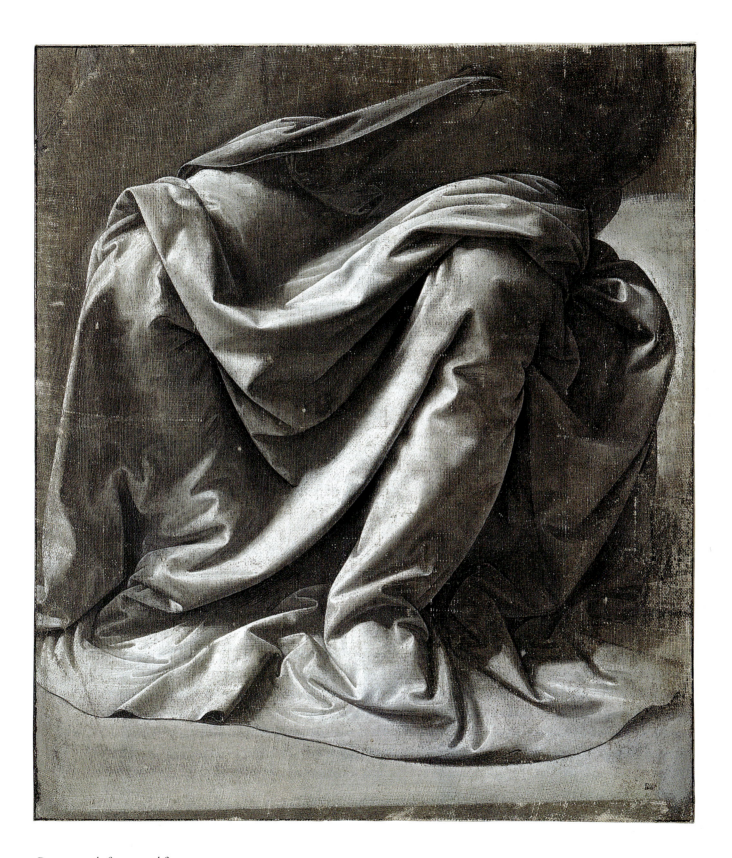

Drapery study for a seated figure, 1470s.
Brush with grey tempera and white highlighting, traces of brush and black ink on linen, 266 × 233 mm.
Paris, Louvre, inv. 2255.

Head of a grotesque man, c. 1503.
Red chalk with traces of stylus, 90 × 61 mm.
Paris, Louvre, inv. 2249.

most extensive of them all. It represents an advanced design for the painting, which Leonardo left unfinished when he left for Milan in 1482–3. Through the drawing one can gain a sense of Leonardo's ambition to unite the group around the Virgin and Child, the cohesiveness of these figures contrasting with the animated bustle of the scene behind.

Leonardo arrived in Milan before April 1483. Projects of this period are diverse. They include paintings of the *Virgin of the Rocks*, the *Last Supper* in Santa Maria delle Grazie, various portraits, the decoration of the Castello Sforzesco, designs for a bronze equestrian monument, architectural projects, designs for military machines and his first notebooks exploring light and colour, perspective, mathematics and the human body. The fearsome study of *Military machines* with its representation of a tank-like vehicle (p. 96) dates from Leonardo's experiments into instruments of war for Duke Ludovico Sforza. The revolving scythes and two views of a beetle-like tank annotated with Leonardo's notes to himself, written in his characteristic reverse script, are inventive, if impractical, weapons.

The French invasion of Lombardy in 1499 ousted Ludovico from Milan and caused Leonardo to flee. He journeyed to Venice, stopping in Mantua where he drew the sublime *Portrait of Isabella d'Este*, daughter of the Duke of Ferrara and sister of Ludovico Sforza's duchess (p. 94). Isabella married Francesco Gonzaga, Marquess of Mantua, in 1490. She was cultured, erudite and fiercely independent, and saw herself as a muse to artists and musicians. She made ambitious plans for her *studiolo*, a room to be filled with paintings by the most outstanding masters in Italy, designed to her specifications so that each picture would be of a similar size and scale and comply with her chosen subject. Unsurprisingly, the maverick Leonardo declined to contribute. Despite repeated requests for a painting, this highly finished cartoon in coloured chalks was the only work she managed to wrest from him.

In 1500 Leonardo returned to Florence. Curiously, little of the first two years of the decade is known with certainty, except that he was working on various compositions of the Virgin and Child. In the summer of 1502 he became military architect to Cesare Borgia, but he returned to Florence in 1503 at the behest of Piero Soderini, the new Republican leader of the city. Soderini commissioned Leonardo and Michelangelo, the greatest Florentine painters of their respective generations, to paint the council chamber walls with

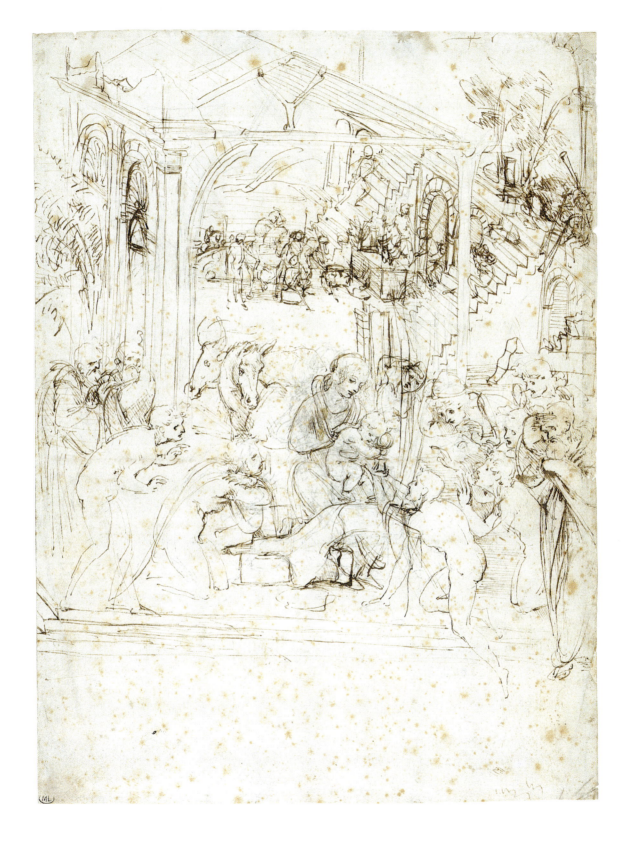

Adoration of the Magi, 1481.
Pen and ink over traces of stylus and leadpoint, 284 × 213 mm.
Paris, Louvre, RF 1978.

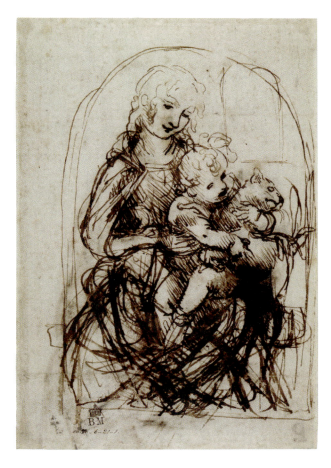

Virgin and child with a cat, 1470s. Pen and ink over stylus, 132 × 96 mm. London, British Museum, 1856-6-21-1 (verso).

images of Florentine victories. Leonardo's *Battle of Anghiari*, like Michelangelo's cartoon for the *Battle of Cascina*, made a sensational impact. Unlike Michelangelo, Leonardo actually began his painting, but his experimental technique caused it to deteriorate rapidly and Vasari covered it over when he redecorated the room for Cosimo I de' Medici in the 1550s.

Leonardo returned to Milan in 1506 to work for the French king Louis XII and his governor Charles

d'Amboise. The sheet of *Studies for the Virgin and Child with Sts Anne and John the Baptist* (p. 97) probably dates from this period. The drawing is particularly interesting for the insights it gives into Leonardo's design process. The figures were drawn over and over again until the resulting density of chalk made the composition practically illegible. This method of brainstorming, also seen in other sheets by Leonardo where he superimposed one drawing upon another, was one of his methods of exercising ideas. The indication of a frame and dots to aid with scale suggests that he was working up this drawing for enlargement. It is a preparatory study for the large cartoon of the *Virgin and Child with St Anne and St John the Baptist* (National Gallery, London), which was never realized in paint. The intimate choreography of the figures, with the Virgin improbably seated on the lap of her mother Anne, underlines Leonardo's relentless search to give his narratives greater psychological resonance. The quick sketch of dams and water wheels in the margin hints at Leonardo's inability to stay focused on one single task.

In 1513 Leonardo journeyed to Rome, perhaps with the promise of patronage from the Medici Pope Leo X. In the event, no commissions were forthcoming, and yet Leonardo appears to have stayed in Rome until 1516. In 1515 François I became king of France. Leonardo's reputation was already well established in France and the cultured François invited him to become the 'first painter, engineer and architect to the King'. By all accounts François delighted in Leonardo's company and the great Florentine artist spent the last years of his life in comfort at the king's pleasure.

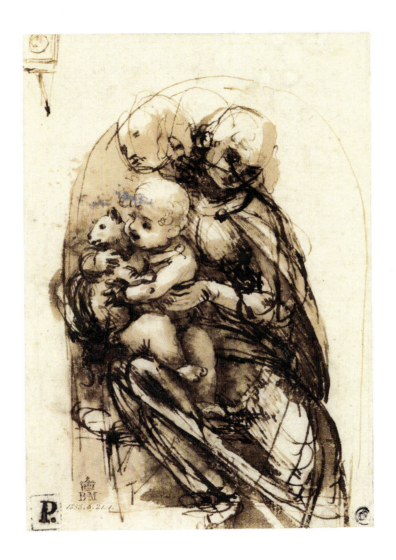

Virgin and Child with a cat, 1470s.
Pen and ink and brown wash over stylus, 132 × 96 mm.
London, British Museum, 1856-6-21-1 (recto).

Three studies of a child with a cat, 1470s.
Pen and ink over stylus, 208 × 143 mm.
London, British Museum, 1857-1-10-1 (verso).

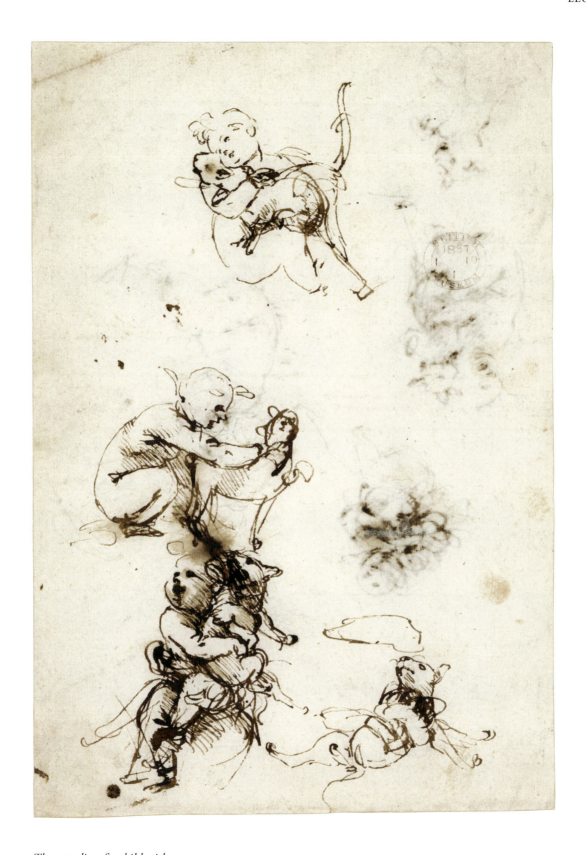

Three studies of a child with a cat, 1470s.
Pen and ink over stylus, 208 × 143 mm.
London, British Museum, 1857-1-10-1 (recto).

93

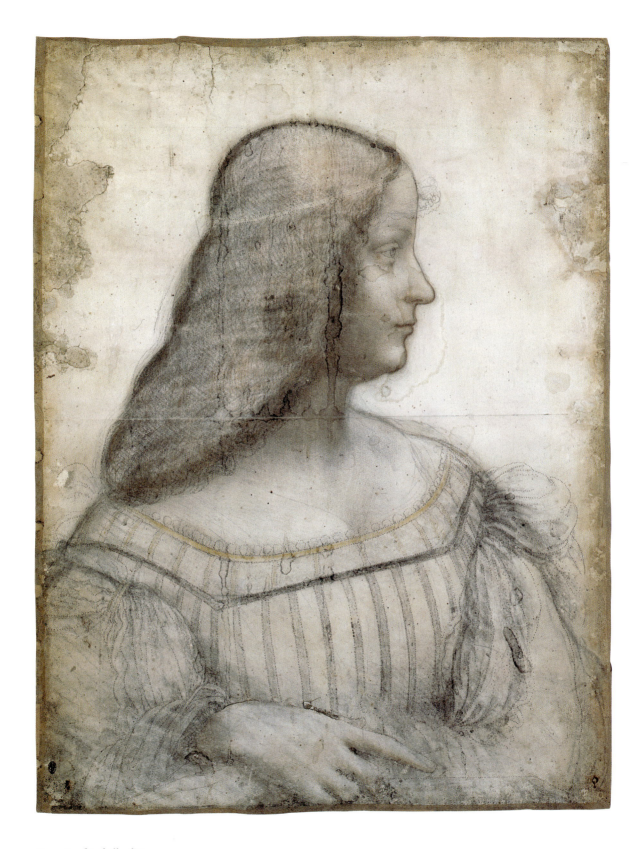

Portrait of Isabella d'Este, 1499.
Black, red and ochre chalks with white highlighting, pricked for transfer, 610 × 465 mm.
Paris, Louvre, MI 753.

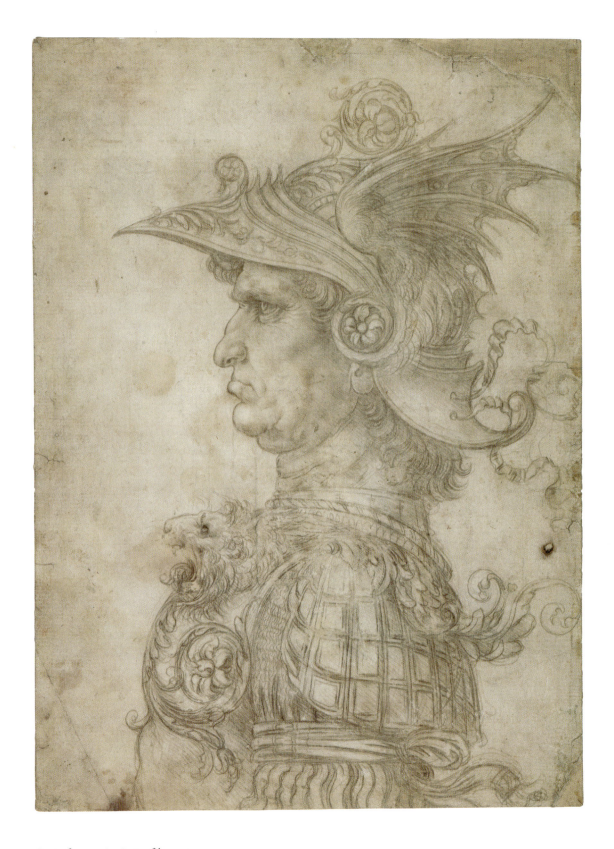

Bust of a warrior in profile, 1470s.
Metalpoint on cream-coloured prepared paper, 285 × 208 mm.
London, British Museum, 1895-9-15-474.

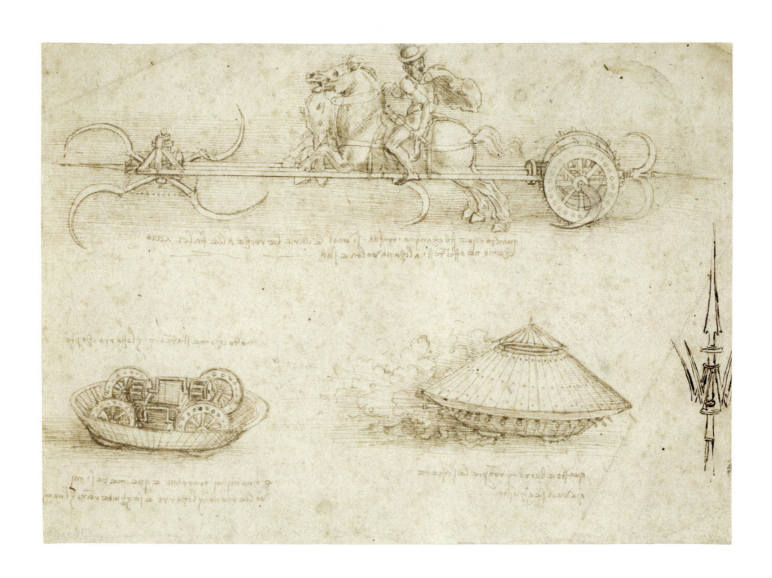

Military machines, 1483–99.
Pen and ink, 173 × 246 mm.
London, British Museum, 1860-6-16-99.

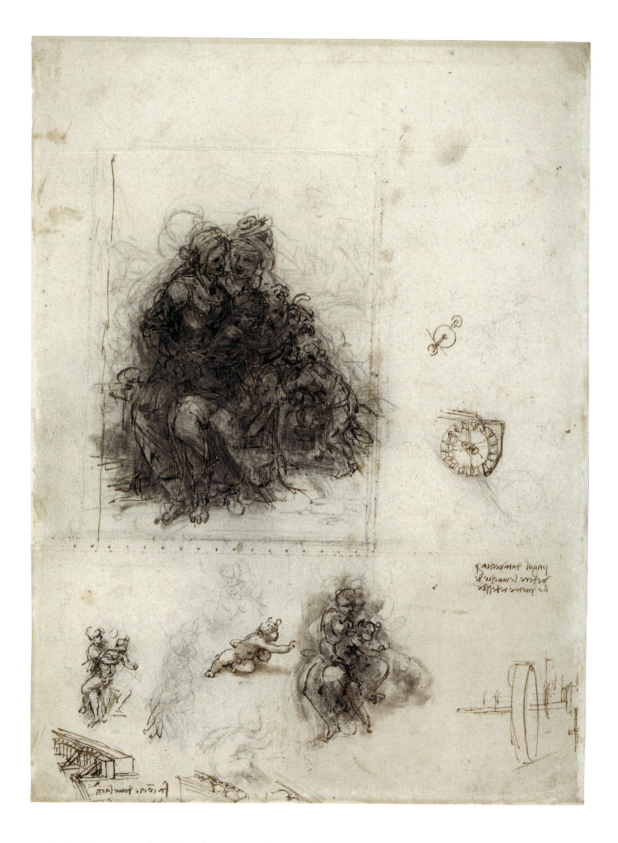

Studies for the Virgin and Child with St Anne and St John the Baptist; machinery, c. 1506.
Pen and ink and grey wash and black chalk, 267 × 201 mm.
London, British Museum, 1875-6-12-17.

Filippino Lippi
Prato *c.* 1457–1504 Florence

THE ACCOUNT BOOK OF SPOLETO CATHEDRAL records a payment in 1467 to Fra Filippo Lippi for 'a pair of stockings for his son Filippino', who was then ten years old. It is a reminder of Filippino's illegitimate birth and of the fact that his earliest artistic tutoring was received from his father. Filippo died in Spoleto in 1469 and and Filippino was then cared for by his assistant, Fra Diamante (*c.* 1430–98). By 1472 Filippino was apprenticed to Botticelli in Florence, who in turn had trained with Filippo. Filippino remained in the Botticelli workshop through the 1470s.

Filippino's first major frescoes were in the Brancacci Chapel, a place that had been such an inspiration to his father. Masaccio's pioneering paintings in the chapel were left unfinished on his death in 1428, and in the mid-1480s Filippino was commissioned to finish them. Filippino skilfully blended his work with Masaccio's and Masolino's revered masterpieces. During the remainder of the 1480s Filippino worked on altarpieces and frescoes in Florence and Tuscany, including important contracts for the Signoria, the seat of Florence's government. In 1487 he was contracted by Filippo Strozzi to paint frescoes in a chapel in Santa Maria Novella. He worked intermittently on this project for the next fifteen years of his life.

Four months after signing the contract for the Strozzi Chapel, Filippino agreed to fresco a chapel for Cardinal Carafa in Santa Maria sopra Minerva, Rome. The *Triumph of St Thomas Aquinas* (p. 101) is a composition study for the west wall of the chapel. It depicts the thirteenth-century Dominican theologian, triumphant over the heretics, being crowned by angels. The completed fresco differs slightly from this sheet, indicating Filippino's further work on the composition.

The monumental setting is a reflection of Filippino's discovery of classical art and architecture in Rome.

Numerous figure studies by Filippino survive, many in metalpoint on prepared paper. The pair of drawings of cloaked figures (p. 100) is from a group of similar drawings that may have come from a sketchbook. The figures do not relate to any specific composition, but may have been studio exercises. Filippino's finesse in metalpoint overcomes the inflexibility of the medium; in his hands it can be spontaneous and expressive. Similarly, the figure of the lunging nude (opposite) demonstrates how Filippino used metalpoint to study motion. The bold hatching on the muscles, the spirited strokes creating the hair and the lively highlights combine to emphasize the movement of the body.

Filippino's trip to Rome was a turning point in his style. Works painted after the Carafa Chapel show a monumentality and attention to classical motifs not seen in his earlier paintings. In some, such as the *Sacrifice of Laocoön* fresco in the loggia of Lorenzo de' Medici's villa at Poggio a Caiano, Filippino quoted the ancient sculptures and decorative designs he had seen in Rome; in others, such as the *Adoration* painted for San Donato a Scopeto to replace Leonardo's unfinished work, the lessons of Rome are expressed through greater monumentality in his figures.

Filippino died in his forties. According to Vasari he more than compensated for the lascivious reputation of his father by his modest civility, appealing personality and the excellence of his art.

A nude man, 1480s?
Metalpoint and white heightening on mauve-grey prepared paper, 236 × 177 mm.
London, British Museum, 1860-6-16-64.

Two men, one seated, the other standing, c. 1482–3.
Metalpoint and white heightening on grey prepared paper, 274 × 195 mm.
London, British Museum, 1895-9-15-454 (recto).

The Triumph of St Thomas Aquinas, c. 1487.
Pen and ink with brown wash, 291 × 239 mm.
London, British Museum, 1860-6-16-75.

Lorenzo di Credi

Florence 1459–1537 Florence

Like Leonardo da Vinci, Lorenzo di Credi worked under Verrocchio in the 1470s and remained in the workshop in the 1480s after he matriculated into the painter's guild as an independent master. His allegiance to Verrocchio must reflect the special nature of the shop, where the brightest pupils graduated to become trusted collaborators. Verrocchio depended on these assistants, especially in painting, where he seemed to limit himself to design, leaving the execution to others. In the Pistoia altarpiece of the *Virgin and Child with Sts John the Baptist and Zenobius*, for instance, Lorenzo appears to have painted most of the altarpiece. Although he was following Verrocchio's designs, several surviving drawings show that Lorenzo was even encouraged to develop some elements of the composition himself.

When Verrocchio relocated to Venice to work on the monumental bronze equestrian sculpture of Bartolommeo Colleoni, he made Lorenzo his chief assistant in charge of the Florentine workshop. Lorenzo repeatedly journeyed to Venice in the late 1480s to keep his master abreast of the studio's progress. When Verrocchio died in 1488, Lorenzo was his executor and inherited the contents of his workshop. Credi then set up his own shop in Florence and continued a successful career in painting altarpieces for another forty years.

Vasari, who was a personal acquaintance of one of Lorenzo's pupils and therefore reliably informed, wrote about Lorenzo's meticulous technique, explaining that the perfection in his works was dependent on hours of grinding pigments and purifying oils as well as on keeping separate brushes for each tint. He conceded that this incredible amount of labour yielded an impressive range of tone and colour, but 'such excessive care is perhaps no more worthy of praise than the other extreme of negligence, for in all things one should observe a certain mean and avoid extremes which are generally harmful'. In this respect Lorenzo could not have been more different from Leonardo, who was constantly experimenting with techniques, often with disastrous results.

Lorenzo's meticulous drawings are a reflection of his fastidious nature. He had a masterly command of metalpoint, a medium he used often for studies of heads such as the *Bust of an old man wearing a hat*. The careful attention to soft shadows on the face is reminiscent of the lessons learned in Verrocchio's shop in portraying three-dimensional forms through the play of light. The wrinkles around the eyes, the thin lips and slightly hollowed cheeks infuse this man's face with character. The drawing was undoubtedly studied from life, either as a portrait or to expand the repertoire of figures that populate Lorenzo's paintings.

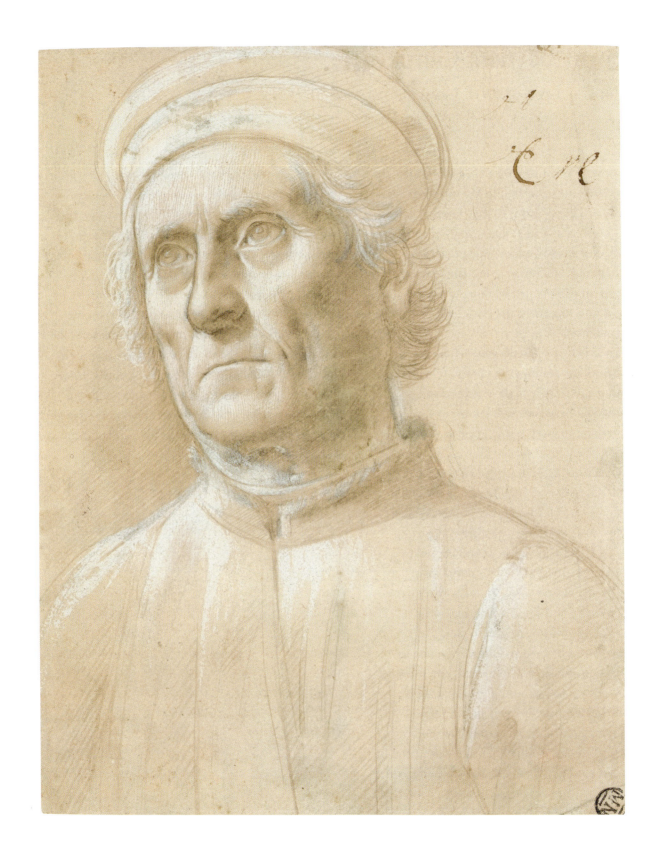

Bust of an old man wearing a hat, c. 1500.
Metalpoint with white highlighting on pink prepared paper, 215 × 170 mm.
Paris, Louvre, inv. 1785.

Giovanni Battista Cima

Conegliano *c.* 1459–1517/18 Conegliano

CIMA WAS BROUGHT UP IN CONEGLIANO on the Venetian mainland. In Venice, where his artistic training seems to have taken place and where the Vivarini and Bellini dynasties dominated painting, Cima was notable for coming from a non-artistic background. His father, as his name implies, was a *cimatore*, or cloth cutter, working in Conegliano, a reminder of how important the cloth trade was to the Venetian economy.

Stylistic references in Cima's works show that he was familiar with the paintings of Giovanni Bellini, Alvise Vivarini and Antonello da Messina. Each of these artists would have been well known to a student of Cima's generation, but it is thought that Giovanni Bellini is most likely to have been his master.

Once established as an independent artist, Cima remained in Venice even though he sent many of his paintings to churches in Conegliano and the Veneto. The majority of his works were altarpieces depicting the Virgin and Child with saints, as popularized by Bellini in works like the San Giobbe altarpiece of *c.* 1487. Like Lorenzo Lotto's works, many of Cima's paintings are signed and dated, which makes his stylistic development relatively easy to plot.

Cima's style is restrained and dignified. Having perfected his approach he hardly strayed from it for the rest of his life. For a period during the 1490s, when Giovanni Bellini was busy working on the Doge's Palace, Cima was one of the few artists painting altarpieces for Venetian churches. During this period he also made four paintings for Emilian patrons in Carpi and Parma. Aside from this he received little patronage outside the Veneto.

By 1505 the extraordinary talents of the next generation of Venetian artists were starting to emerge.

However, despite the stylistic and technical changes to Venetian painting made by Giorgione, Titian and Sebastiano del Piombo, Cima did little to adapt his own works to the new fashion. This did not seem to harm his business: his altarpieces and devotional images remained in demand until his death.

Christ the Redeemer is one of Cima's few surviving drawings. It cannot be connected with any known painting by the artist, but is thought to date from the early part of his career, in the mid- to late 1480s. On blue paper, it is striking for the minute, finely drawn folds of drapery. The careful strokes and sculptural effect are reminiscent of drawings like *A man lying on a stone slab* by Giovanni Bellini's brother-in-law, Andrea Mantegna (p. 57).

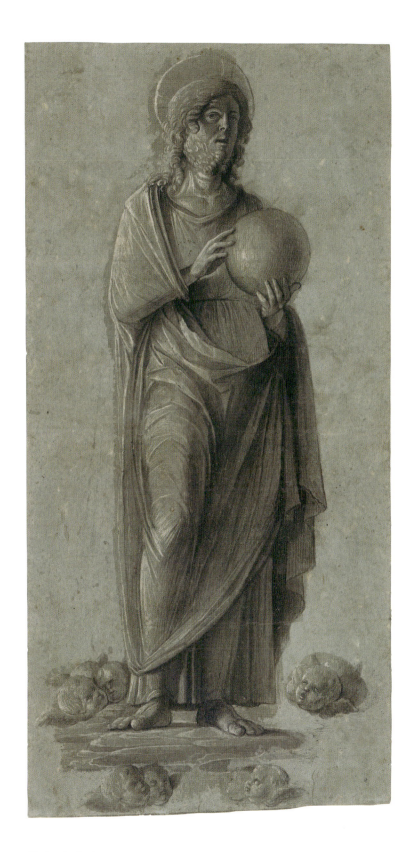

Christ the Redeemer, c. 1485–90.
Drawn with point of the brush in brown on blue paper, heightened with
white, 397 × 193 mm. London, British Museum, 1895-9-15-803.

Vittore Carpaccio
Venice *c.* 1460–*c.* 1525/26 Venice

VITTORE CARPACCIO WAS A MASTER of large narrative paintings on canvas. His works were resolutely Venetian and often depict religious or historic stories in a contemporary fifteenth-century idiom. His two greatest cycles of paintings were made for important Venetian *scuole*, lay confraternities dedicated to charitable work and religious devotion. They are full of pageantry, jewel-like colours and architectural detail that reflect the very particular kind of patron and space that the *scuole* provided.

Carpaccio's early models were Gentile and Giovanni Bellini's paintings for the Scuola di San Giovanni Evangelista and the Doge's Palace. His first great commission was the cycle of pictures for the *scuola* of St Ursula painted between 1490 and 1495. The eight large canvases and altarpiece that tell the legend of Ursula are packed with elegantly dressed figures theatrically posed in a fanciful Venetian setting. In 1502 the Scuola di San Giorgio degli Schiavoni commissioned Carpaccio to paint his second great cycle of pictures with episodes from the lives of Christ and Sts Jerome, George and Tryphone, the patron saints of the confraternity. Once again, this project consisted of numerous large canvases to decorate the confraternity walls.

The *Vision of St Augustine* is a study for the San Giorgio degli Schiavoni cycle. It tells how Augustine was interrupted while writing a letter to Jerome when a divine light entered his study and he suddenly heard Jerome's voice announcing his death. Carpaccio's painting freezes the moment when Augustine is listening to the spiritual voice. The artist created the drawing to lay out the details of Augustine's room and to map out the lights and shadows within the space. The figure is drawn in a simple outline and is not the focus of this sheet. The numerous books, decorative objects, imaginative wall lights, furniture and altar are rendered in greater detail and transform Augustine's study to that of a fifteenth-century Venetian scholar. Much of the drawing is brushed with brown wash to intensify the divine light that pours through the windows, illuminating Augustine. The drawing is extraordinarily close to the finished work, with only minor changes to the ermine, which became a dog in the painting. This suggests that it may have been made to show to the patron for approval.

It is often thought that the Venetian painters did not draw as much as the Florentines, but this is probably a misconception initiated by Vasari, who was excessively proud of the skills of Florentine artists. Carpaccio's many surviving sheets, including the lively *Head of a middle-aged man* (Fig. 1), attest to his superlative skill as a draughtsman.

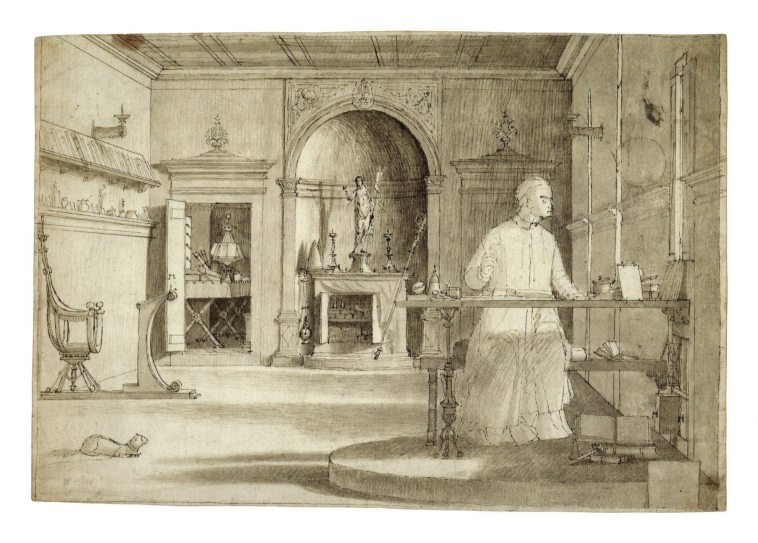

The Vision of St Augustine, c. 1502.
Pen and ink with brown wash, 277 × 427 mm.
London, British Museum, 1934-12-8-1.

Andrea Solario
Milan *c.* 1465–1524 Milan

BORN INTO A FAMILY OF SCULPTORS and architects, Andrea's earliest training may have taken place in the workshop of his brother, the sculptor Cristoforo Solario. Andrea's early career is mysterious, but his first documented painting has a Venetian provenance, suggesting that he accompanied Cristoforo when he went to Venice in the 1490s. His early works also reflect the influence of the Venetian followers of Antonello da Messina, further supporting the theory of a formative stay in Venice. Andrea was certainly established in his native Milan from 1495, and remained a successful artist until his death in 1524. His career took him from Milan to France during a time when there was turbulent interaction between these two states.

On 6 October 1499 the French king Louis XII, his prime minister Cardinal Georges d'Amboise and an army of French troops seized Milan. The French remained in control of the city for twelve years until 1511, when the troops of Pope Julius II pushed them back and the Italians regained control. Even though the arrival of the French was devastating to the Sforza duke, it opened new cultural frontiers for artists like Solario and Leonardo da Vinci. Cardinal d'Amboise, a powerful man with designs on the papacy, was an informed patron of the arts. From 1502 to 1509 he rebuilt his summer residence in France, the Château de Gaillon near Rouen, with the help of Italian architects and craftsmen. Around 1507 Solario travelled to France to paint the chapel at Gaillon. He remained there until the death of the cardinal in 1510.

In addition to decorating the chapel, Solario painted various pictures for the cardinal. The Louvre has owned at least two of these paintings for some time, the *Virgin and Child with a green cushion* and the *Head of John the Baptist.* As recently as 1978 it acquired a previously unknown *Lamentation* with the Amboise arms surmounted by a scarlet cardinal's *galero* (hat) that securely dates the picture to Solario's French period. The discovery of this painting secured the attribution of a drawing in the collection of the British Museum, now recognizable as a preparatory study for the cardinal's painting.

Solario is considered one of the *leonardeschi,* a group of painters who worked with or were influenced by Leonardo during his Milanese stays (1482/3–99 and 1506–13). The *Lamentation* shows his influence in the rocky landscape and the figure to the right of Christ, which is based on Leonardo's St John the Baptist in the first version of the *Virgin of the Rocks* painted in Milan in the mid-1480s (now in the Louvre). Curiously, the preparatory drawing is much less dependent on Leonardo: Solario's graphic style shows little debt to Leonardo's draughtsmanship and the figure on the right of Christ is different from the painted version.

Solario returned to Milan and continued his career in Italy. His greatest legacy was the introduction of the style of the Italian Renaissance to France long before the arrival of Leonardo, Andrea del Sarto or Rosso Fiorentino at the court of François I.

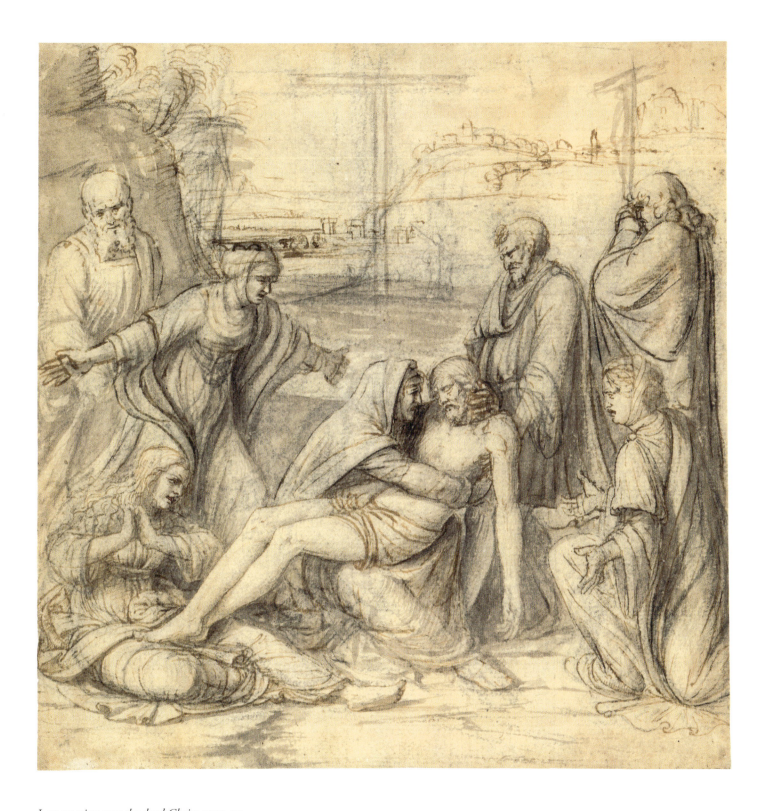

Lamentation over the dead Christ, 1507–10.
Pen and ink with brown wash over black chalk, 189 × 186 mm.
London, British Museum, 1895-9-15-771.

Marco d'Oggiono
Milan? *c.* 1467–1524 Milan

MANY ASSISTANTS ARE MENTIONED in Leonardo's notes from his first Milanese period, but few are recognizable as painters. Considering the vast array of projects that Leonardo was tackling, this is not surprising. While it is not clear if Solario was directly attached to Leonardo's workshop or if he was merely influenced by his works, two other *leonardeschi*, Marco d'Oggiono and Giovanni Antonio Boltraffio, can be documented as painters in Leonardo's workshop in the 1490s. By 1487 Marco was already taking on his own apprentices, suggesting that Leonardo employed him as a qualified artist rather than as a pupil. We know that he was living in Leonardo's house in 1491 because in September of that year Giacomo Salai, Leonardo's assistant, was accused of stealing valuable silverpoint drawings belonging to him and Boltraffio.

As the *Drapery study for the Resurrection of Christ* demonstrates, Marco was technically skilled in making drawings in silverpoint. The concentration on the fabric and the light and shade created by its folds recall earlier examples by Leonardo (p. 87). While the drapery is studied in great detail, the body and upraised arm are barely indicated with a few strokes of the metalpoint. The choice of medium is significant because the metalpoint and white heightening emphasize the volume of the folds, freezing them in pleasing surface patterns. And yet this drawing does not reach the heights of Leonardo, whose dynamic style, particularly in his pen studies, was too advanced for Marco and his Milanese contemporaries to grasp.

The drapery is a study for the dramatic figure of Christ in an altarpiece commissioned by the Griffi brothers from Marco and Boltraffio in 1491. The central panel, now in Berlin, depicts the Resurrected Christ with Sts Leonardo and Lucy in the foreground. The commission was awarded to the two artists while they were in Leonardo's shop, perhaps because the patrons desired a work in the style of Leonardo. The beauty of the drawing is not matched in the painting, which is more clumsily executed. In the drawing the Christ is a dynamic figure, but in the painting he appears to be tumbling out of the tomb rather than rising up from it. His robe, however, is painted with the same attention to light and shade as in the drawing and is beautiful in its luminosity. The collaborative nature of the altarpiece has led some scholars to attribute this drawing to Boltraffio, even though d'Oggiono is known to have painted the figure.

In the late 1490s Marco left Milan and worked in Venice and Lecco, north of Milan and close to his home town, Oggiono. Around the turn of the century he worked in Liguria, where in 1501 Cardinal Giuliano della Rovere, the future Pope Julius II, commissioned him to paint a chapel in Savona.

Marco returned to Milan in around 1504. His style never progressed beyond formulaic repetitions of Leonardo. Nevertheless, he enjoyed a successful career until his death in 1524.

Drapery study for the Resurrection of Christ, 1491–4.
Metalpoint with white highlighting on blue prepared paper, 180 × 155 mm.
London, British Museum, 1895-9-15-485.

Giovanni Antonio Boltraffio
Milan 1467–1516 Milan

LIKE MARCO D'OGGIONO, Giovanni Antonio Boltraffio seems to have been attached to Leonardo's Milanese workshop after 1491, the year the two artists received the joint commission from the family of Archbishop Leonardo Griffi to paint an altarpiece. This painting, intended for a newly constructed chapel dedicated to Griffi's patron saint in the Church of San Giovanni sul Muro, Milan, was finished in around 1494. Only the central panel of the *Resurrection of Christ with Sts Leonard and Lucy* survives (Staatliche Museen, Berlin). We have already seen Marco's drawing for the drapery of Christ. It is not clear how the labour on the work was divided, but the fact that Leonardo's assistant Salai stole silverpoint drawings from both Marco and Boltraffio suggests that Boltraffio was also an accomplished practitioner of the medium. This engaging *Portrait bust of a young man* suggests a familiarity with drawings by Leonardo and his master Verrocchio. The luminosity of the face, achieved through subtle rubbing and stumping, creates a sensitive portrait reminiscent of Verrocchio's black chalk *Head of a woman* (p. 66). However, the attribution to Boltraffio is not secure. It has also been suggested that the sheet could be by the Veronese artist G. F. Caroto (*c.* 1480–*c.* 1555), demonstrating that connoisseurship is not an exact art.

It is possible that Leonardo used Boltraffio to paint pictures to his own designs. A sublime *Virgin and Child*, the so-called *Madonna Litta* attributed to Boltraffio (Budapest), is so close to Leonardo, especially in the squirming figure of the Child, that it appears to have been painted from Leonardo's drawings. If this is the case, then Leonardo was employing Boltraffio much as Verrocchio used his able assistants Leonardo himself and Lorenzo di Credi to complete his paintings.

After the French invasion of Lombardy and the departure of Leonardo from the city, d'Oggiono and Boltraffio left Milan to seek independent careers. Around 1500 Boltraffio was in Bologna working for the Casio family. He painted an altarpiece of the *Virgin and Child with Sts John the Baptist and Sebastian* for their chapel in Santa Maria della Misericordia, near Bologna (Louvre). Kneeling in the foreground of the picture are the patrons, Giacomo Marchione de Pandolfi da Casio and his son Girolamo Casio. Girolamo and Giovanni Antonio became friends. Casio was a poet and mentioned Boltraffio in his verses; in return, Boltraffio painted Girolamo's portrait several times. In the version in the Brera, Milan, Casio is crowned with laurels and holds a page of his poetry.

Boltraffio painted altarpieces and devotional images of the Virgin, but he was especially acclaimed in his own lifetime for his portraits. He did not rejoin Leonardo when the Florentine returned to Milan in 1506, but his paintings continued to quote from Leonardo's repertoire. His paintings show more imagination and greater sensitivity in execution than those of his erstwhile collaborator Marco d'Oggiono.

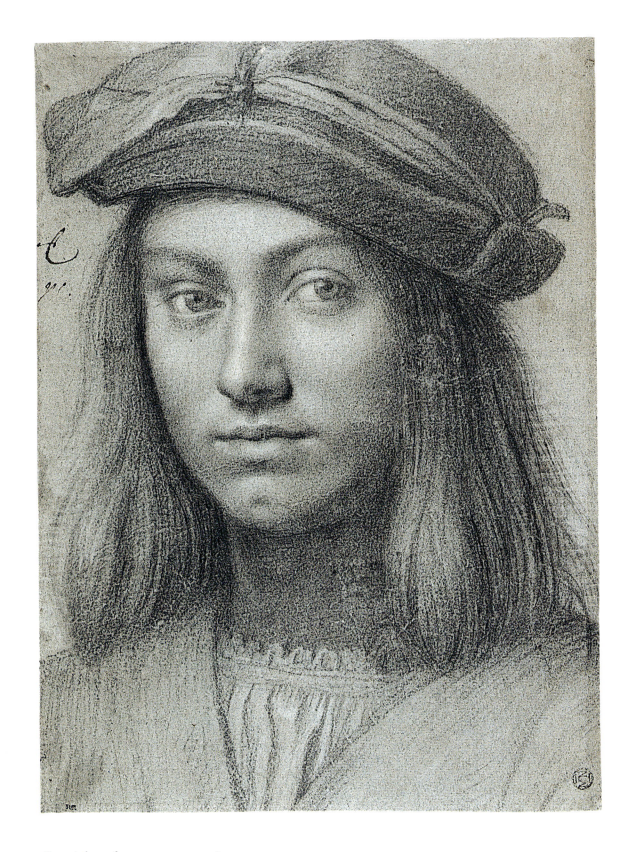

Portrait bust of a young man, c. 1510?
Black chalk with traces of white highlighting on blue paper, 341 × 256 mm.
Paris, Louvre, inv. 10971.

Raffaellino del Garbo
Florence 1466–*c.* 1527 Florence

Raffaellino, nicknamed 'del Garbo' because his *bottega* was located on the via del Garbo near the Badia in Florence, got his start as a painter under the supervision of Filippino Lippi during the project to fresco Cardinal Carafa's chapel in Rome. Filippino completed the chapel in 1493, but Raffaellino stayed on to execute frescoes in the vault of the adjacent antechamber following Filippino's designs. Afterwards he assisted Bernardino Pintoricchio with frescoes for the private Vatican apartments of the Borgia pope Alexander VI. It is clear from Raffaellino's style that the paintings of Perugino were also a profound influence.

On his return to Florence in around 1496, Raffaellino set up his own workshop. Vasari describes his early career as filled with great promise. The altarpieces of the *Resurrection of Christ* painted in 1497 for the Capponi family chapel in San Bartolomeo, Monte Oliveto, on the outskirts of Florence, and the *Pietà* painted for the Nasi Chapel in Santo Spirito are considered to be the best works of his early independent style.

The present drawing is a study for the Resurrected Christ in the Capponi altarpiece. The curvaceous body of the figure in the drawing is rendered with subtle shading on the torso and arms. His sweet face, flowing hair and delicate demeanour are drawn with great skill. The sensuality of Raffaellino's treatment of the figure, his head adorned with a wreath like that of a classical hero, is extraordinary for a study of Christ. It has been suggested that the drawing could have been studied from an antique sculpture, but the shadow cast by the figure's feet and the close attention to the musculature could equally indicate a study from life. Unsurprisingly, the painted Christ is much more traditional. The two studies of hands relate to the hands of an angel in another painting, the *Virgin and Child with angels* of a similar date, once again demonstrating that artists often worked on more than one project at a time.

Raffaellino's mature style was derivative, not inventive. His continuing dependence on Filippino and Perugino prompted Vasari to complain that he was never able to live up to the potential exhibited in his youth. Vasari claims that Raffaellino was forced to accept any business that came to him and was reduced to designing embroidery for vestments. A number of drawings attest to his activity in this field. Raffaellino's commissions do seem to have become more infrequent as he aged, although Vasari never wavered in his praise for his skills as a draughtsman. It is also telling that Raffaellino's pupils Andrea del Sarto and Agnolo Bronzino were among the finest draughtsmen of the next generation of Florentine artists.

The drawing of the Resurrected Christ is set in a mount from Vasari's *Libro de' Disegni*. The inscription on the bottom of Vasari's fictive frame attributes the drawing to Raffaellino. In his biography Vasari explained that Raffaellino's son was forced to sell his father's drawings for very little money: 'Some drawn with stylus, some with pen and wash, but all on tinted paper with luminous highlights made with fineness and admirable skill like many that are in our *Libro* of this most beautiful style.'

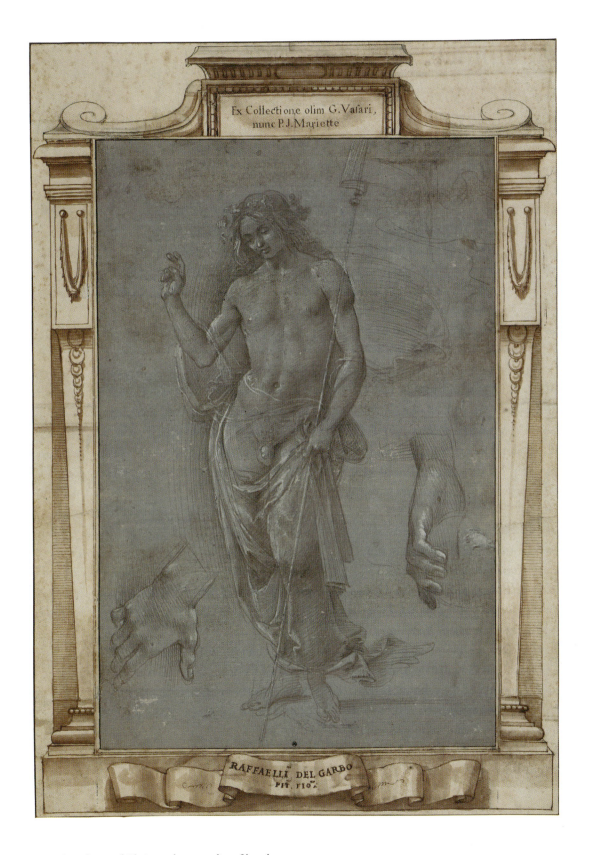

Standing figure of Christ and two studies of hands, 1497.
Metalpoint and white heightening on blue-grey prepared paper, set in a Vasari mount, 380 × 256 mm.
London, British Museum, Pp. 1–32.

Fra Bartolommeo
Florence 1472–1517 Pian di Mugnone

THE CAREER OF FRA BARTOLOMMEO is remarkably well documented. He made a large number of paintings for patrons in Florence as well as Venice, Lucca, Pavia, Rome and Ferrara, and left a vast number of drawings, many of which survive today. As a boy Bartolommeo was called 'Baccio della Porta' because his family lived next to one of Florence's city gates. His artistic career began long before he took any monastic vows. As was the custom, he became apprenticed at the age of twelve to Cosimo Rosselli, who had recently returned from painting the walls of the Sistine Chapel. By the age of nineteen he had formed a successful partnership with Mariotto Albertinelli. Together they painted a variety of pictures, both religious and secular. The partnership was dissolved in around 1493 for about a year, but by 1494 it was functioning once again. This pattern was repeated three times.

In the late 1490s Bartolommeo was increasingly affected by the zealous preaching of the Dominican reformer Girolamo Savonarola. Pope Alexander VI excommunicated Savonarola in 1497, but this did not dissuade Bartolommeo, who by this time was living in the Dominican convent of San Marco even though he was not yet a monk. In 1498 Bartolommeo burned all his profane works of art, including drawings of nudes, in one of Savonarola's bonfires of the vanities. Later that year Savonarola was tried as a heretic and burned at the stake in the Piazza della Signoria. Bartolommeo formally entered San Marco where, like Fra Angelico eighty years earlier, he became the order's artist in residence.

The remainder of Bartolommeo's career was devoted to religious painting. His third partnership with Albertinelli lasted from 1508 to 1513, and his work continued to be in great demand in Florence and beyond until his death. He rarely ventured far from Florence, except for a trip in 1508 to Venice and another in 1514 to Rome. Each of these visits made an impact on Fra Bartolommeo's style. In Venice he learned about colour and atmosphere, while in Rome he visited his old friend Raphael and studied his work in the Vatican.

Fra Bartolommeo was a prolific draughtsman. The unusually large number of surviving sheets demonstrates his methodical planning of paintings, following the progression from *primi pensieri* to cartoon in very much the same deliberate manner as Domenico Ghirlandaio. The *Annunciation* is typical of his penmanship: although the penwork is lively, it is carefully calculated and rarely impulsive. Fra Bartolommeo was also a master of black chalk and experimented with drapery studies on linen support that come close to Leonardo's mastery. His drawings were working tools, with one notable exception: the beautiful studies of landscapes made while on retreat outside Florence, which show a spontaneity and an impulsive side of his character rarely glimpsed in his polished paintings and drawings. After Fra Bartolommeo's death, his assistant Fra Paolino inherited the workshop and continued to paint in his master's tradition, using the many surviving drawings as models for paintings.

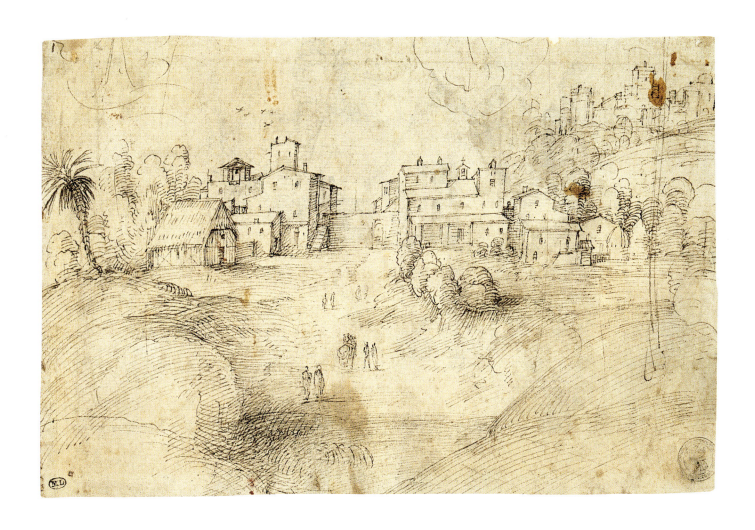

Landscape with houses and a castle, 1510s.
Pen and ink, 133 × 205 mm.
Paris, Louvre, inv. 18645.

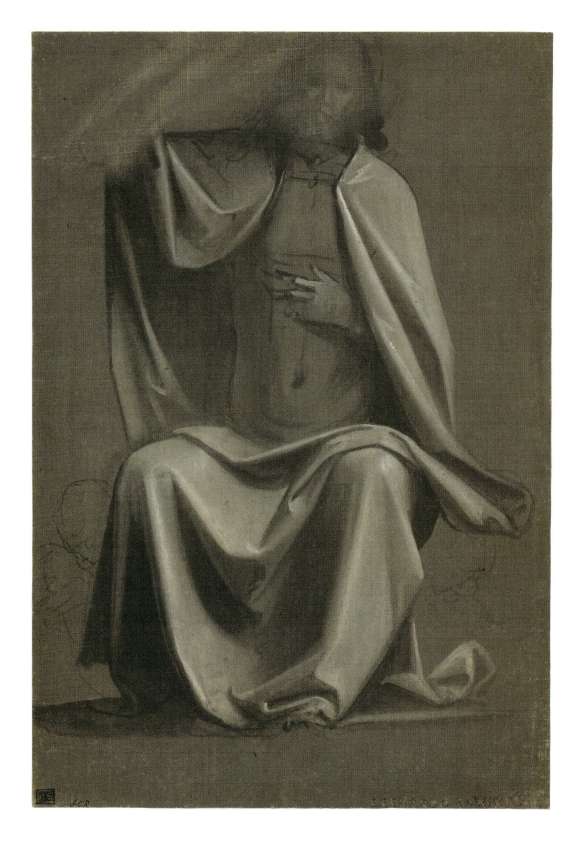

Drapery study for a figure of Christ in the Last Judgement, 1499.
Brush drawing in grey-brown and white distemper on linen tinted dark grey, 307 × 213 mm.
London, British Museum, 1895-9-15-487.

The Annunciation, c. 1500.
Pen and ink, 140 × 138 mm.
Paris, Louvre, RF 5558.

Michelangelo Buonarroti
Caprese 1475–1564 Florence

THE MYTH OF MICHELANGELO began in his own lifetime. He was considered a solitary genius driven by divine inspiration. However, in spite of his undeniable genius, the truth of Michelangelo's life is more prosaic. At the age of twelve he joined the thriving Ghirlandaio workshop around the time of the Tornabuoni commission (pp. 72–5). He later denied this apprenticeship, preferring to be seen as possessing innate talent that required no instruction. This enraged Vasari, who supplied documents proving Michelangelo's ties to Ghirlandaio. The Ghirlandaio brothers instructed Michelangelo in their traditional methods of drawing and gave him grounding in painting techniques. The adept penwork in Michelangelo's study of a *Youth beckoning* (opposite) is redolent of his apprenticeship, but his audacious interpretation of a famous classical statue, the *Apollo Belvedere*, to create a pose of fluid grace goes far beyond his master's teaching.

After about two years Michelangelo left the Ghirlandaio workshop to join an informal school of sculpture set up by Lorenzo de' Medici in his garden near San Marco. Lorenzo quickly noticed Michelangelo's precocious talent and invited him to live with his family. This familiar contact with the Medici was crucial to Michelangelo's career: his youthful companions grew up to be Popes Leo X and Clement VII.

After the death of Lorenzo, Michelangelo pursued a career as a sculptor, first for Lorenzo's heir Piero and then, when the Medici were exiled, in Bologna. By 1495, when he was aged twenty and when the political upheaval in Florence had abated, he had returned home. He sculpted a now lost *Sleeping Cupid* that was so classical in spirit that it was sold as an antique work. The purchaser, Cardinal Riario, soon discovered the

deception but was so impressed by the work that he invited Michelangelo to come to Rome. During this first stay in Rome Michelangelo carved a *Bacchus* and his first masterpiece, the marble *Pietà* now in the Vatican.

The vicissitudes of Michelangelo's career were often due to political upheavals. In 1501 he returned to Florence and was commissioned to sculpt a colossal *David* from an abandoned block of marble. The sculpture was intended for the façade of Florence Cathedral, but the Republican government decided to install it instead outside the Palazzo Vecchio, its seat of power. In around 1504 Michelangelo completed two marble tondos, circular reliefs of the Virgin and Child, as well as the *Doni Tondo*, a round painting of the Holy Family. At the request of Piero Soderini, Florence's new leader, he designed a gigantic mural depicting the *Battle of Cascina* to commemorate a great Florentine victory over the Pisans. The work was meant to be a comparison to Leonardo's *Battle of Anghiari*, but neither painting was completed. Michelangelo never progressed beyond a life-sized cartoon of the central section. This lost work, known as the *Bathers*, caused a sensation because his dynamic representation of male nudes in violent motion was completely unprecedented.

In 1505 Pope Julius II summoned Michelangelo to Rome. Even though he had been in office for barely two years, Julius ordered Michelangelo to design an elaborate tomb. The ensuing project dogged Michelangelo for forty years until a much-reduced and compromised version was finally finished in 1545. Michelangelo's tempestuous nature and his difficult relationship with the fiery Julius crystallized in his famous flight from Rome in 1506. However, such were

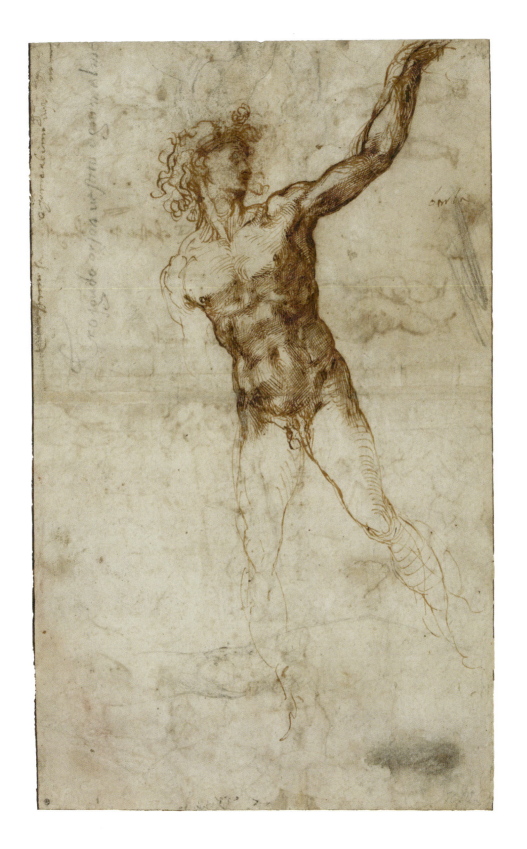

A youth beckoning; a right leg, c. 1504–5.
Pen and ink, black chalk, 375 × 230 mm.
London, British Museum, 1887-5-2-117.

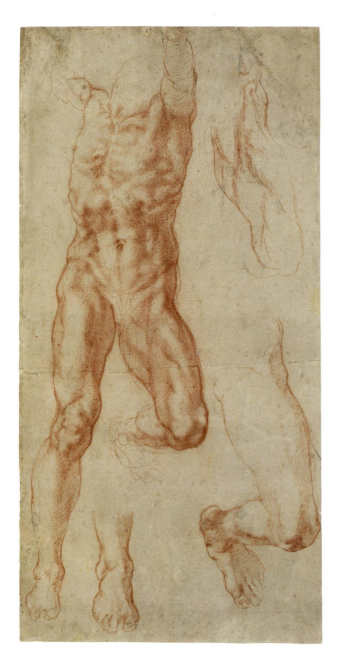

Studies for Haman's torso, 1511–12.
Red chalk, 406 × 207 mm.
London, British Museum, 1895-9-15-497.

Michelangelo's talents that Julius forgave him, deflecting his energies from the tomb to decorating the ceiling of the Sistine Chapel. This was a dynastic project, as the chapel had been built by Julius's uncle Sixtus IV and Michelangelo's ceiling was the pope's chance to leave his stamp on the building.

The drawings made for the Sistine ceiling demonstrate that as Michelangelo tackled this difficult project he stretched his ideas to previously unachieved heights. He drew countless studies from life, often in red chalk. As the studies for *Adam* (opposite) and *Haman's torso* (left) demonstrate, the resulting nudes often focused on details of the bodies and the way in which the light rippled over the muscles. One of the extraordinary innovations of the ceiling design was the *ignudi* or seated male nudes that frame the narrative scenes (pp. 126–7). Michelangelo took his inspiration for these figures from classical statues, adding an elasticity of pose and highly sensual appreciation of the male form that is entirely his own. The resulting figures changed the vocabulary of decorative art for ever.

In 1512 Michelangelo finished the ceiling and in 1513 Julius died. His compatriot Giovanni de' Medici became Leo X, but the new pope preferred Raphael to the difficult Michelangelo. The rivalry between the two artists poisoned the atmosphere of the papal court and Leo was moved to send Michelangelo to Florence to work on Medici projects. This did not end Michelangelo's hostility towards Raphael and, in a bid to undermine the painter's sway in Rome, Michelangelo supplied drawings to the Venetian artist Sebastiano del Piombo. Michelangelo's designs undoubtedly assisted Sebastiano in attracting important commissions, notably from Cardinal Giulio de' Medici, who revelled in pitting Sebastiano against Raphael.

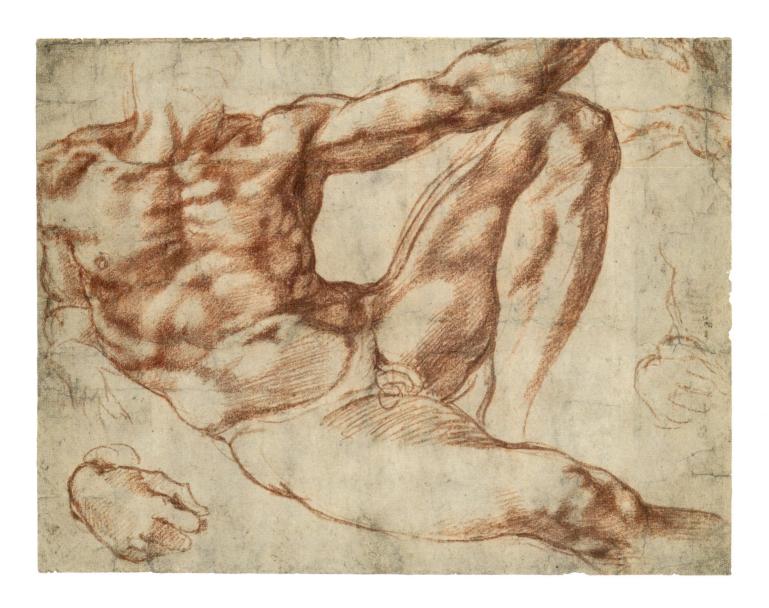

Study for Adam, c. 1511.
Red chalk, 193 × 259 mm.
London, British Museum, 1926-10-9-1.

After Raphael's death Michelangelo continued to supply Sebastiano with drawings. One of their last collaborations was the Ubeda *Pietà* in the 1530s. Michelangelo's exquisite black chalk study of the dead Christ (p. 129) has an affecting power that explains why Sebastiano so prized their friendship.

In 1516 Leo asked Michelangelo to design a façade for the Medici family church, San Lorenzo in Florence. This commission led to a series of Medici commissions at the church, including the Laurentian Library and the Medici tombs in the New Sacristy. These kept Michelangelo busy in Florence until 1534, well into the pontificate of Clement VII.

Vasari wrote that Michelangelo disliked making portraits and such was his stubborn independence that he was rarely obliged to produce them. His haunting drawing of *Andrea Quaratesi* (p. 130) made during this period is a rare exception, a token of his feelings for the well-born Florentine. The idealized *Head of a woman* (p. 131) could date from a similar period. Its high degree of finish, especially in the delicately moulded shading, suggests that it may also have been a present.

In 1533 Sebastiano del Piombo, now a great ally of Clement VII, wrote to Michelangelo that the Pope intended 'to give you a contract for something beyond your dreams', to return to the Sistine Chapel to paint the vast altar wall. Michelangelo initially grumbled about this project because he had resumed work on the Julius tomb, but he soon moved to Rome. Clement died within days of Michelangelo's arrival, but the new pope, Paul III, encouraged Michelangelo to continue. The *Last Judgement*, for which the *Nude seen from behind* (p. 128) is a preparatory study, is a dizzying hierarchy of extraordinary nudes posed in a seemingly infinite number of ways. The close study of the nude

pushing himself upwards is a reflection of the figure's proximity to the viewer at the bottom of the vast fresco. Paul also commissioned Michelangelo to paint another smaller chapel in the Vatican, the Pauline Chapel.

Michelangelo continued to work for another three decades until his death at the age of eighty-eight. In 1546 he was appointed architect to St Peter's, and the supervision of the construction of the new church occupied much of his late career. The study for the dome (opposite), now in Lille, demonstrates the considerable energy Michelangelo devoted to St Peter's and caps his singular career as sculptor, painter and architect. The fact that this is one of only two surviving studies of the dome underlines how many of Michelangelo's late designs must have perished in the bonfires of drawings at the end of his life.

Study for the dome of St Peter's in Rome, late 1550s.
Black chalk with brown wash, 270 × 268 mm.
Lille, Musée des Beaux-Arts, PL 93.

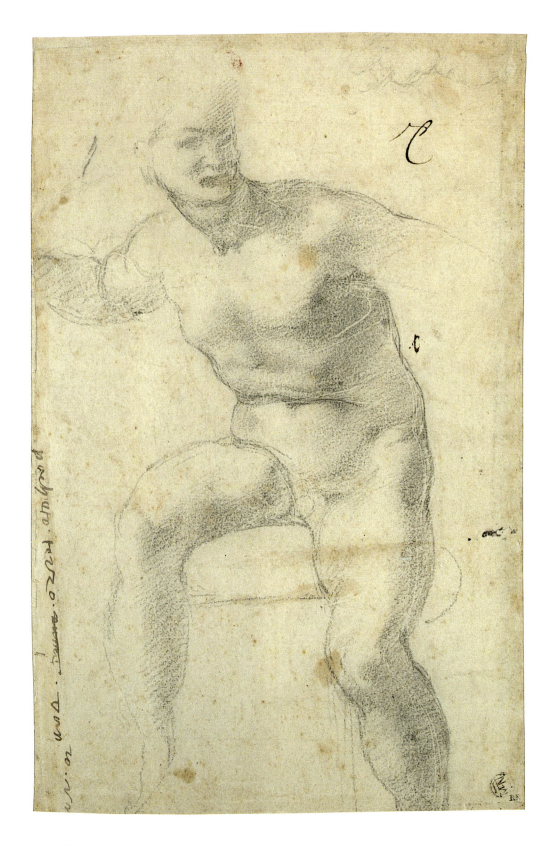

Ignudo, c. 1511.
Black chalk with traces of white over stylus, 308 × 206 mm.
Paris, Louvre, inv. 860 (verso).

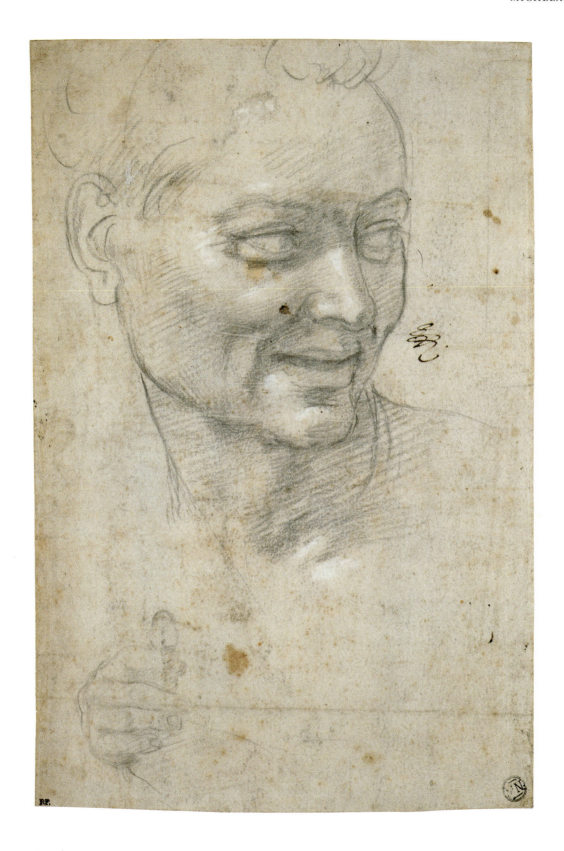

Ignudo, c. 1511.
Black chalk with traces of white over stylus, 308 × 206 mm.
Paris, Louvre, inv. 860 (recto).

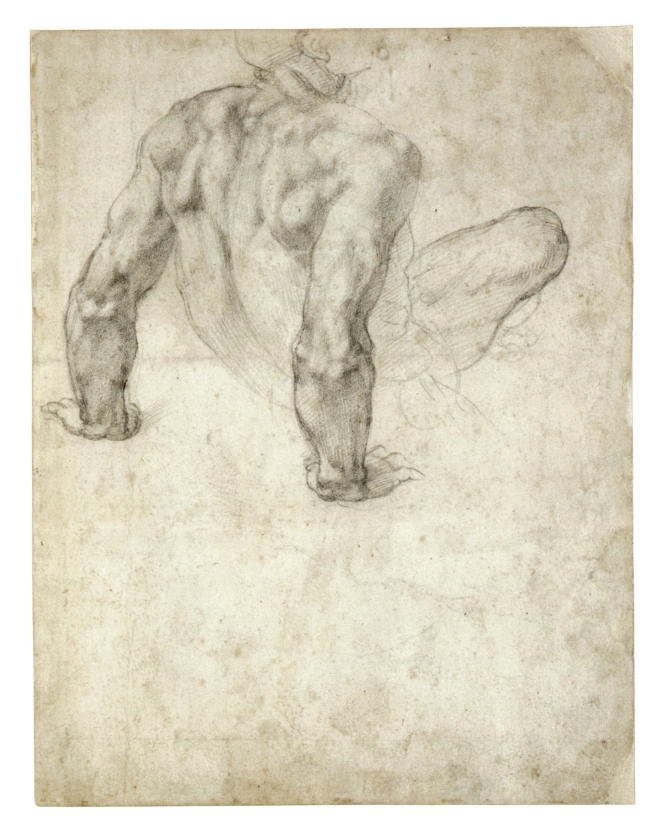

A male nude seen from behind, 1539–41.
Black chalk, 293 × 233 mm.
London, British Museum, 1886-5-13-5.

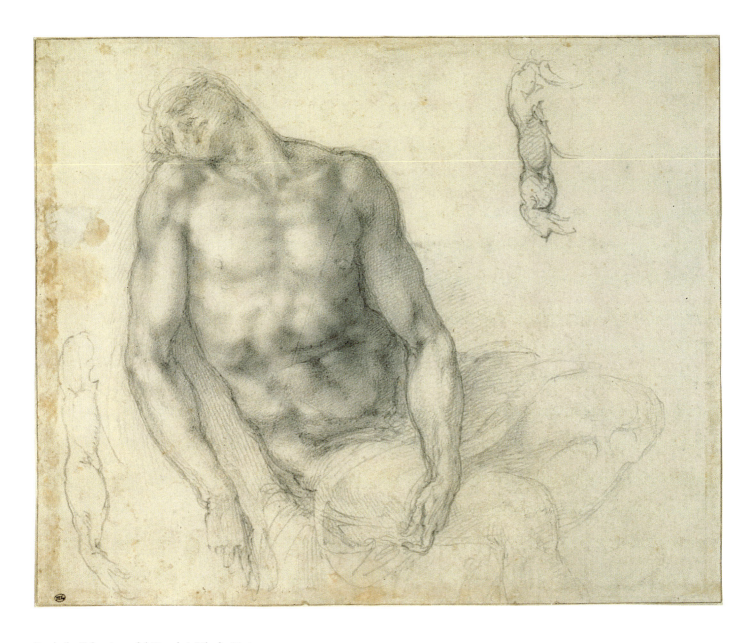

Study for Sebastiano del Piombo's Ubeda Pietà, c. 1533.
Black chalk, 254 × 318 mm.
Paris, Louvre, inv. 716.

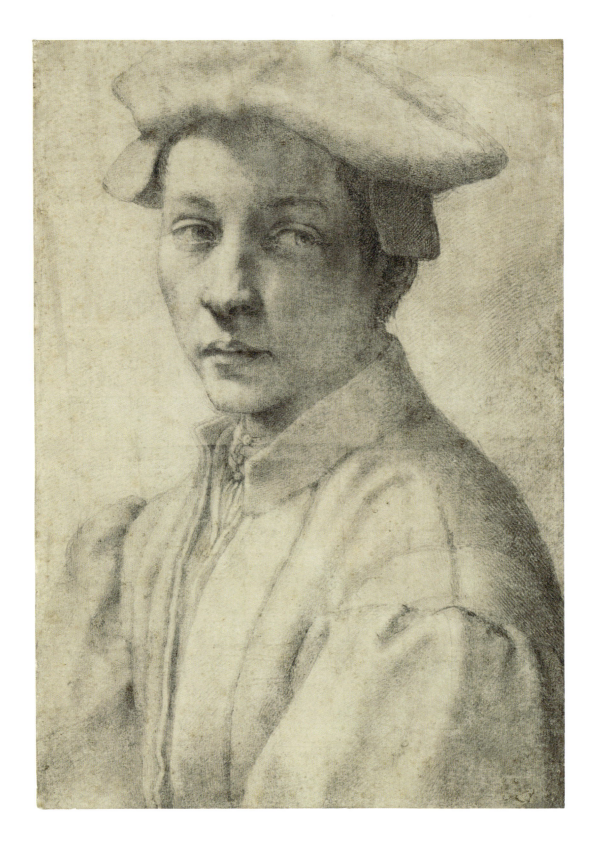

Andrea Quaratesi, c. 1528–32.

Black chalk, 411 × 292 mm.

London, British Museum, 1895-9-15-519.

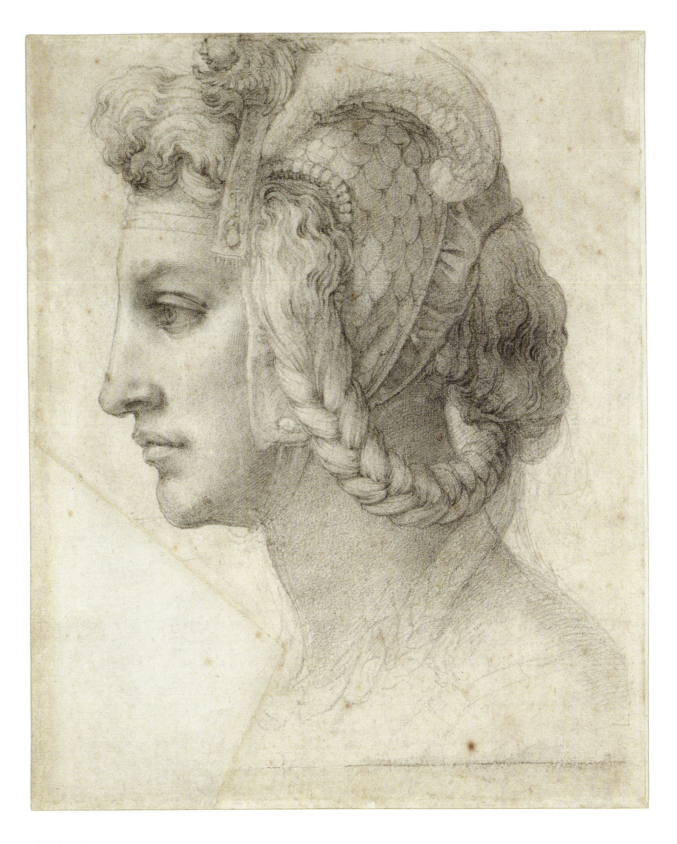

Ideal head of a woman, c. 1525–8.
Black chalk, 287 × 235 mm.
London, British Museum, 1895-9-15-493.

Lorenzo Lotto

Venice *c.* 1480–*c.* 1556/57 Loreto

LOTTO DOES NOT FIT INTO THE PATTERN of Venetian artists. He may have had a traditional apprenticeship with Alvise Vivarini, but this is undocumented and his first recorded works were made in Treviso, not Venice. This early foray into the Veneto was representative of Lotto's entire career. While Giorgione and Titian dominated Venetian art, Lotto worked outside their sphere of influence in the Veneto, the Marches, Lombardy and even the Vatican.

In the early 1500s Lotto was employed by Pope Julius II in Loreto. This association led to the invitation to paint Julius's Vatican apartments alongside Raphael. Most of Lotto's frescoes were removed soon after being painted, but recent restoration of the Vatican *stanze* suggests his intervention in some of Raphael's frescoes. Lotto returned to the Marches and then moved to Bergamo in 1513, where he painted the high altarpiece of the Dominican church. This period in Bergamo was a fruitful and apparently happy one, when he received numerous commissions for altarpieces, portraits, small devotional images, frescoes and even designs for intarsia panels for the choir of Santa Maria Maggiore.

In 1525 Lotto moved back to Venice. Curiously, this move has given us a greater understanding of Lotto's character because of the abundant correspondence between him and the patrons of the still unfinished intarsia panels in Bergamo. The letters detailing the designing of the panels and the quarrels between the patrons and the artist reveal that Lotto had an eccentric, difficult character. It appears that he moved to Venice because of another Dominican commission, but it is telling that, while there, he was not awarded any other large commission. As in Bergamo, he had greater success with portraiture and small devotional images.

The charming atmosphere of an *Ecclesiastic in his study* is typical of Lotto's portraiture. The man may be identified as a cleric by his distinctive *biretta*, a square cap with three flat points, and religious gown. He is surrounded by personal belongings: a comfortable bed, books, various objects of beauty and of daily life, and even a miniature dog on the cushion next to him. The overall impression of these objects is of erudition and luxury. The man himself is caught in the moment when the viewer interrupts his reading. He looks up in surprise and perhaps delight at this intrusion into his private world. Lotto drew this work in the same way that he painted numerous portraits and representations of saints. Rather than depicting a static figure, he put the man into a context that gives a sense of his character and interests.

Lotto's late career is well documented. He divided his time between Venice and the Marches, painting pictures for clients in various places. He signed and dated many of these works, a rare practice for a Renaissance artist. In addition, his private account book for the last twenty years of his life survives. In this book Lotto made notes on his pictures, patrons, friends, costs of supplies and sale prices of pictures. Lotto never married, often argued with relatives, friends and colleagues, and continued his peripatetic life right up to his death in Loreto when he was well into his seventies.

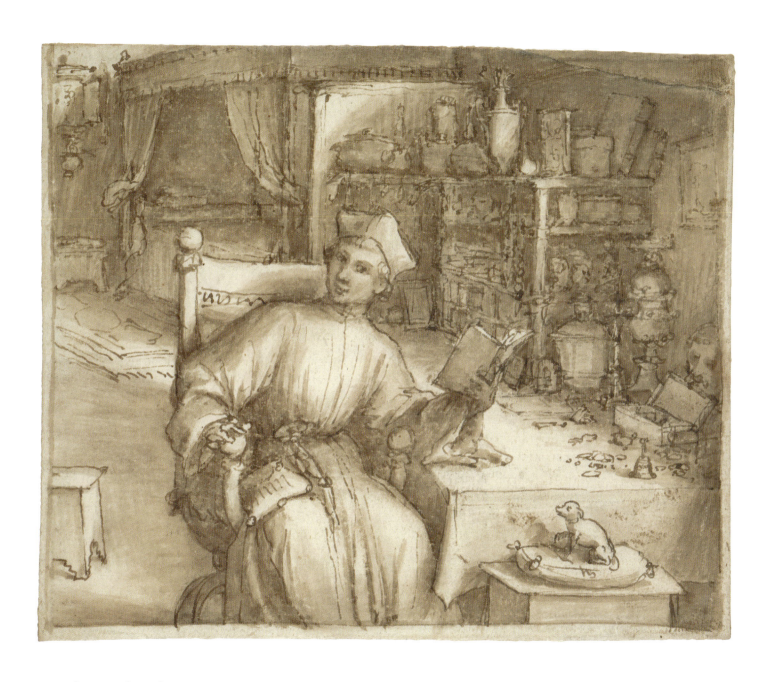

An Ecclesiastic in his study, c. 1530.
Pen and brown wash heightened with white, 162 × 198 mm.
London, British Museum, 1951-2-8-34.

Baldassare Peruzzi
Siena 1481–1536 Rome

BALDASSARE PERUZZI WAS BORN NEAR SIENA and spent his childhood in that city. Little is known of his early training, but like his compatriot Francesco di Giorgio Martini he must have been trained in draughtsmanship, architecture and painting. Also like Francesco, Peruzzi had a profound interest in antiquity and made numerous studies of classical buildings. At the age of twenty-one he settled in Rome to become an architect and painter. The many facets of his career show that he was an erudite thinker and excellent draughtsman, fascinated by geometry and mathematics. He was a pioneer of axonometric drawing, a style of architectural drawing still used today that ignores the usual rules of perspective in order to show each axis of an object.

Peruzzi arrived in Rome in 1502, the last year of Pope Alexander IV's reign, when Roman architecture was reaching new heights of refinement. Donato Bramante (1444–1514) had just shown his command of classical form in the Tempietto at San Pietro in Montorio and would soon be commissioned by the new pope, Julius II, to rebuild St Peter's. Peruzzi's first Roman works were paintings. These led to a commission from the pope to paint the ceiling in the Stanza d'Eliodoro, the room next to Raphael's Stanza della Segnatura. The two artists worked alongside each other in the pope's apartments and their careers remained intertwined for the rest of Raphael's life. During the same period Peruzzi designed the lavish palace on the banks of the Tiber for his compatriot Agostino Chigi, who was also Raphael's great patron.

Commissions for architecture and painting, often in Raphael's footsteps, followed. After Raphael's death in 1520, Peruzzi succeeded him as the architect of St Peter's. He continued to paint and to design buildings,

notably a new façade for the Cathedral of San Petronio in Bologna. During the sack of Rome in 1527, Peruzzi was captured and imprisoned. In an echo of the lives of Fra Filippo Lippi and Parmigianino, Vasari recounts that he was freed by his captors after painting the portrait of one of their captains. He fled to his native Siena, where he remained until 1535 with intermittent trips to Rome to supervise work at St Peter's. After resettling in Rome he continued as architect of St Peter's and completed the Palazzo Massimo alle Colonne. He died the next year and was buried alongside Raphael in the Pantheon.

Vasari praised Peruzzi for his drawings: 'Baldassare drew most excellently in every way with great judgment and diligence, but more in pen with wash and chiaroscuro than in other media.' Peruzzi's style is a true reflection of his multifaceted career. As these three sheets demonstrate, his interest in mathematics and classical architecture permeate his drawings. At the same time, the touches of wash and highlights in the *Adoration of the Magi* (p. 136), as well as the complex composition, testify to the hand of a painter.

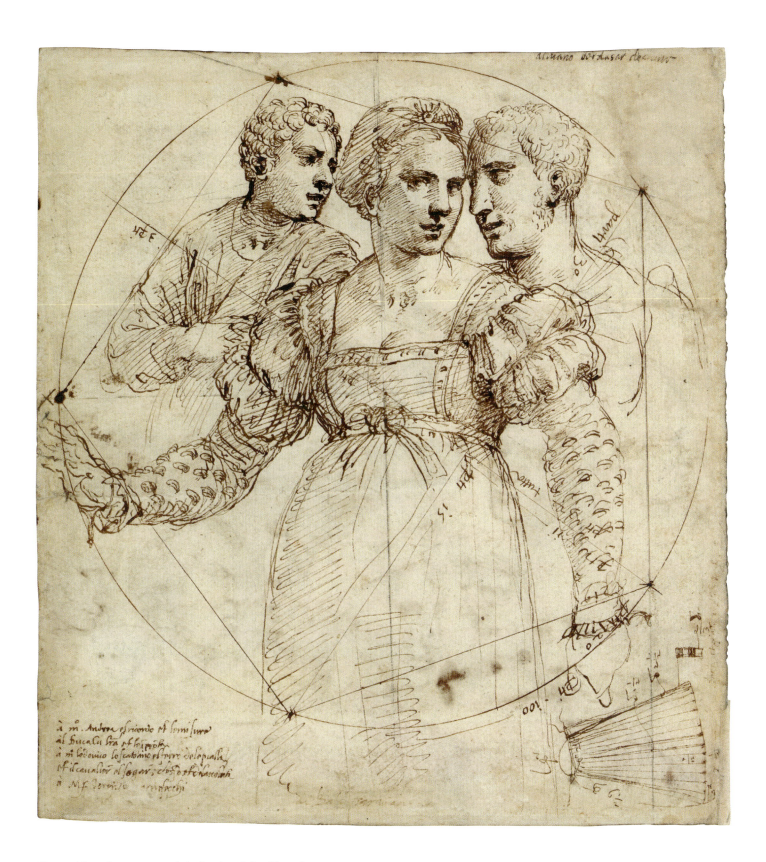

Composition of a woman and the head and shoulders of two men, c. 1511.
Pen and ink, 234 × 216 mm.
London, British Museum, 1874-8-8-22.

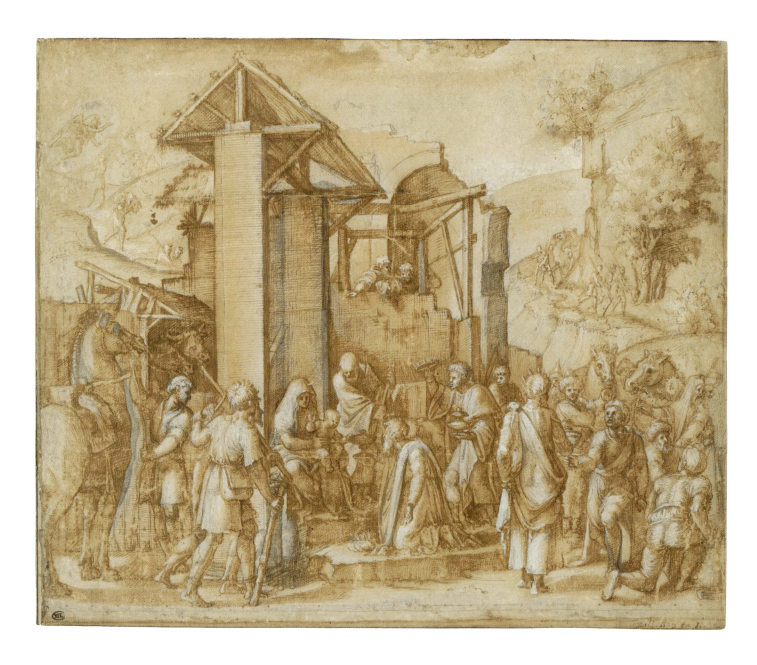

The Adoration of the Magi, c. 1514.
Pen and ink, brown wash and black chalk with white highlighting, 237 × 283 mm.
Paris, Louvre, inv. 1416.

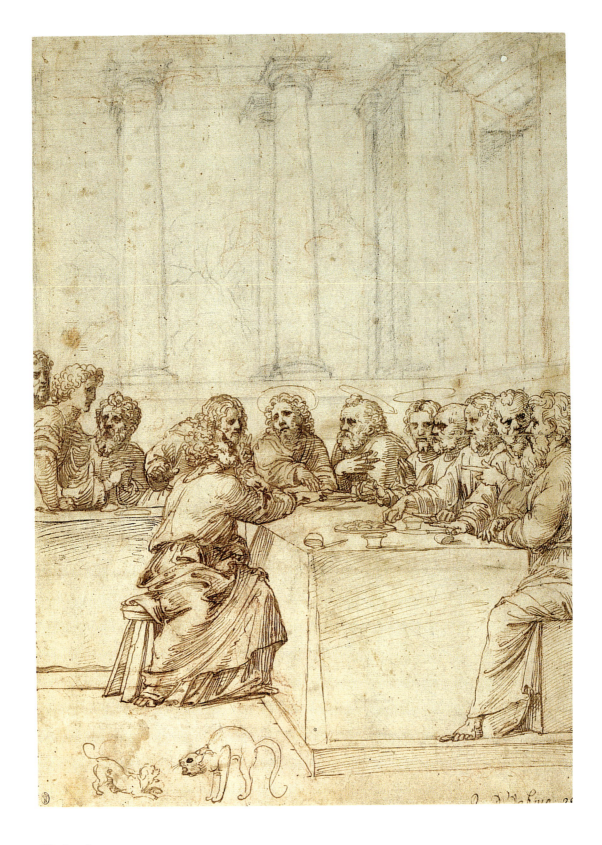

The Last Supper, c. 1517.
Pen and ink, red and black chalks, 340 × 244 mm.
Paris, Louvre, inv. 5634.

Giovanni Antonio de' Sacchis, il Pordenone

Pordenone 1483–1539 Ferrara

GIOVANNI ANTONIO DE' SACCHIS was more commonly known as 'il Pordenone' after the town of his birth. Details of his early life and training are sparse. His date of birth is calculated from Vasari's comment that he died at the age of fifty-six and his documented death in 1539. Vasari certainly got his surname wrong, calling him Liciano, so his information on Pordenone's age could also be unreliable. He is virtually unknown until 1506, when he signed a fresco at Valeriano in Friuli as 'Zuane Antonius de Sacchis' when, if Vasari was anywhere near correct about his age, he would already have been twenty-three years old.

Pordenone's early works, many of which are in the province of Friuli north of Venice near his home town, show an unsophisticated style dependent on the lingering influence of Andrea Mantegna. By the second decade of the sixteenth century, his maturing style demonstrates the increased influence of Giorgione. After 1516 his figures become more monumental. It is thought that this could be due to a trip to Rome, where he came into contact with the works of Michelangelo and Raphael. The hypothesis for this trip is supported by frescoes attributed to Pordenone in Alviano, Umbria, just north of Rome.

The decade of the 1520s was a particularly active one for Pordenone. He worked throughout northern Italy in Mantua, Treviso and – most importantly – in Cremona, where he replaced Girolamo Romanino in the decoration of Cremona Cathedral. The resulting frescoes are Pordenone's masterpieces. They exhibit daring illusionistic perspective, theatrical compositions and dramatic lighting. The splendid red chalk study opposite was made for the *Lamentation*. Pordenone's competent handling of red chalk shows that he was an accomplished draughtsman. The drawing is squared for transfer, implying that it could be a finished design for the fresco. In fact, Pordenone made significant changes to the figure of Christ, whose body is depicted in the drawing in a foreshortened pose derived from a print by the German artist Albrecht Altdorfer (*c.* 1480–1538).

After completing the Cremona frescoes, Pordenone continued to work in various northern Italian centres, especially in Friuli, the Veneto and Venice, where his dramatic frescoes in the Scuola di San Rocco (now destroyed) are said to have been very illusionistic. In the 1530s he worked in Piacenza and Cortemaggiore, where he was influenced by Correggio's works. In 1533 he was as far west as Genoa, where he painted the *Stories of Jason* in the Palazzo Doria (also destroyed). In the Palazzo Doria he would have seen the works of Perino del Vaga.

Unlike many artists who found a successful style and remained true to it throughout their careers, Pordenone was constantly open to fresh influences. He returned to Venice in the mid-1530s and remained there until called to Ferrara by Duke Ercole II d'Este. He died there unexpectedly, according to Vasari under the suspicion of poisoning.

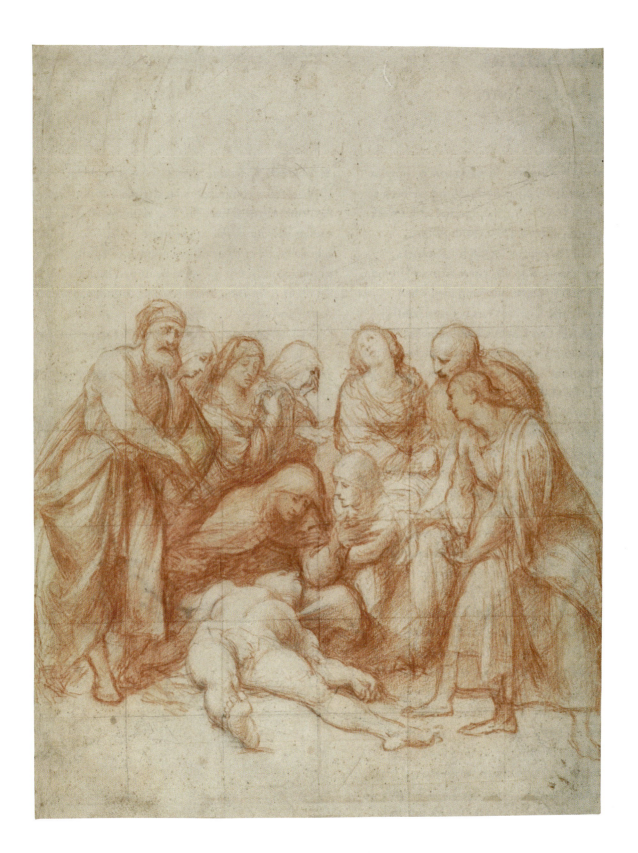

The Lamentation, 1520–1.
Red chalk over stylus, 368 × 278 mm.
London, British Museum, 1958-2-8-1.

Raphael Sanzio
Urbino 1483–1520 Rome

RAPHAEL'S ARTISTIC FORMATION is complex. He is traditionally considered to have been a pupil of Pietro Perugino, but in fact his work with Perugino post-dates his first commissioned painting. It would have been logical for Raphael's father, Giovanni Santi, who was court artist in Urbino, to have taught him to paint, but Santi died when Raphael was only ten. The six years between Santi's death and Raphael's first commission, undoubtedly a critical moment in his education, remain unclear. What is evident is that Raphael had an exceptional artistic eye and a great gift for absorbing the styles of other artists and adapting them to his own means.

In 1500, when he was only thirteen years old, Raphael and another painter from his father's workshop received a commission for an altarpiece in Città di Castello. Two years later Raphael moved to Perugia and came into contact with Perugino's workshop when the painting of the Cambio was under way. Raphael did not stay in Perugia for long and by 1504 had moved on to Florence. He arrived at an opportune moment to learn: Fra Bartolommeo was painting at San Marco, Perugino was about to tackle the Annunziata *Deposition*, Michelangelo had finished the colossal *David* and the *Doni Tondo*, and Leonardo had just returned. Michelangelo and Leonardo, rarely resident in Florence at the same time, were occupied with designing battle murals for the Palazzo Vecchio. Raphael remained in Florence for four years until he was called to Rome by Pope Julius II to work in his private apartments in the Vatican. For the rest of his career Raphael dominated the arts in Rome, his pre-eminence curtailed not by a rival but by his untimely death on his thirty-seventh birthday.

The double-sided drawing for the *Coronation of*

St Nicholas of Tolentino (pp. 142–3) was made for Raphael's first commission, an altarpiece in Sant' Agostino, Città di Castello. The recto drawing of figure studies laid out in the composition is characteristic of Raphael's ability to develop a number of figures simultaneously. On the verso he turned his focus to details of a head and draperies. The confidence of the design and beautiful execution of the head show precocious talent from the thirteen-year-old artist. The

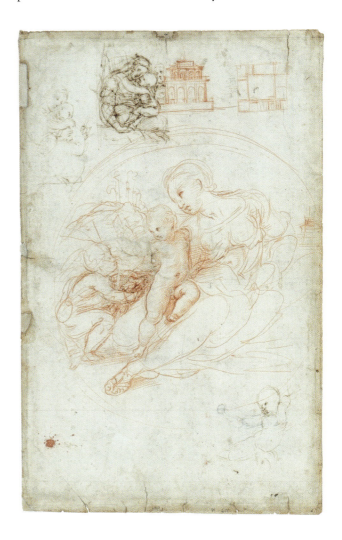

Studies for the Alba Madonna (see opposite), recto.

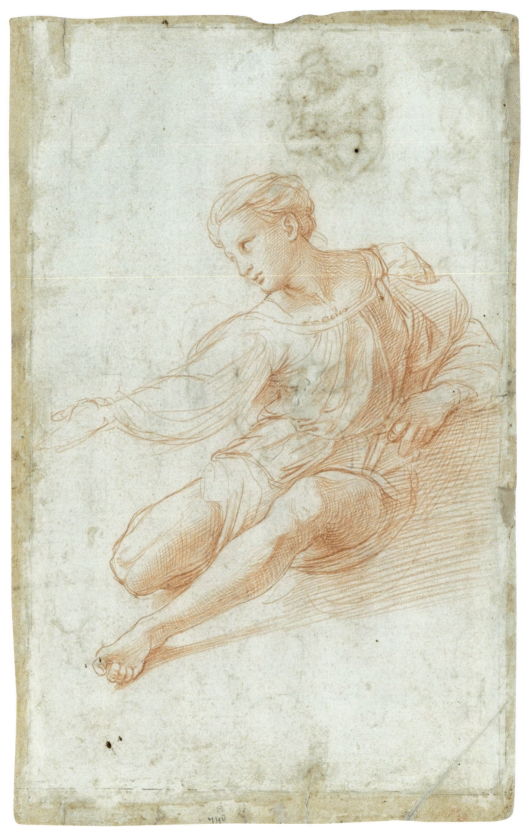

Studies for the Alba Madonna, c. 1509–11.
Red chalk, 422 × 273 mm.
Lille, Musée des Beaux-Arts, PL 457 (verso).

choice of black chalk, a medium traditionally used as a preparatory tool, may have been influenced by Signorelli's dynamic drawings, which Raphael could have seen in Città di Castello.

In Florence Raphael established his reputation by painting a series of Virgin and Child compositions inspired by the new art he was studying. The three examples in this selection are illustrative of Raphael's development of these small devotional images, both in Florence and later in Rome. The spirited page of pen and ink sketches of the Virgin and squirming Child (p. 145) reveal Raphael's response to Leonardo. Both sides of the sheet are covered with rapid sketches reminiscent of Leonardo's *Virgin and Child with a cat* (pp. 90–1), where the creative ideas seem to spill directly out of the artist's mind and onto the page. The metalpoint *Heads of the Virgin and Child* (p. 145) was drawn in a more traditional and stiffer medium, but Raphael was able to use it to convey a naturalistic, tender expression. The double-sided sheet for the *Alba Madonna* (pp. 140–1), especially the sweeping figure of the Virgin sketched on the recto and refined on the verso, reflects Raphael's response to Michelangelo's *Doni Tondo*.

The most important lesson Raphael learned in Florence was to incorporate movement into his compositions. The *Entombment* and the *St Catherine*, both painted in around 1507, reflect this transformation. Raphael's numerous drawings for the *Entombment* show its development from a static composition dependent on Perugino to an energy-filled narrative that captures figures in motion. The London drawing (p. 146) comes from a late moment in the evolution of the composition, when Raphael was working out the dynamism of the figures: note the way Raphael expresses the strain of the two men who bear

the heavy weight of Christ's body. In the *St Catherine* (p. 147), a cartoon for the painting (National Gallery, London), the sinuous curve of the saint's body harks back to classical sculptures of Venus but is infused with vigour inspired by the Virgin in Michelangelo's *Doni Tondo*.

Raphael's promise was recognized by Julius II's call to Rome to decorate his private library. This was the beginning of the artist's meteoric rise at the papal court,

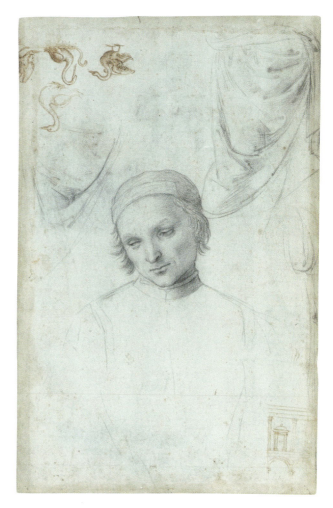

Study for the altarpiece of St Nicholas of Tolentino (see opposite), verso.

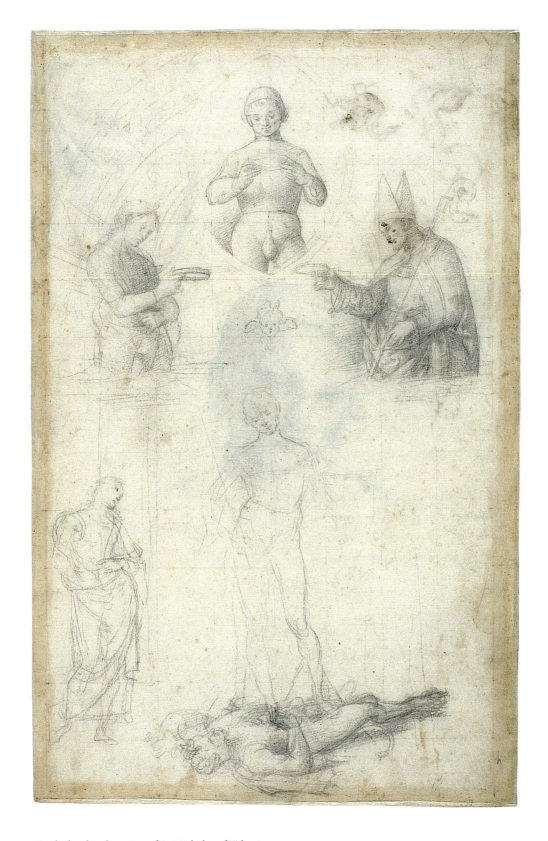

Study for the altarpiece of St Nicholas of Tolentino, 1500.
Black chalk over stylus with some pricking and squaring (recto) and black chalk with pen and ink
(verso), 394 × 263 mm. Lille, Musée des Beaux-Arts, PL 474 (recto) and 475 (verso).

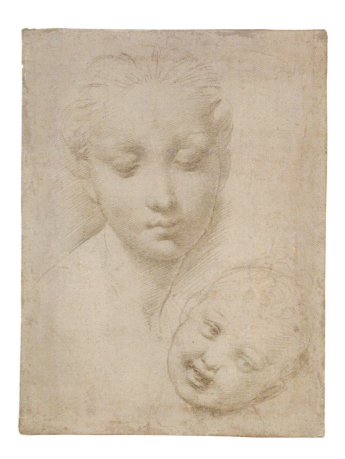

Heads of the Virgin and Child, 1504–8.
Metalpoint on pink prepared paper, 143 × 110 mm.
London, British Museum, 1866-7-14-79.

which inflamed Michelangelo's jealousy. The first scene that Raphael designed was the *Dispute of the Holy Sacrament*, known simply as the *Disputà*. Perhaps because this was his first work in the Vatican, he drew many sketches for the scene (Fig. 22). Surviving examples show that he made a combination of drawings of individual figures, groups of figures and the entire composition. As in the designs for the *Entombment*, their evolution shows how he moved from a static design to one of far greater animation. The London drawing (p. 148) is a study of the lower left portion of the composition. The application of white with the point of a brush on the figure ascending the stairs shows that Raphael was working on the lighting as well as the placement of the figures. The careful attention he paid to the designs for the *Disputà* yielded good returns. For the next eighteen years he was indispensable to Julius and his successor Leo X not only as a painter, but also as a designer of tapestries, architect of St Peter's and even procurer of antiquities.

Equally important to the patronage of these two popes was that of Agostino Chigi, the fabulously rich Sienese banker. Raphael designed two chapels for Chigi, including his burial chapel in Santa Maria del Popolo and another family chapel in Santa Maria della Pace, plus frescoes for his villa alongside the River Tiber. The *Sibyl* (p. 149) was drawn for Santa Maria della Pace and shows the strong influence of Michelangelo's recently unveiled Sistine ceiling. Raphael's ability to adopt Michelangelo's style and make it his own doubtless underlay the sculptor's hatred of his younger rival. The *Sibyl*, drawn in red chalk like Michelangelo's *Adam* and *Haman*, was strongly influenced by the *ignudi* and sibyls surrounding the narrative scenes on the ceiling.

At the end of his life Raphael was head of a hugely productive workshop that nurtured Giulio Romano, Polidoro da Caravaggio and Perino del Vaga. As he became ever busier with an increasing variety of projects, Raphael delegated more and more work to his assistants. He maintained consistent quality by remaining chief designer, and drawing was therefore the foundation of his immensely successful career.

Studies for the Virgin and Child, 1504–8.
Pen and ink with faint traces of underdrawing in red chalk, 254 × 184 mm.
London, British Museum, Ff. 1-36.

Study for the Borghese Entombment, 1507.
Pen and ink with traces of underdrawing in black chalk, 230 × 319 mm.
London, British Museum, 1855-2-14-1.

Cartoon for St Catherine of Alexandria, c. 1507.
Black chalk, 587 × 436 mm.
Paris, Louvre, inv. 3871.

Study for the left side of the Disputà in the Stanza della Segnatura, 1508.
Pen and ink with wash over stylus, some white heightening, 247 × 401 mm.
London, British Museum, 1900-8-24-108.

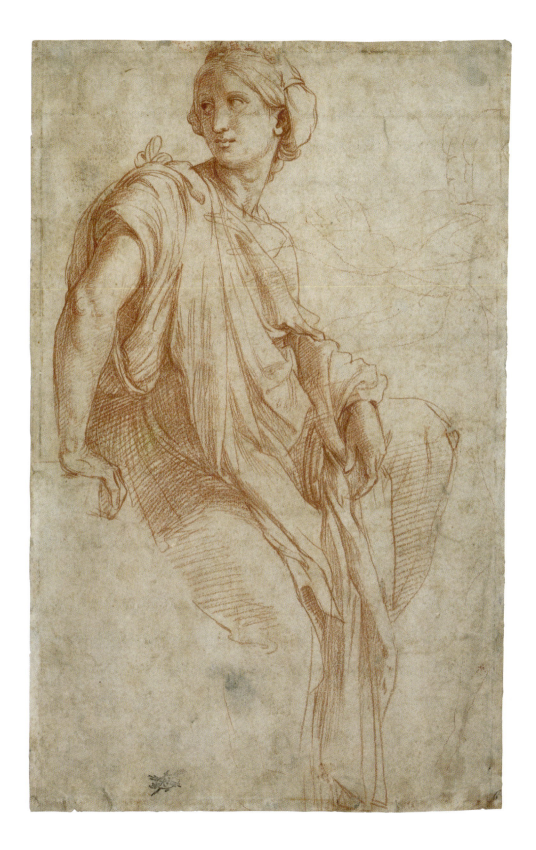

Study for the Phrygian Sibyl in Santa Maria della Pace, 1511–12.
Red chalk over stylus, 262 × 167 mm.
London, British Museum, 1953-10-10-1.

Sebastiano Luciani, *called* Sebastiano del Piombo

Venice *c.* 1485–1547 Rome

SEBASTIANO IS KNOWN AS A PAINTER of the Roman school, even though he was born and trained in Venice and habitually called himself Sebastiano Veneziano. Facts pertaining to his origins are murky, but emphasis on atmosphere and colour in his early pictures demonstrates that he was a close colleague of Giorgione. In 1511 Agostino Chigi brought Sebastiano from Venice to Rome and from then on his career is well documented. Sebastiano set to work in the villa designed for Chigi by Baldassare Peruzzi, but the results were not successful. His struggle to adapt to the dynamism of the Roman style and his unfamiliarity with working in fresco combined to make the *Polyphemus* an unimpressive debut. Raphael's graceful *Galatea* in the same room further emphasizes the weaknesses of Sebastiano's fresco.

Sebastiano's strengths lay in oil paint, not fresco, and the tranquil, poetic harmony of his Venetian style was ill adapted to competing with the grandeur of Raphael and Michelangelo. Fortunately for him, his arrival in Rome coincided with Michelangelo's mounting jealousy of Raphael. Michelangelo began to supply Sebastiano with drawings in the hope that the Venetian's painterly style combined with his own dynamic nudes would win commissions from Raphael. This led to three collaborations between 1513 and 1520: the *Pietà* for San Francesco in Viterbo, the *Flagellation of Christ* for the Borgherini Chapel at San Pietro in Montorio and the *Raising of Lazarus* for Cardinal Giulio de' Medici. Sebastiano profited from this partnership by gaining new patrons and by strengthening his own style. The monumentality of his *Standing female nude* (opposite), a study for the *Martyrdom of St Agatha* (Galleria Palatina, Florence), demonstrates how Sebastiano's extraordinary access to

Michelangelo's drawings affected his own graphic style. In the vacuum created by Raphael's death, Sebastiano became the city's pre-eminent painter. When Giulio de' Medici was elected Clement VII in 1523, Sebastiano was in an ideal position to gain favour from the new pope.

The sack of Rome in 1527 by the army of the Holy Roman Emperor was catastrophic for the pope as well as for artistic activity in Rome. Sebastiano briefly fled to Venice, but returned to Rome in 1529, apparently out of loyalty to Clement. This sentiment is expressed clearly in the drawing of *Clement VII and Charles V in Bologna* (p. 152), which turns reality on its head by showing the pope as the commanding figure in the negotiations with his imperial conqueror. In the autumn of 1531 Clement gave the papal office of the Piombo, the lead papal seal, to Sebastiano. The large salary this bestowed apparently made the indolent Sebastiano reluctant to paint. He collaborated with Michelangelo for the last time on the Ubeda *Pietà*, painted in around 1533 (see p. 129). The two men fell out soon after Michelangelo's return to Rome in 1534, marking the end of their long collaboration and friendship.

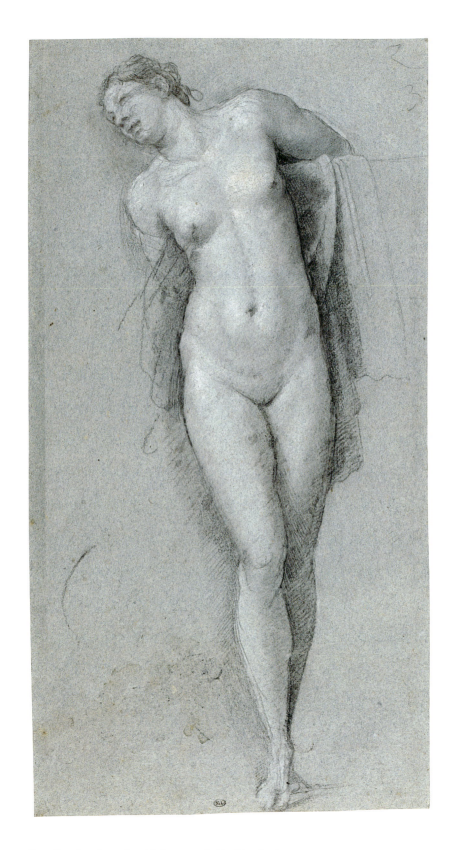

Standing female nude with her arms behind her back, 1517–19.
Black chalk with white highlighting on blue paper, 355 × 188 mm.
Paris, Louvre, inv. 10816.

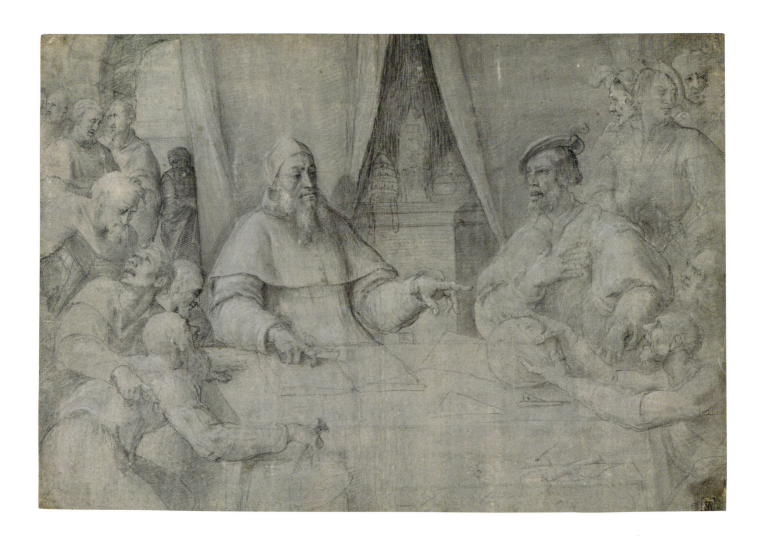

Clement VII and Charles V in Bologna, 1529.
Black and white chalks on grey-washed paper, 310 × 462 mm.
London, British Museum, 1955-2-12-1.

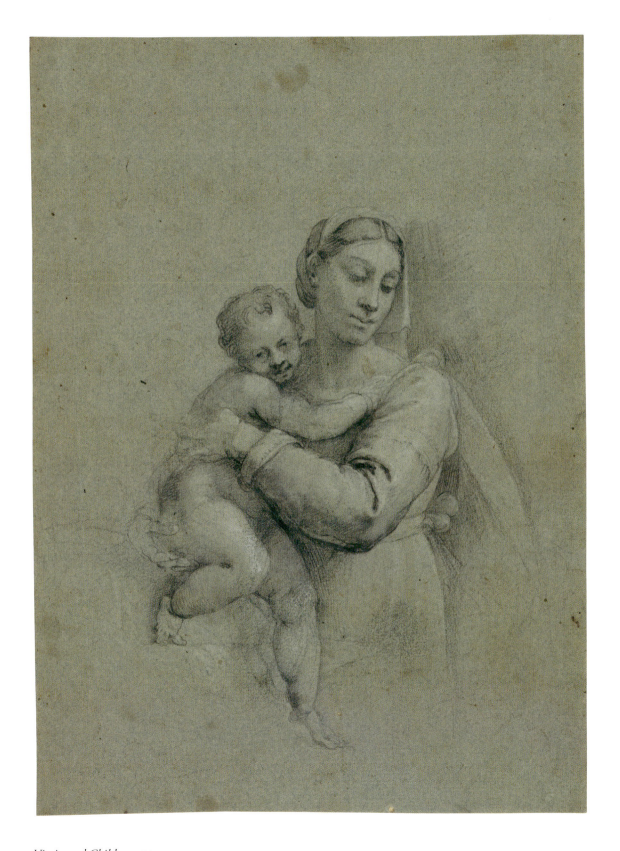

Virgin and Child, c. 1530.
Black chalk heightened with white on blue-grey paper, 245 × 188 mm.
London, British Museum, 1974-9-14-1.

153

Andrea del Sarto

Florence 1486–1530 Florence

As his name implies, Andrea del Sarto (Andrea of the tailor) did not come from artistic stock. His earliest education was with a goldsmith, but eventually he was apprenticed to a painter and ended up in the studio of Piero di Cosimo. Vasari writes that during his free time Andrea would join the crowd of young artists making sketches after Leonardo and Michelangelo's famed battle pieces in the Palazzo Vecchio. By 1508, when Andrea was twenty-two years old, he had become an independent painter.

Andrea received his first important commission from the Servites to paint scenes from the life of Filippo Benizzi, the spiritual founder of the order, in the entrance court of their pilgrimage church of Santissima Annunziata. The frescoes were finished in 1510 and their success led to two further commissions in the same cloister, a *Procession of the Magi* completed in 1511 and the *Birth of the Virgin* completed in 1514. In around 1512 Andrea began work on frescoes of the life of St John the Baptist in the Chiostro dello Scalzo, the entrance to the chapel of the Disciplinati, a Florentine confraternity dedicated to the patron saint of the city. The frescoes were made in grisaille, a method of painting in monochrome to mimic relief sculpture. Andrea's first concentrated burst of activity in the cloister was from 1515 to 1517. Numerous interruptions delayed the completion of the frescoes, so that the cloister is an interesting indicator of the development of Andrea's style.

In 1515 Andrea contracted to paint a high altar for the convent of San Francesco de' Macci. Commonly called the *Virgin of the Harpies* because of the mythological figures adorning the Virgin's pedestal, the picture shows the Virgin and Child flanked by Sts Francis and John the Evangelist. The painting (now in the Uffizi, Florence) is representative of Andrea's restrained yet lyrical style at this date. Vasari praised the picture: in particular he cites the feet of St Francis as marvellous. Vasari was undoubtedly familiar with Andrea's black chalk drawing of *A hand and two feet* (opposite) made as a study for the figure of St Francis, because the sheet was once part of his *Libro de' Disegni*.

Andrea remained in Florence for most of his life, with the notable exception of a year spent in the service of François I during 1518–19. While in France he painted a number of pictures, including the *Charity* now in the Louvre. Back in Florence, he resumed painting in the Scalzo and accepted many new commissions. The engaging red chalk studies of a child (p. 156) were drawn in around 1520 for an altarpiece of the *Virgin and Child with the infant St John the Baptist* (Wallace Collection, London). He finally painted the last scene of the *Birth of John the Baptist* in the Scalzo in 1526. The elongated figures of the red chalk study for this composition (p. 157) are typical of Andrea's invention drawings. Vasari praised Andrea as 'free from errors and absolutely perfect in every respect'. It is this perception of perfection that has led scholars to consider Andrea and Fra Bartolommeo as the summit of Renaissance art in Florence. The harmonious, measured balance of Andrea's style was challenged by the next generation of Florentine painters, Pontormo and Rosso, who pushed art to another level.

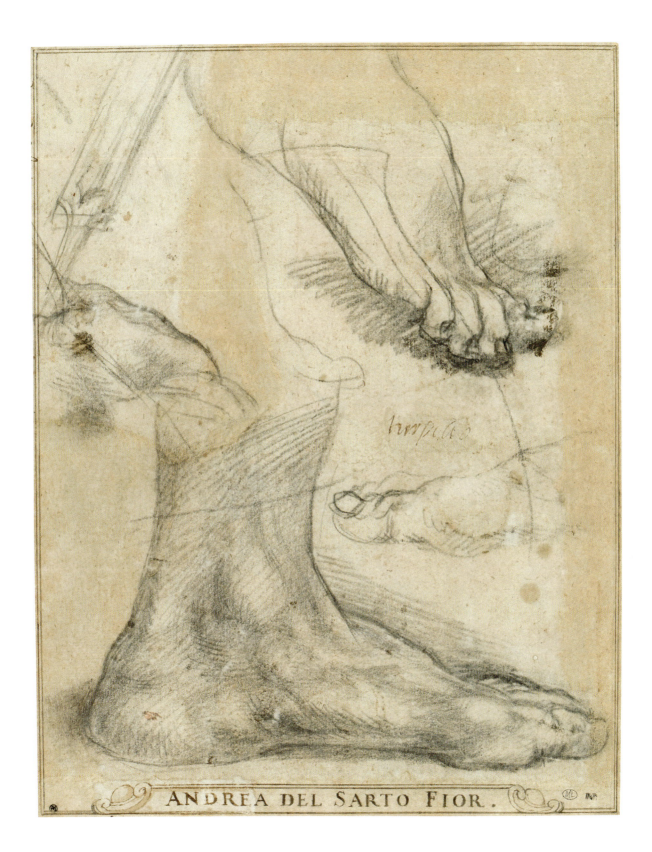

Studies of a hand and two feet, 1515.

Black chalk, 280 × 220 mm.

Paris, Louvre, inv. 1679.

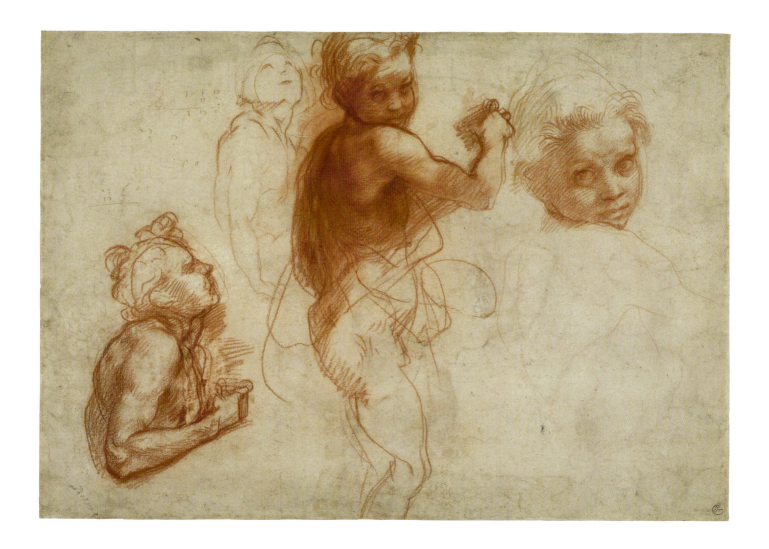

Four studies of a child, c. 1520.
Red chalk with some red wash, 255 × 372 mm.
London, British Museum, 1896-8-10-1.

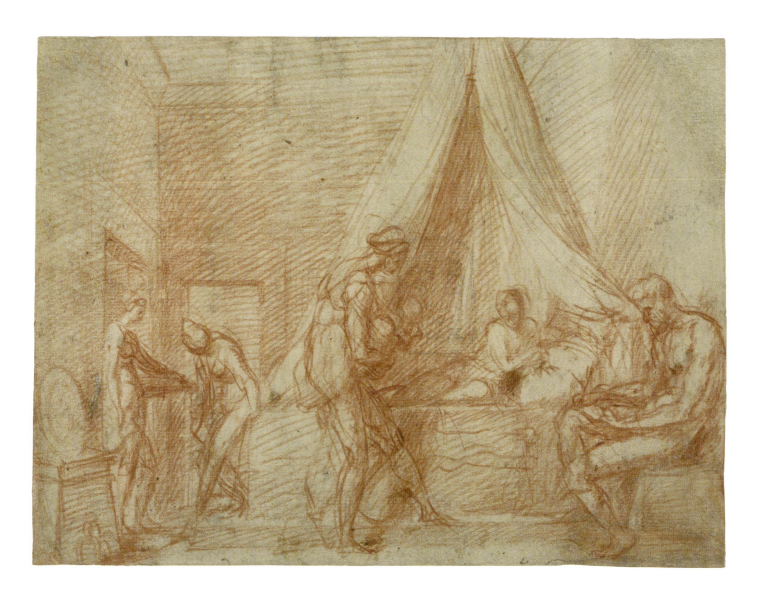

The Birth of St John the Baptist, c. 1520–6.
Red chalk, 164 × 222 mm.
London, British Museum, SL 5226-86.

Tiziano Vecellio (Titian)
Pieve di Cadore *c.* 1488/90–1576 Venice

Tᴛᴛᴀɴ's ᴇᴅᴜᴄᴀᴛɪᴏɴ was profoundly Venetian. At around the age of eight he was apprenticed to Gentile and then to Giovanni Bellini. By 1506 he had moved to the workshop of Giorgione, who had himself been one of Giovanni's pupils. Titian quickly picked up Giorgione's expressive use of colour and monumental figures and, according to early accounts, rapidly surpassed his master when in 1508 they worked side by side on the Fondaco dei Tedeschi, the German merchant's warehouse on the Grand Canal. Giorgione's death in 1510 should have left Titian as the pre-eminent painter in Venice, but their old master Giovanni Bellini, who was then in his eighties, continued to dominate Venetian painting until he died in 1516.

By 1520 Titian's youthful style had matured in his huge and majestic paintings of the *Assumption of the Virgin* and the *Virgin of the Pesaro Family* in the church of the Frari. These works are notable for their daring compositions, intense colours and expressive brushwork. In tandem with these great altarpieces, Titian was also proving himself as an important painter of mythological and historical scenes. His *Battle of Cadore* in the Doge's Palace was a monumental work of movement and power but, like all the old paintings in the palace, it perished in the devastating fire of 1577. By 1530 Titian had made a lasting imprint on the vocabulary of Venetian art and his fame spread wide, attracting wealthy patrons from across Europe.

In the 1540s Titian was working on canvases of reclining female nudes such as the *Venus of Urbino* and the *Danaë*. The latter was painted for a kinsman of the Farnese pope Paul III and was displayed in the Vatican when Titian visited Rome. Vasari used the *Danaë* to illustrate the contrast between his hero Michelangelo and the Venetian, whom he considered to be deficient in *disegno*. Without a doubt, Michelangelo's strong emphasis on drawing is the opposite of Titian's brilliance with colour, but Vasari's bias in favour of Florentine artists did not take into account the huge fame that Titian had achieved by this date.

While in Rome, Titian painted a portrait of Paul III – a type of painting that could not be compared with Michelangelo's work as the Florentine resolutely avoided portraiture. The visit also led to an introduction to Emperor Charles V, who invited Titian to paint at his imperial court. As court artist Titian painted numerous works, including the outstanding equestrian portrait of Charles and a series of lyrical mythological paintings called *poesie* for Philip II, the emperor's son and king of Spain.

If Titian did make preparatory drawings, remarkably few survive and there is much dispute over his activities as a draughtsman. The drawing illustrated here has a good claim to be by him, as the expressive line and range of tone is suggestive of his painterly style. When viewed alongside Jacopo Bellini's meticulous drawing of the same subject (p. 43), the progress of Venetian art in the fifteenth and sixteenth centuries is immediately apparent.

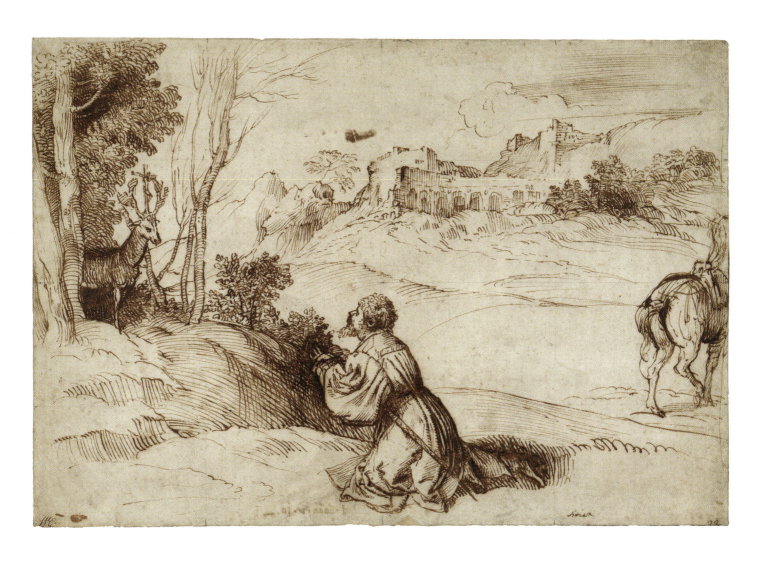

St Eustace or St Hubert in a landscape, 1518–22.
Pen and ink, lightly squared for transfer, 216 × 316 mm.
London, British Museum, 1895-9-15-818.

Antonio Allegri, il Correggio

Correggio *c.* 1489–1534 Correggio

THE CAREER OF ANTONIO ALLEGRI, called Correggio after the place of his birth, centred on his home town and nearby Parma. In his youth he travelled to Mantua and perhaps to Rome, but in contrast to many of his contemporaries, he seemed content to remain in a provincial centre. This led Vasari to criticize him, but with hindsight it may be argued that the history of painting is richer because Correggio developed a unique style.

No single artist stands out as Correggio's teacher. In fact Correggio and Parma were places where outsiders, not local talent, dominated important commissions. It is therefore not surprising that Correggio's earliest works were influenced by a variety of artists, notably Leonardo, who was in Milan from 1484 to 1499, and Mantegna, who was alive until 1506. In addition, the Bolognese artist Francesco Francia (*c.* 1450–1517) and the Ferrarese Lorenzo Costa (*c.* 1460–1535) made an impact on Correggio. Correggio's frescoes in the vault of the Camera di San Paolo, Parma, of 1519 are seen as the turning point from his youthful to his mature style. Echoes of Michelangelo and Raphael have led scholars to conclude that he must have travelled to Rome before designing them. He painted the vault with playful putti peering through fictive oval apertures above illusionistic lunettes with grisaille paintings of classical sculpture. The soft colours and atmospheric lighting of these frescoes are hallmarks of Correggio's work.

Correggio remained in Parma for the next ten years, where he was engaged on the two most important projects of his career. At San Giovanni Evangelista he painted the dome, the apse, the choir and the nave of the church. This enormous project occupied Correggio from 1520 to 1524, taxing his imaginative powers unlike any previous work. He made countless drawings, including two of those illustrated here (pp. 160–1), that examine possible solutions for the dome and its pendentives. The subtle tonality of the red chalk *Study of two apostles* demonstrates how Correggio was working out the positions of the apostles as well as their lighting. The figure on the right appears as St Peter in the vault, but his companion was much altered between this drawing and the painting. Similarly, the pendentive depicting Sts Mark and Gregory was developed from the pen and ink sketch of two draped figures seated on clouds. The rapid strokes of the pen are evocative of the flow of the artist's ideas. The drawing was probably squared for transfer to another sheet for further work.

The triumph of the paintings at San Giovanni Evangelista led to the commission to paint the dome, apse and choir vault of Parma Cathedral, an undertaking that occupied Correggio from 1522 to the end of the decade. The swirling mass of figures in the *Assumption of the Virgin* painted in the dome pushed the boundaries of illusion and movement that Correggio had explored in San Giovanni. The provocative, fleshy red chalk study of Eve offering the apple (opposite), designed for the spiral of figures who welcome Mary into heaven, is the epitome of Correggio's genius: no painter before him had made such a sensual connection between subject and viewer.

Eve holding the apple: study for the cupola of Parma Cathedral, 1522–30.
Red chalk with white highlighting, 116 × 104 mm.
Paris, Louvre, RF 499.

Sts Mark and Gregory seated on clouds, 1520–4.
Pen and brown ink with wash over chalk, squared for transfer, 130 × 155 mm.
Paris, Louvre, inv. 5968.

Study of two apostles for the dome of San Giovanni Evangelista, 1520–4.
Red chalk with white highlighting, 208 × 277 mm.
Paris, Louvre, inv. 5970.

Giulio Pippi, *called* Giulio Romano
Rome *c.* 1492/99–1546 Mantua

Fra Angelico, Pintoricchio, Filippino Lippi, Michelangelo and Raphael helped to shape Roman painting during the fifteenth and early sixteenth centuries, but no major Roman painter was born in the city before Giulio Romano. Giulio entered Raphael's orbit in late 1515 or early 1516 at the moment when the Stanza d'Eliodoro was complete, work had commenced on the Stanza dell' Incendio and the tapestries for the Sistine Chapel, and Raphael had been appointed architect of St Peter's. Giulio may have received some artistic training before joining Raphael, for he swiftly rose to the position of chief assistant in the bustling workshop of the pope's favourite artist. The tender red chalk study of the *Virgin and Child* (opposite) captures Giulio's early style under the influence of Raphael. It is reminiscent of Raphael's own paintings of the Virgin, especially the *Madonna della Sedia* painted *c.* 1513–14 (Galleria Palatina, Florence).

Within the workshop Giulio was responsible for implementing Raphael's overall designs and contributing his own drawings for details in the many Vatican projects or Agostino Chigi's Loggia. The large team of painters, including Gianfrancesco Penni (*c.* 1496–1528), Perino del Vaga, Giovanni da Udine (1487–1564) and Polidoro da Caravaggio, appears to have been a tight-knit group. The sudden death of Raphael at the age of thirty-seven and at the height of his career must have been a devastating blow to the members of his workshop.

Giulio and Gianfrancesco Penni inherited Raphael's shop and continued work on outstanding projects. Penni's nickname, 'il Fattore' (the administrator), implies that he had previously been responsible for the ordinary business of the workshop. In a brief challenge to their authority, Sebastiano del Piombo lobbied the pope to be awarded the contract for the *Sala di Costantino*. Giulio and Gianfrancesco successfully argued that they held Raphael's original drawings and were the only artists who could complete the room as planned. The pen and ink drawing for *Pope Sylvester I being carried in a procession, followed by a cardinal* (p. 166) is an early study by Giulio for an abandoned scheme for this room. It is only half of the original drawing: the right-hand portion of the sheet is now in Stockholm. Although this drawing was once attributed to Penni it lacks his methodical hand, but exhibits some of the inventive penwork of Giulio.

After the Sala di Costantino was completed in 1524, Giulio left Rome and established himself in Mantua as court painter and architect to Frederico Gonzaga. Giulio, who even in Raphael's shop was more interested in decoration and artifice than naturalistic depictions of the body, excelled in his new position as a designer of many things from spoons to palaces. He spent the last two decades of his life as the head of his own thriving workshop, creating fanciful designs such as the playful vessel illustrated here (p. 167). Drawings such as this one give a sense of how artists were asked to turn their design talents to all kinds of tasks. As Renaissance silver has almost all been melted down, Giulio's designs are precious records of these works.

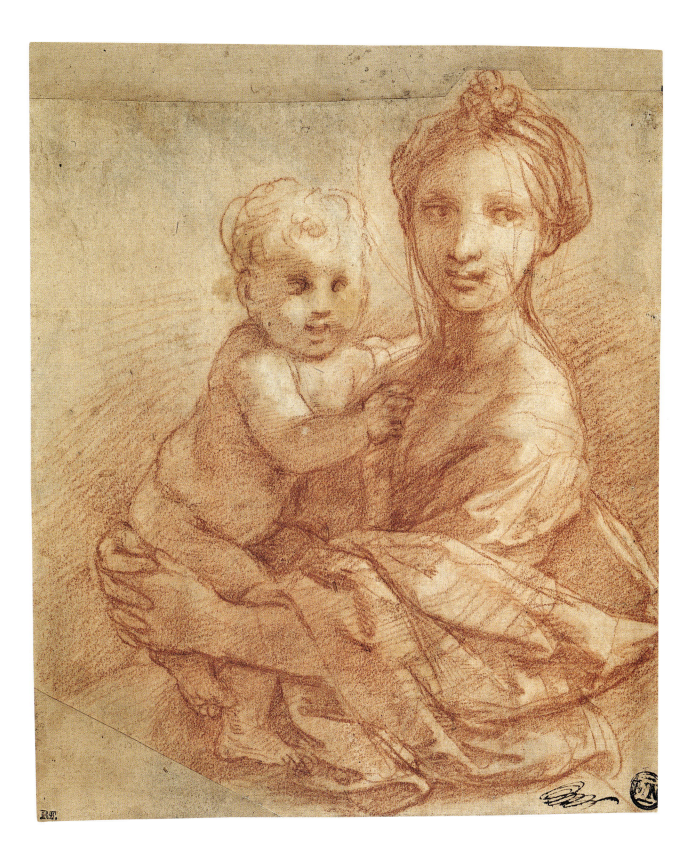

Virgin and Child, c. 1516.
Red chalk with traces of white highlighting, 202 × 177 mm.
Paris, Louvre, inv. 3607.

Pope Sylvester I being carried in a procession, followed by a cardinal, 1520–4.
Pen and ink over traces of stylus and black chalk, 420 × 288 mm.
Paris, Louvre, inv. 3874.

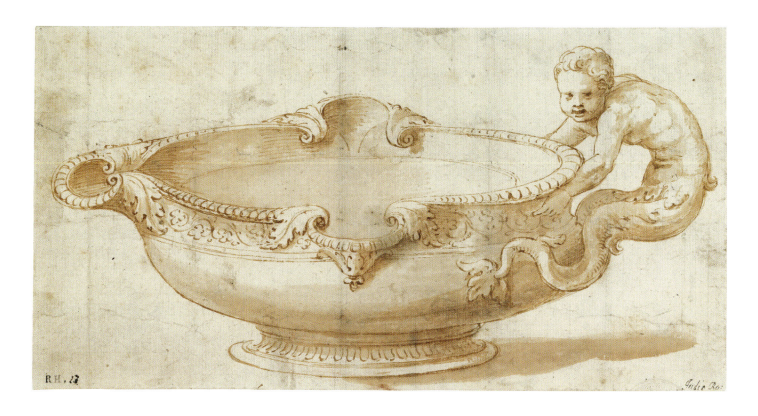

A shallow vessel with three spouts, the handle formed by an infant triton with two tails, 1524–46.
Pen and ink with brown wash, 108 × 212 mm.
London, British Museum, Ff. 1–53.

Baccio Bandinelli

Florence 1493–1560 Florence

BY ALL ACCOUNTS BANDINELLI was an extremely difficult man with an impossible character. He was jealous of his colleagues and quick to be spiteful about their work. He was a conniving schemer and an obsequious sycophant to potential patrons. But he was also a masterly draughtsman and excellent teacher who left a legacy of numerous drawings. Bandinelli learned the art of drawing from his father, a successful Florentine goldsmith. Vasari tells a colourful tale of Bandinelli's youthful promise: one winter's day the young Baccio was challenged to make a snowman and the resulting figure was so good that his father sent him to train as a sculptor.

Throughout his life Bandinelli remained staunchly loyal to the Medici, even during the years of the Republic when a pro-Medician stance made him very unpopular. He reaped the rewards of this allegiance when the Medici were restored to power: Leo X, Clement VII and Cosimo I, the first Grand Duke, each bestowed important commissions upon him. Bandinelli became increasingly boastful of his talents. He claimed that he could sculpt a copy of the much-revered antique *Laocoön and his sons* that would surpass the original. Although the Medici seemed to appreciate his sculpture, his contemporaries reviled him. The goldsmith Benvenuto Cellini (1500–71), a former pupil of Bandinelli's father, called Bandinelli's monumental marble of *Hercules and Cacus* a 'sack of melons'. The sculpture was perhaps at an immediate disadvantage because it was placed in the Piazza della Signoria next to Michelangelo's *David*, but even when it is considered on its own Cellini's jibe is justified.

Despite Bandinelli's bravado he was not a prolific sculptor. His greater legacy must be his drawings, of which over 400 survive. He was proficient in a variety of media from subtle chalk drawings to bold pen and ink sheets like the *Two standing nudes*. This drawing demonstrates the profound influence of Michelangelo on Bandinelli's style. The cross-hatched penwork and the pose of the figures, especially the one on the right, which is clearly inspired by the *David*, are dependent on Michelangelo. Unlike an artist such as Sebastiano, who learned lessons from Michelangelo and used them to improve his own style, Bandinelli's grasp of the great Florentine sculptor never progressed beyond aping his works. Vasari was critical of Bandinelli, his rival at the Medici court, and yet he could not deny that Bandinelli's virtuosity in *disegno* eclipsed his negative characteristics and made him worthy of praise. Of course Bandinelli was not shy about praising himself. In his memoirs he boasted, 'All my concentration was fixed in drawing: in the judgement of Michelangelo, of our Princes and other notables, it is above all in that activity that I have prevailed.'

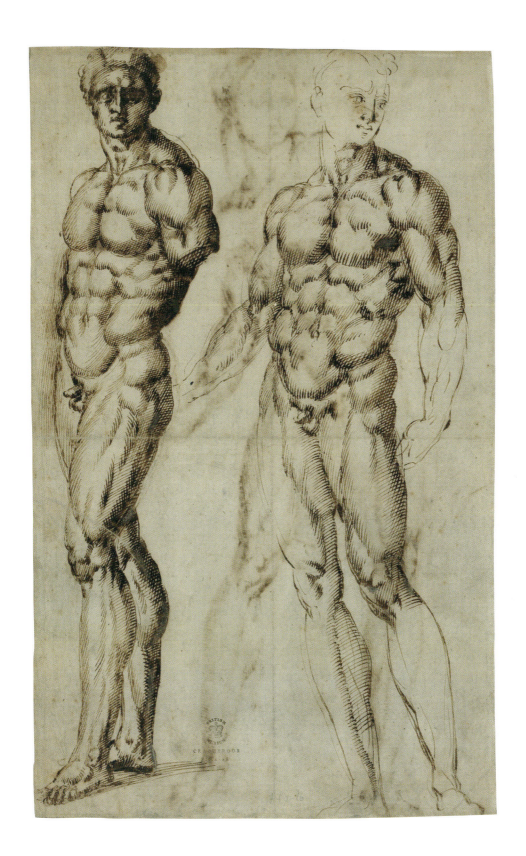

Two standing nudes, c. 1526.
Pen and ink, 419 × 262 mm.
London, British Museum, Ff. 1–16 (verso).

Jacopo Carrucci, il Pontormo

Pontormo 1494–1557 Florence

THIS ARRESTING SELF-PORTRAIT is indicative of Pontormo's eccentric character. He stands in his underpants working at an unseen easel, captured in the moment as he turns wide-eyed to point at the mirror used to record his position. It is an extraordinary image of an artist whose idiosyncratic and often antisocial behaviour was recorded not just by Vasari but also in his own diaries, where he details the course of his work in the choir of San Lorenzo, Florence, during the 1540s, his neurotic habits and his curious diet of eggs.

According to Vasari, Pontormo was orphaned at a young age and passed through no fewer than four Florentine masters during his apprenticeship. Of these, Andrea del Sarto seems to have been the longest and greatest influence. By 1513 Pontormo was receiving orders for works in an established studio of his own. Notable among these early commissions were ephemeral decorations for Leo X's triumphal entry into Florence in 1515. This much-heralded event was a significant celebration for the Medici, who relished their return to power not just in Florence but also in Rome. In 1515–16 Pontormo painted the *Visitation* in the cloister of Santissima Annunziata, where his master Andrea and colleague Rosso had been hard at work. At around the same time he collaborated on pictures to decorate the bedroom of Pierfrancesco Borgherini (now National Gallery, London). At the end of the second decade of the sixteenth century, Pontormo was busy painting an altarpiece for the Pucci family in the Church of San Michele Visdomini and working on frescoes at the Medici villa at Poggio a Caiano.

Legend has it that during an outbreak of the plague, Pontormo sought refuge in the nearby Certosa at Galuzzo. It is apparently at this moment (1523–5)

that he drew the self-portrait. The other side of the sheet has a drawing of two Carthusian monks (one of whom is thought to be the prior of Galuzzo, Leonardo di Giovanni Buonafé), which was used in preparation for the canvas of the *Supper at Emmaus* painted for the Certosa.

When Pontormo returned to Florence he set to work on the Capponi Chapel in the Church of Santa Felicità. The bright palette and haunting figures, particularly in the altarpiece of the *Deposition*, make this chapel one of his masterpieces. It was around this time that Agnolo Bronzino (1503–72) was Pontormo's apprentice. Pontormo adopted Bronzino even though Agnolo was only nine years younger than him. Jacopo's erratic conduct at times alienated Bronzino, and yet his pupil remained devoted to him for life.

Many of Pontormo's late works were made for the Medici. He was a skilled portraitist and completed many pictures for their villas at Poggio a Caiano, Careggi and Castello, as well as frescoes in the choir of their church, San Lorenzo. In an age when most of his contemporaries achieved success in various parts of Italy and even France, Pontormo never strayed from Florence and its environs. It is telling that in Benedetto Varchi's *paragone* on the superiority of painting or sculpture, it is Pontormo, well schooled by the great draughtsman Andrea del Sarto, who states that the indisputable foundation for each of the arts is *disegno*.

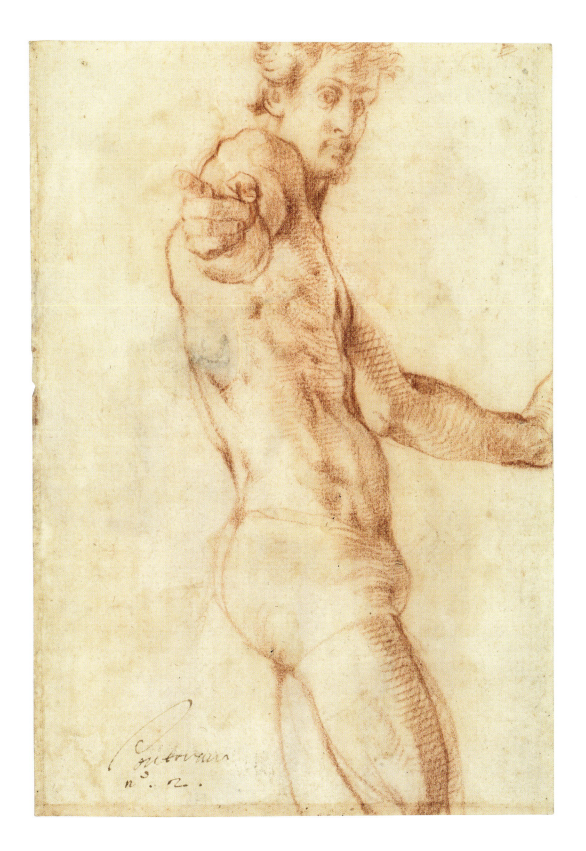

Self-portrait, 1523–5.
Red chalk, 281 × 195 mm.
London, British Museum, 1936-10-10-10.

Rosso Fiorentino
Florence 1494–1540 Paris

Rosso belongs to a generation of artists who no longer considered themselves craftsmen, but artistic talents. Vasari commented on this when he wrote that Rosso was too independent to remain with a single master, 'having a certain opinion of his own that conflicted with their manners'. The only certainty about his training is that he passed through the *bottega* of Andrea del Sarto in around 1517. This is unlikely to have been a traditional master-pupil relationship as Rosso was just seven years younger than Andrea and, judging by Vasari's comments, already possessed a developed talent.

Rosso is often portrayed as an eccentric who had trouble securing Florentine commissions. This image is in part due to the rejection of two of his early Florentine works by their respective patrons. He achieved greater success in Volterra, where in 1521 he signed and dated a *Deposition from the Cross* that is arguably one of the outstanding works of his career. Upon his return to Florence, Rosso's fortunes improved. He secured important commissions like the *Marriage of the Virgin* of 1523, painted for the banker Carlo Ginori's family altar in San Lorenzo.

After completion of the Ginori altarpiece and the election of the new Medici pope, Clement VII, Rosso left Florence for Rome. He remained there for four years until the sack of Rome drove him and all artistic commissions from the city. Few of the Roman works survive, with the notable exceptions of the frescoes of the Cappella Cesi and the *Dead Christ supported by angels*, now in Boston. Equally important were Rosso's collaborations in printmaking with the engraver Giovanni Jacopo Caraglio (*c*. 1505–65). The resulting prints played a large part in disseminating Rosso's designs to a large audience.

After the sack of Rome, Rosso worked in various Italian cities for three years. The two highly finished composition drawings illustrated here date from this period. The first, a design for an elaborate altarpiece with the *Gathering of Manna* as its central scene (opposite), can plausibly be dated to 1529, when the artist was in Città di Castello. This detailed drawing is of the type that might accompany a contract for the approval of the patron, but neither a corresponding contract nor a finished altarpiece survives, indicating that the design was probably rejected. The equally elaborate drawing of *Mars and Venus* (p. 175) is striking for its use of white highlights on a dark prepared paper. The sheet, mentioned by Vasari, was made when the artist was in Venice in the spring of 1530 and living in the house of the writer Pietro Aretino. Its highly polished style and virtuoso treatment supports the idea that it was made as a gift to François I to encourage him to employ Rosso.

Even though François I had previously succeeded in luring Leonardo and Andrea del Sarto to France, it is Rosso who had the most enduring impact on the development of French art. He spent the last decade of his life at François' court, working principally at the château in Fontainebleau, where he headed a large team of artists. The erotically charged *Recumbent nude female figure asleep* (p. 174), drawn during this period and ultimately derived from Michelangelo's figure of *Dawn* on the Medici tombs, achieves its effect by placing the viewer as a voyeur gazing down on the model's sleeping form.

Design for an altar, 1529.

Pen and brown wash, heightened with white over traces of black chalk on blue-green prepared paper,
461 × 338 mm. London, British Museum, 1948-4-10-15.

Recumbent nude female figure asleep, 1530–40.
Red chalk with traces of underdrawing in black chalk, 126 × 244 mm.
London, British Museum, Pp. 5–132.

Mars and Venus, 1529.

Pen and ink with brown wash with white highlighting on brown prepared paper, 429 × 339 mm.

Paris, Louvre, inv. 1575.

Polidoro Caldara, *called* Polidoro da Caravaggio

Caravaggio *c.* 1497–*c.* 1543 Messina

According to Vasari, Polidoro began his artistic career as a labourer carrying rubbish and plaster for the painters of Raphael's busy workshop. Giovanni da Udine allegedly recognized artistic talent in this young Lombard and encouraged him to learn to paint. Soon afterwards Polidoro became a member of Raphael's team of painters and assisted with the frescoes in the Loggia of Leo X.

Vasari combined Polidoro's biography with that of a relatively unknown painter named Maturino Fiorentino, stating that the two men became as close as brothers while in Raphael's workshop. After Raphael's death, when the members of his workshop dispersed and found their own specialties, they set up shop together and provided frescoes for the façades of Roman buildings with monochrome friezes intended to imitate classical marble relief. These paintings, called *graffiti*, once adorned over forty Roman palaces and were much admired and copied in their day. Polidoro is credited with making innumerable studies after antique models: according to Vasari there was hardly a relief, statue or vase either broken or whole that was not drawn by Polidoro in his quest to develop his own *all' antica* style.

Polidoro's interest in the antique extended to a study of ancient painting. The chance discovery in the late fifteenth century of the Domus Aurea, a palace with fanciful painted walls built after AD 64 by the Roman emperor Nero, motivated Pintoricchio, Filippino Lippi, Michelangelo and Raphael to incorporate antique motifs into their own work. The ancient paintings were the inspiration for the *grotteschi* in Raphael's designs for the Loggia and would have been well known to Polidoro. In addition to the *grotteschi*, images of landscapes in the Domus Aurea made a profound impression on Polidoro. His frescoes painted in around 1524–7 in the Church of San Silvestro al Quirinale and the *Landscape with classical buildings* illustrated opposite demonstrate his unique treatment of landscape painting. Whereas landscapes had previously been confined to the backgrounds of pictures, under Polidoro they became the main motif.

The *Meeting of Janus and Saturn* (p. 178) also dates to the period after the break-up of Raphael's workshop and before the sack of Rome. Polidoro's nervous style and elongated figures are typical of his many red chalk drawings. This sheet is a preparatory study for the four scenes painted with his former colleagues from Raphael's workshop in the Villa Lante on Rome's Janiculum hill. After the sack of Rome and the death of Maturino, Polidoro fled to Naples and then to Sicily. He remained there in artistic isolation, which only heightened his already eccentric manner. The dramatic chiaroscuro and overhanging landscape of the *Entombment* (p. 179) are characteristic of Polidoro's emotionally charged style.

Because of numerous earthquakes in Sicily, few documents dating from Polidoro's Sicilian period survive, making his late works difficult to date. Even his death is a mystery: Polidoro was reputedly robbed and murdered in Messina in 1543, just as he was preparing to return to Rome.

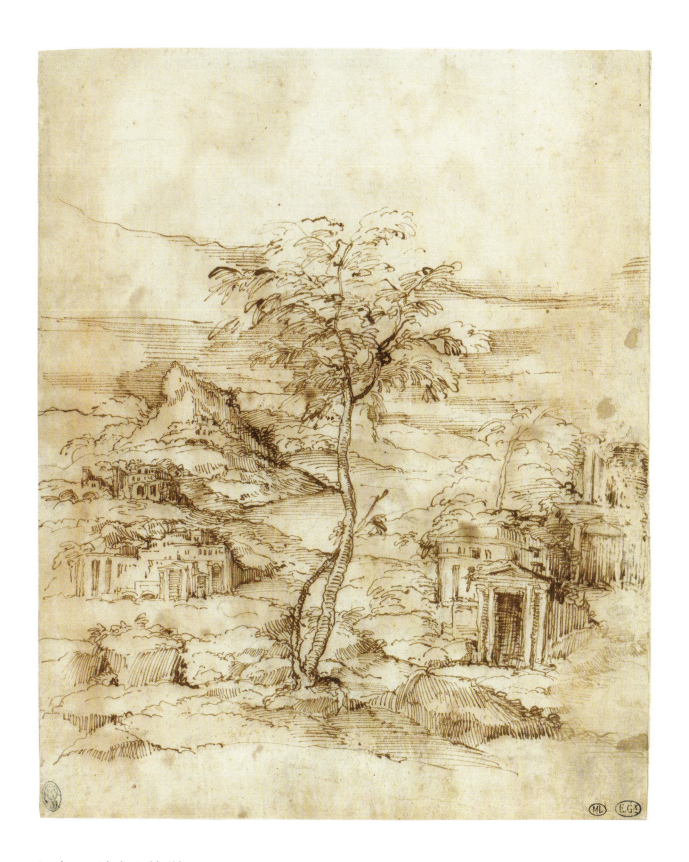

Landscape with classical buildings, c. 1524–7.

Pen and ink with brown wash, 249 × 200 mm.

Paris, Louvre, RF 61.

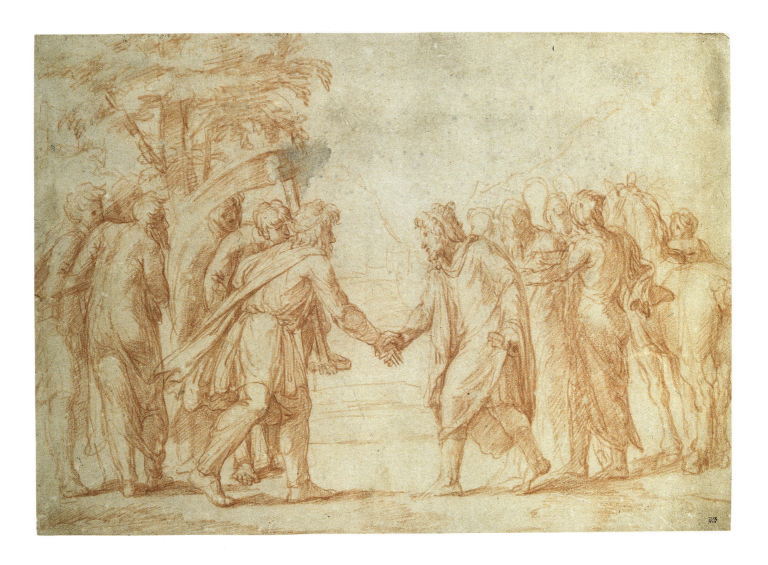

The meeting of Janus and Saturn, 1520–7.
Red chalk, 198 × 284 mm.
Paris, Louvre, inv. 6078.

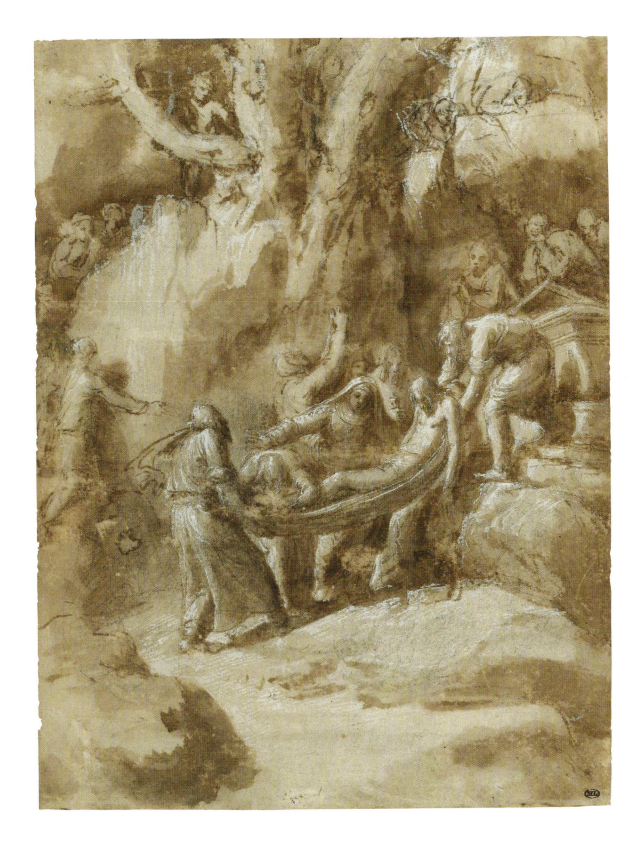

The Entombment, 1528–43.
Black chalk, pen and ink with brown wash and white highlighting, 275 × 215 mm.
Paris, Louvre, inv. 598.

Perino del Vaga (Pietro Buonaccorsi)

Florence 1501–47 Rome

THE CAREER OF PERINO DEL VAGA parallels the evolution of art in early sixteenth-century Italy. He was schooled in the well-established tradition of *disegno* in the Florentine workshop of Ridolfo Ghirlandaio. This training naturally embraced copying examples of the great masters, which in Perino's case included Leonardo and Michelangelo's cartoons for the *Battle of Anghiari* and the *Battle of Cascina*. Michelangelo's genius must have loomed large in Ridolfo's workshop: he was, of course, the pupil of Ridolfo's father, Domenico Ghirlandaio.

By 1516 Rome had supplanted Florence as the artistic nucleus of Italy. Michelangelo, Sebastiano and Raphael were at the height of their Roman careers and Leo X was three years into his reign. When Perino was fifteen he was taken to Rome with an artist named Vaga (hence the nickname). By 1518 Perino had joined Raphael's busy team of artists. This workshop was then in full swing: the altarpiece for Santa Maria del Spasimo (now in the Prado, Madrid) and the cartoons for the Sistine tapestries (Victoria and Albert Museum, London) had recently been completed, the commission to paint the *Transfiguration* (Vatican Museums) had been granted, and work was winding down on two altarpieces commissioned as presents for the French king (Louvre). In addition, Raphael was the architect of St Peter's, overseer of all Roman archaeological excavations and designer of Agostino Chigi's burial chapel. Perino was hired to work on the private loggia of Leo X, which was being decorated and stuccoed by Giovanni da Udine, Gian Francesco Penni, Polidoro da Caravaggio and other members of Raphael's team.

After Raphael's death the team drifted apart to specialize in different aspects of the workshop's production. Perino began to receive independent commissions from Roman patrons, although he assisted Raphael's heirs with the decoration of the Sala dei Pontefici. The sack of Rome in 1527 abruptly truncated Perino's ascending career. The invitation from Andrea Doria to come to Genoa proved irresistible, and Perino established himself as an important painter in the Ligurian city, much as Giulio Romano established himself in Mantua. He went back to Florence, where he drew a large cartoon to advertise his modern style, and returned to Rome in around 1536 when Paul III had ascended to the papal throne. In the last decade of his career Perino became the pope's official painter. His thriving workshop mirrored that of Raphael twenty years earlier. He died, according to Vasari, from exhaustion at the age of forty-six and was buried in the Pantheon with Raphael and Peruzzi. Michelangelo, whose genius remained an example to Perino throughout his life, outlived him by another seventeen years.

The *St Matthew* is a study for the vault of the Chapel of the Crucifix in San Marcello a Corso, Rome. Perino received this commission in 1525, but the sack of the city interrupted the project. He returned to it in 1539, finally completing the frescoes in 1543. The drawing of St Matthew (opposite) and another of St Luke (both now in the Louvre) were made in the second phase of work on the chapel. The pose and pronounced musculature of the Evangelist are reminiscent of Michelangelo's *ignudi* on the Sistine Ceiling, yet the soft handling of the black chalk stems from Perino's master, Raphael.

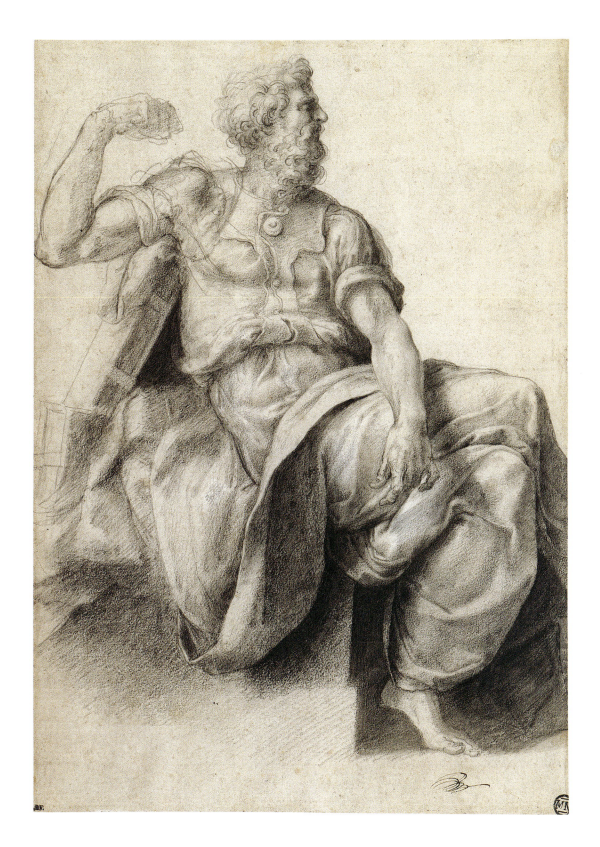

St Matthew, 1539–43.
Black chalk with touches of white highlighting, pen and grey ink on grey-beige prepared paper, 371 × 267 mm.
Paris, Louvre, inv. 2815.

Francesco Mazzola, il Parmigianino

Parma 1503–1540 Casalmaggiore

A S THE SON AND NEPHEW of painters, Parmigianino grew up in an atmosphere that nurtured his talent for drawing and painting. According to Vasari he was a precocious artist who completed his first altarpiece by the age of sixteen. This work coincided with the arrival of Correggio in Parma. It is not clear if Parmigianino became a pupil of Correggio's in the traditional sense, but it is evident that Correggio's works had a profound impact on Parmigianino's style. Early drawings such as the *Rape of Europa* (opposite) reflect his interpretation of Correggio's characteristic sweet faces and luminous use of red chalk. His hallmarks are also visible in Parmigianino's early paintings in San Giovanni Evangelista and in the sensuous frescoes at Fontanellato.

By the age of twenty-one, Parmigianino had set his sights on goals outside Parma and moved to Rome armed with a number of his pictures to present to Pope Clement VII. Parmigianino became interested in printmaking, perhaps because of Marcantonio Raimondi's success with prints after Raphael and Rosso Fiorentino's prints of his own designs. He teamed up with Rosso's engraver Giovanni Jacopo Caraglio to make prints such as the *Martyrdom of Sts Peter and Paul*, for which the Louvre's drawing (p. 184) is one of three extant studies. It is dependent on Marcantonio's print after Raphael's *Martyrdom of St Cecilia* and shows how Parmigianino absorbed the lessons of Raphael during his Roman sojourn. The sack of Rome in 1527 abruptly ended Parmigianino's dreams of Roman fame. If Vasari is to be believed, he fled while his one important Roman commission, an altarpiece of the *Vision of St Jerome* (National Gallery, London), was still wet on the easel, evading imprisonment because of the skilful portraits he drew of his German captors.

Parmigianino eventually reached Bologna, where he remained for three years. He continued to design prints and became an innovator in etching, a technique that allowed the artist to make his own plates without using an engraver as an intermediary. His surviving drawings give the impression that he was an artist who loved to draw, whether or not the drawing was intended for a work of art. The charming *Man holding up a pregnant bitch* (p. 186), which could be a self-portrait, is typical of Parmigianino's observations of the world around him.

By 1531 Parmigianino had returned to his home town, where he contracted to paint the eastern apse and vaults of the new Santa Maria della Steccata. It is clear from the many surviving drawings, some of which are very elaborate (p. 185), that the designs for this project occupied Parmigianino for years, but he never succeeded in finishing the paintings. After the first contract to complete the scheme within eighteen months was broken, three subsequent agreements were flouted until December 1539, when the exasperated patrons had Parmigianino thrown into jail. On his release he returned to the church to deface part of the completed vault before escaping to Casalmaggiore, outside Parma, where the authorities could not touch him. His freedom was short-lived. By August 1540, when he was just thirty-seven years old, Parmigianino was dead.

The Rape of Europa, *c.* 1520.
Red chalk, 330 × 200 mm.
Paris, Louvre, inv. 6021.

The Martyrdom of Sts Peter and Paul, 1524–7.
Pen and ink with brown wash, heightened with white, 175 × 288 mm.
Paris, Louvre, inv. 6399.

Study for the Steccata vault, 1531–9.

Pen and ink with brown wash and red chalk with white highlighting, 196 × 142 mm.

Paris, Louvre, inv. 6466.

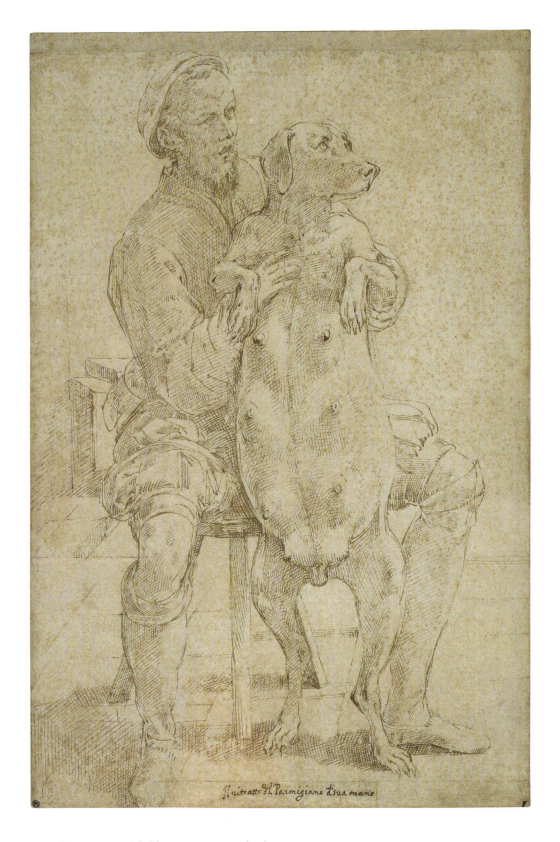

Man (Parmigianino?) holding up a pregnant bitch, 1530–40.

Pen and ink, 305 × 204 mm.

London, British Museum, 1858-7-24-6.

Suggested reading

General

Ames-Lewis, F., *Drawing in Early Renaissance Italy*, 2nd edn, New Haven and London, 2000.

Alberti, L.B., *On Painting*, trans. C. Grayson, London, 1991.

Armenino, G., *On the True Precepts of the Art of Painting*, trans. and ed. E. J. Olszewski, New York, 1977.

Baldinucci, F., *Notizie dei professori del disegno da Cimabue in qua*, ed. P. Barocchi *et al.*, Florence, 1975.

Baldinucci, F., *Vocabolario toscano dell' arte del disegno*, Florence, 1975.

Berenson, B., *The Drawings of the Florentine Painters*, 3 vols, Chicago, 1938.

Cennini, C., *The Craftsman's Handbook*, trans. D. V. Thompson, Jr., New Haven, 1933.

Hunter, D., *Papermaking: The History and Technique of an Ancient Craft*, New York, 1978.

James, C., Corrigan, C., Enshaian, M.C., *et al.*, *Old Master Prints and Drawings: A Guide to Preservation and Conservation*, trans. M. B. Cohen, Amsterdam, 1997.

Meder, J., *The Mastery of Drawing*, trans. and rev. W. Ames, 2 vols, New York, 1978.

Richter, C. (ed.), *A Selection from the Notebooks of Leonardo da Vinci*, Oxford, 1977.

Vasari, G., *Lives of the Painters, Sculptors and Architects*, 2 vols, trans. G. du C. Vere with an introduction by D. Ekserdjian, London, 1996.

Watrous, J., *The Craft of Old Master Drawings*, Madison, 1967, repr. 2006.

British Museum catalogues

Gere, J.A., and Pouncey, P., *Italian Drawings in the Department of Prints and Drawings in the British Museum: Artists working in Rome c.1550 to c.1640*, 2 vols, London, 1983.

Popham, A.E., and Pouncey, P., *Italian Drawings in the Department of Prints and Drawings in the British Museum: The Fourteenth and Fifteenth Centuries*, 2 vols, London, 1950.

Pouncey, P., and Gere, J.A., *Italian Drawings in the Department of Prints and Drawings in the British Museum: Raphael and his Circle*, 2 vols, London, 1962.

Wilde, J., *Italian Drawings in the Department of Prints and Drawings in the British Museum: Michelangelo and his Studio*, 2 vols, London, 1953.

British Museum exhibition catalogues

Royalton-Kisch, M., Chapman, H., and Coppel, S., *Old Master Drawings from the Malcolm Collection*, London, 1996.

Turner, N., *Florentine Drawings of the Sixteenth Century*, London, 1986.

Turner, N., *The Study of Italian Drawings: The Contribution of Philip Pouncey*, London, 1994.

Artists

(alphabetical order of surname)

Fra Angelico

Kanter, L., and Palladino, P., *Fra Angelico*, exh. cat., Metropolitan Museum of Art, New York, 2005.

Pope-Hennessy, J., *Fra Angelico*, London, 1974.

Baccio Bandinelli

Ward, R., *Baccio Bandinelli 1493–1560: Drawings from British Collections*, exh. cat., Fitzwilliam Museum, Cambridge, 1988.

Fra Bartolommeo

Fischer, C., *Fra Bartolommeo: Master Draughtsman of the High Renaissance*, exh. cat., Museum Boymans-van Beuningen, Rotterdam, 1991.

Gentile Bellini

Campbell, C., and Chong, A., *Bellini and the East*, exh. cat., National Gallery, London, and Isabella Stewart Gardner Museum, Boston, 2005.

Giovanni Bellini

Robertson, G., *Giovanni Bellini*, Oxford, 1968.

Jacopo Bellini

Eisler, C., *The Genius of Jacopo Bellini: The Complete Paintings and Drawings*, New York and London, 1989.

Giovanni Antonio Boltraffio

Brown, D.A., Bora, G., *et al., The Legacy of Leonardo: Painters in Lombardy 1490–1530*, rev. edn, Milan, 1999.

Sandro Botticelli

Lightbown, R., *Sandro Botticelli,* 2 vols, London, 1978.

Vittore Carpaccio

Fortini Brown, P., *Venetian Narrative Painting in the Age of Carpaccio,* New Haven and London, 1988.

Lauts, J., *Carpaccio: Paintings and Drawings,* London, 1962.

Giovanni Battista Cima (Cima da Conegliano)

Humphrey, P., *Cima da Conegliano,* Cambridge, 1983.

Correggio

Ekserdjian, D., *Correggio,* New Haven and London, 1997.

Bambach, C., Chapman, H., *et al., Correggio and Parmigianino: Master Draughtsmen of the Renaissance,* exh. cat., British Museum, London, 2000.

Lorenzo di Credi

See Verrocchio.

Raffaellino del Garbo

See Filippino Lippi.

Domenico Ghirlandaio

Cadogan, J.K., *Domenico Ghirlandaio, Artist and Artisan*, New Haven and London, 2000.

Giulio Romano

Hartt, F., *Giulio Romano,* 2 vols, New Haven, 1958.

Benozzo Gozzoli

Ahl, D. Cole, *Benozzo Gozzoli,* New Haven and London, 1996.

Leonardo da Vinci

Bambach, C.C. (ed.), *Leonardo da Vinci, Master Draughtsman*, exh. cat., Metropolitan Museum of Art, New York, 2003.

Popham, A.E., *The Drawings of Leonardo da Vinci*, rev. edn with an introduction by M. Kemp, 1994.

Zöllner, F., and Nathan, J., *Leonardo da Vinci, 1452–1519: The Complete Paintings and Drawings*, Cologne and London, 2003.

Filippino Lippi

Goldner, G., and Bambach, C.C., *The Drawings of Filippino Lippi and his Circle*, exh. cat., Metropolitan Museum of Art, New York, 1997.

Fra Filippo Lippi

Ruda, J., *Fra Filippo Lippi: Life and Work with a Complete Catalogue,* London, 1993.

Lorenzo Lotto

Humphrey, P., *Lorenzo Lotto,* New Haven and London, 1997.

Andrea Mantegna

Lightbown, R.W., *Mantegna: with a Complete Catalogue of the Paintings, Drawings and Prints*, Oxford, 1986.

Martineau, J., Christiansen, K., Ekserdjian, D., *et al., Andrea Mantegna* exh. cat., Royal Academy, London, and Metropolitan Museum of Art, New York, 1992.

Bartolommeo Montagna

Puppi, L., *Bartolommeo Montagna,* Venice, 1962.

Michelangelo

Chapman, H., *Michelangelo Drawings: Closer to the* Master, exh. cat., British Museum, London, 2006.

Hirst, M., *Michelangelo and his Drawings*, New Haven and London, 1988.

Marco d'Oggiono

See Boltraffio.

Parmigianino

Ekserdjian, D., *Parmigianino,* New Haven and London, 2005.

See also Correggio.

Pietro Perugino

Scarpellini, P., *Perugino,* rev. edn, Milan, 1991.

Baldassare Peruzzi

Gere, J.A., *Raphael and his Circle*, exh. cat., Pierpont Morgan Library, 1987.

Antonio Pisanello

Syson, L., and Gordon, D., *Pisanello, Painter to the Renaissance Court*, exh. cat., National Gallery, London, 2001.

Polidoro da Caravaggio

Moore-Ede, M., *Polidoro: The Way to Calvary*, exh. cat., National Gallery, London, 2003.

See also Peruzzi.

Antonio del Pollaiuolo

Wright, A., *The Pollaiuolo Brothers: The Arts of Florence and Rome,* New Haven and London, 2005.

Pontormo

Strehlke, C.B. (ed.), *Pontormo, Bronzino and the Medici: The Transformation of the Renaissance Portrait in Florence*, Philadelphia, 2004.

Pordenone (Giovanni Antonio de' Sacchis)

Cohen, C.E., *The Art of Giovanni Antonio da Pordenone: Between Dialect and Language*, Cambridge, 1996.

Raphael Sanzio

Chapman, H., Henry, T., and Plazzotta, C., *Raphael from Urbino to Rome*, exh. cat., National Gallery, London, 2004.

Joannides, P., *The Drawings of Raphael*, Oxford, 1983.

Jones, R., and Penny, N., *Raphael*, New Haven and London, 1983.

Rosso Fiorentino

Franklin, D., *Rosso in Italy: The Italian Career of Rosso Fiorentino*, New Haven and London, 1994.

Andrea del Sarto

Shearman, J., *Andrea del Sarto*, 2 vols, Oxford, 1965.

Sebastiano del Piombo

Hirst, M., *Sebastiano del Piombo*, Oxford, 1981.

Luca Signorelli

Henry, T., and Kanter, L., *Luca Signorelli: The Complete Paintings*, London, 2002.

Andrea Solario

Brown, D.A., *Andrea Solario*, Milan, 1987.

Titian

Wethey, H.E., *The Paintings of Titian*, 3 vols, London, 1961–75.

Perino del Vaga

See Peruzzi.

Andrea del Verrocchio

Butterfield, A., *The Sculptures of Andrea del Verrocchio*, New Haven and London, 1997.

Rubin, P.R., and Wright, A., *Renaissance Florence: The art of the 1470s*, exh. cat., National Gallery, London, 1999.

Marco Zoppo

Chapman, H., *Padua in the 1450s: Marco Zoppo and his Contemporaries*, exh. cat., British Museum, London, 1998.

Index